# Alberta

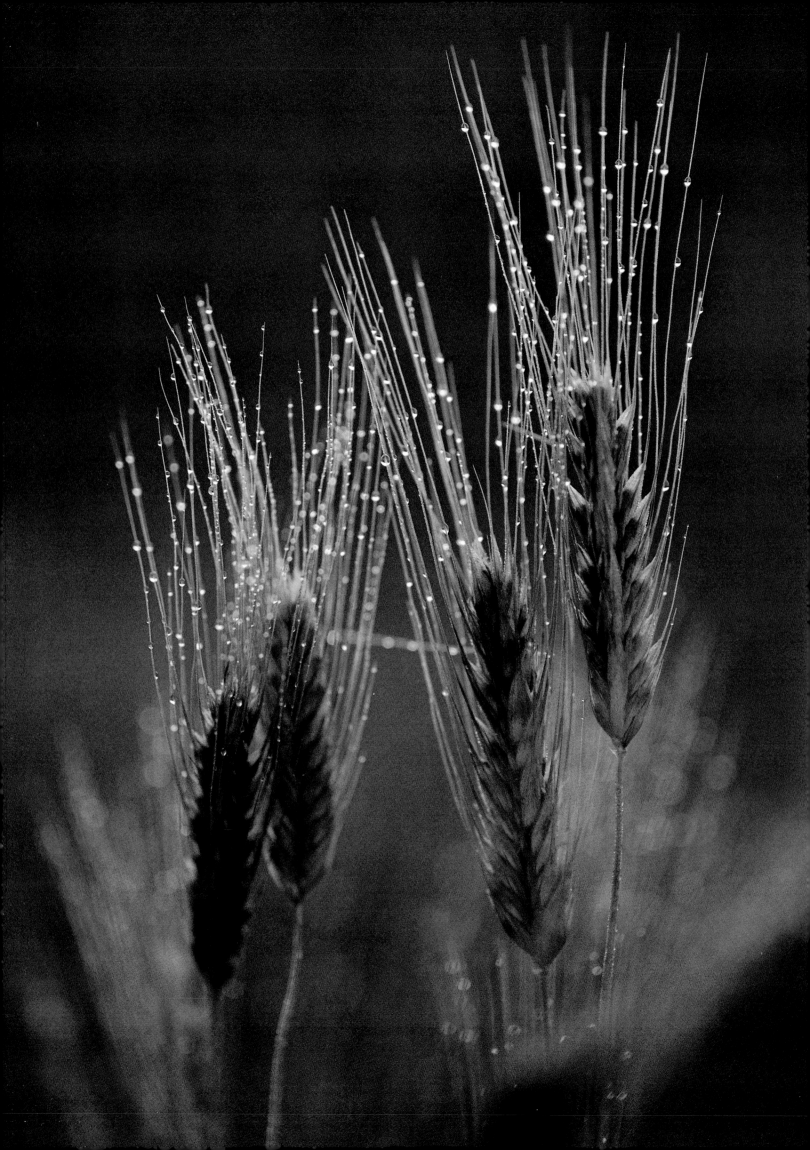

# Alberta

Sherman Hines

Foreword by Sid Marty

Nimbus Publishing Limited

To Glenn Doman.
A friend to the children of the world.

Nimbus Publishing Limited
Post Office Box 9301, Station A
Halifax, Nova Scotia B3K 5N5

CANADIAN CATALOGUING IN PUBLICATION DATA
Hines, Sherman, 1941-
Alberta
ISBN 0-920852-60-2
(Previously published by McClelland and Stewart Limited
under ISBN 0-7710-4155-1)
I. Alberta — Description and travel -1950- Views.
I. Title.

FC3662.H56   917.123'043'0222   C81-094794-3
F1076.8.H56

Printed and bound in Hong Kong

*Page 2:* Dew drops on barley reflect the early morning light.

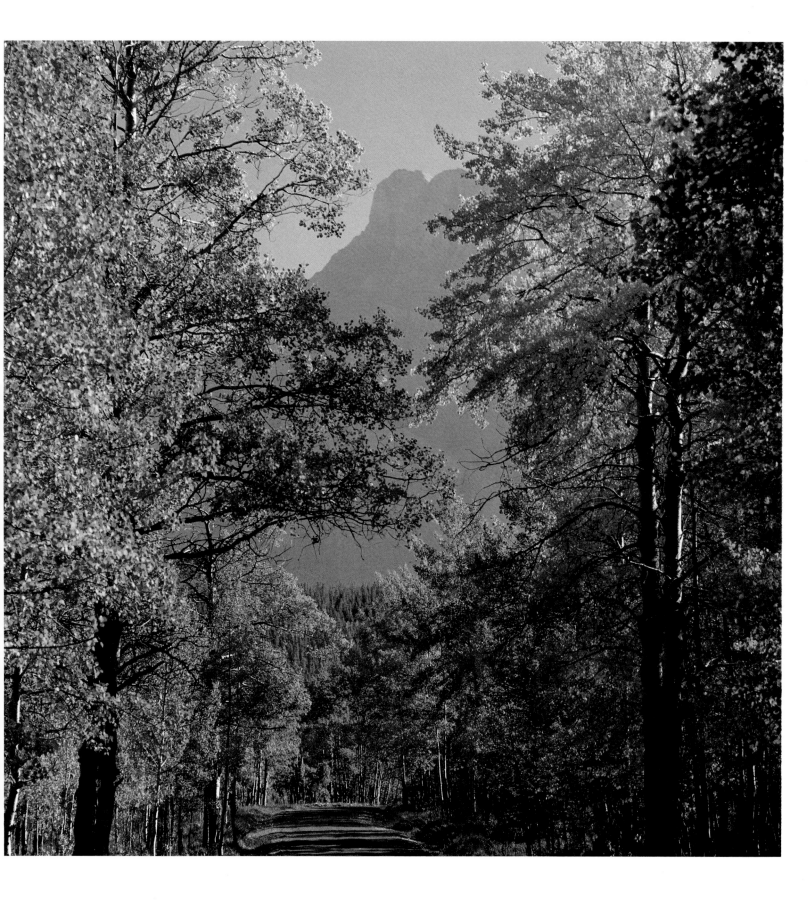

Aspen shade a roadway in the buffalo compound, Banff.

# Foreword

From the top of the Milk River Ridge in southern Alberta, a rolling sea of native grass washes against a horse's legs. The wind combs through it, east towards the Cypress Hills, south to the Montana border, north towards the wheatfields of McGrath, and west towards the mountains.

If there is a guardian spirit that watches over Alberta, its home must be here on the hundred-square-mile rangeland of the McIntyre Ranch. It must live here, where over 7,000 acres of unfenced, unbroken, undeveloped grass, lupine flowers, and wild roses are laconically described by the ranch hands as "the south field."

The south field looks today much as it did through a buffalo's hungry eye a century ago. This great rangeland was formed by prehistoric seas, raised by the earth's shifting plates into mountains, carved by ice, levelled by wind, covered with grass, and designed, as any rancher will be glad to tell you, for the sole purpose of raising beef. But the precious topsoil that makes ranching possible is under the constant rule of the wind, and fortunes are tied to the thinnest of all mooring lines, to the roots of a single blade of grass.

Strangers to the prairie complain about the gales of wind that come roaring out of the mountains, when the big sky of Alberta turns into an upsidedown cauldron of boiling black clouds. But it's the wind, the storied warm Chinook of winter, that makes this rangeland so valuable. It shatters the spell of winter with sudden thaws that expose the grass for the herds of cattle, and for the herds of mule deer and antelope that share the pastures.

Grass anchors the land, keeps it from blowing into Saskatchewan, as it did in the dirty thirties, and will do again if it's overgrazed or poorly farmed. Albertans were made conservative by the Depression. In the drylands of Alberta, we felt its effects well into the late forties. Now there are pots of golden wheat and barrels of oil at the end of the rainbow. But we have memories in this province: we know how rare a rainbow is in the years of drought.

My grandfather was one of many farmers starved out during the bad times, and I've met more than one old sodbuster who remembers the song my grandfather taught me:

We look away across the plains
And wonder why it never rains
Now that the clouds have gone again.

Farmers have learned a thing or two about the prairie wind since the days when they got stiff necked from staring at the empty blue horizon. Even cowboys reveal a grudging respect for today's sodbuster in the story they tell in the bunkhouse down on the McIntyre. It seems the devil was giving a visiting demon a tour through the hottest regions of hell. The devil bragged about his fiery fields of lava and pools of boiling pitch. He claimed that hell was hotter than Saskatchewan in 1935. But around a corner they came on green fields of new hay, trees, and flowering hedges of carraganas. "Those damn Alberta farmers!" roared the devil. "They're irrigating again!"

In a land of mountains and vast prairie so open to the weather, the beauty of local worlds is sometimes forgotten by the inhabitants. A farmer in his tractor at sundown is aware of the field's size and of the hundreds of acres left to seed, but not often of the impression he makes on those who see him, or of the scale of his work in the eye of the hawk overhead. It takes an artist's eye to show him that, to remind him of how a child's eye view of dew on a wheat sheaf once entranced him, or that beauty can lie in a pool of the very hailstones grain farmers despise.

This is prairie, but prairie unlike any other, as contrary and intemperate in climate as it is beautiful. One might compare it to Saskatchewan or Manitoba, if Albertans would allow it. Even the grain

elevators, those hoary old cliches of prairie scenery are different here. In Saskatchewan, the artists and poets revere them as monumental landmarks. But that's because there are no mountains in Saskatchewan, except Mount Blackstrap, which is a gopher mound that grew. In Alberta, elevators are not monuments. People never mention them except when they are too full to hold more grain (blame it on the CPR), or too empty due to drought (also inexplicably the fault of the CPR).

West of every elevator in Alberta is a mountain making it look small. From where I live, near Stand Off, I can see the front range of the Rockies rising like a huge foam-crested wave on the western horizon. They seem close enough to touch, and I can taste the chill of mountain water every time I draw a dipper from the well. Mountains gave rise to the rivers I love, like the Bow, the Belly, the Old Man, and the Waterton. Sometimes, when I'm lucky, they give rise to poems:

> To live here is to know
> The jagged arc of glory
> Is gravity's revenge
>
> That spent footfalls
> Of giant lives still echo
> Among earth's sprawling blue
> Pavilions, the heaped up
> Sharpened bones of history. . . .

Up there are the blue beginnings of Old Man Winter, never far away. Up there are the ochre cliffs above chill lakes where green-backed cutthroat trout are rising. Up there in the aspen meadows the velvet-antlered bucks are running, running for no reason but the joy of it.

From Waterton to Banff to Jasper and beyond, a chain of emerald lakes and white hanging glaciers are studded in the backbone of the Great Divide. The water I drink starts up there as a tinsel ribbon falling over slabs of quartzite by ledges covered with fireweed and paintbrush flowers.

Often in the blinding heat of prairie noon, the wind will come down again from the mountains and lay a cool hand on a horse's back, and on the sweaty forehead of a rider. Sometimes it carries the acrid taint of sour gas from a nearby oil field flare. To me it smells like acid rain, like progress. Maybe I'd feel differently if I owned an oil well. To some Albertans its odour is as sweet as the scent of fresh-minted dollar bills. But the wind picks up speed and brings the smell of clover and running water to our yard. It blows the bulldog flies and the mosquitoes back into the creek bottoms, it chases itself in dust devils around the house. It makes our yellow dog rise from the shade and lift her nostrils to the breeze, remembering the mountains.

South of Fort Macleod, near the Blood reserve, the Belly River buttes are lit now by the setting sun. A nighthawk dips over the cows in my neighbour's pasture on the far side of Highway 2. To the west, Spread Eagle Mountain stretches its fiery pinions and its shadow wings over the prairie to the buttes where the warrior dead are lying. The red-eyed sun blinks out behind the mountain. But lights are weaving slowly across the dark forehead of the distant hills, on the reservation. Late at night we wake up to the faint sound of drums, swelling and growing clear on the ceaseless wind. They signal the end of the yearly Sun Dance ceremony, and celebrate the rise of an orange summer moon.

The midnight highway curls like a snake through moonlit grass, and finally grows still. The nighthawk honours us by perching on our roof, while Alberta dreams of its lost and present empire under the stars.

Sid Marty

*Overleaf:* The ancient ice of the Athabasca glacier dwarfs the people at its base.

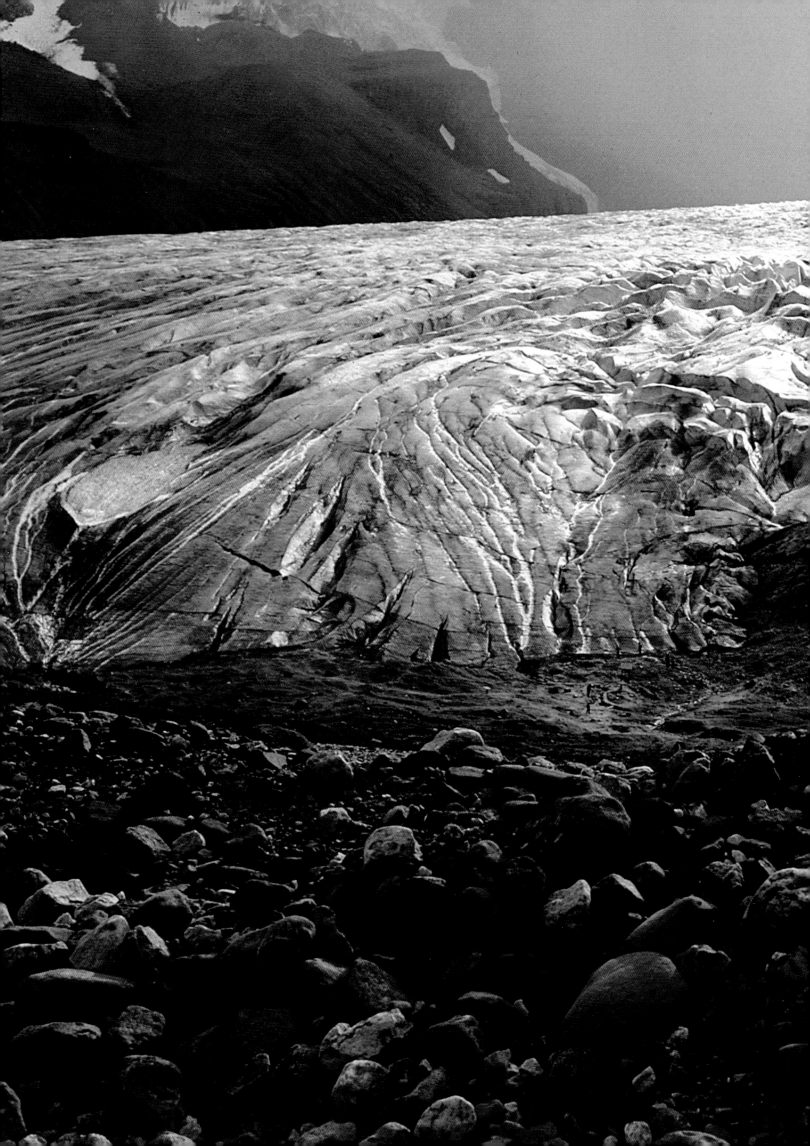

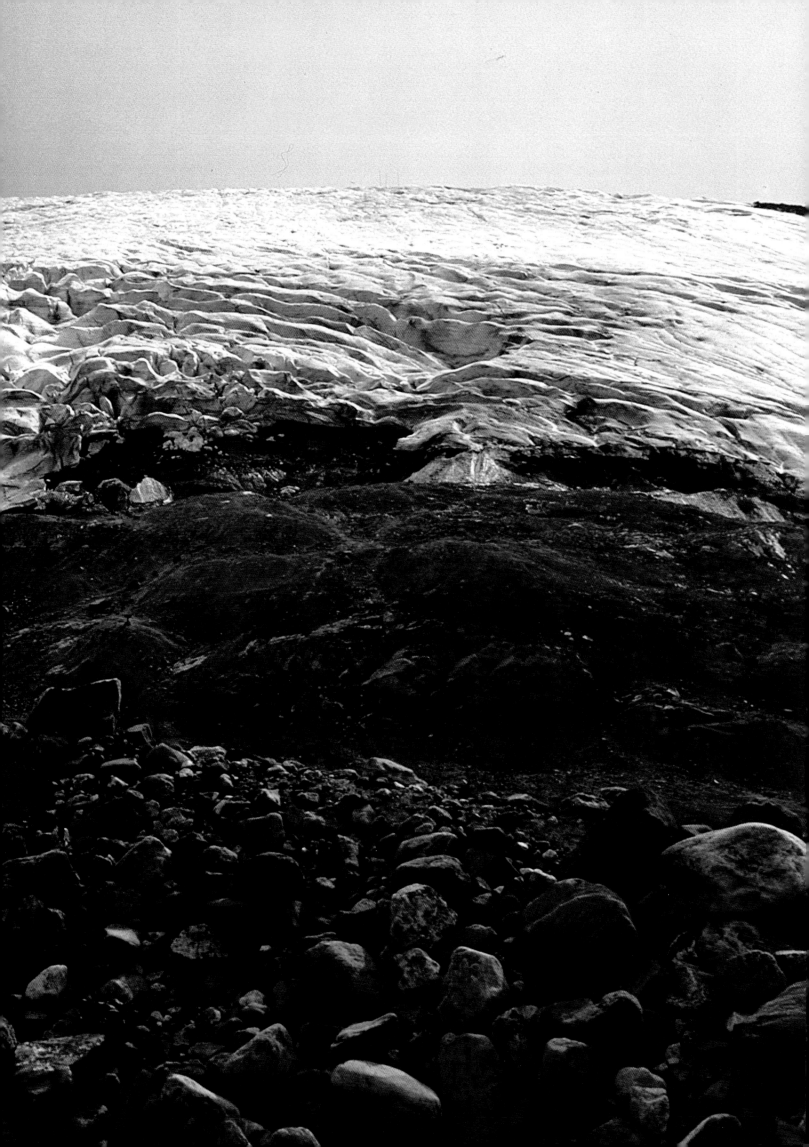

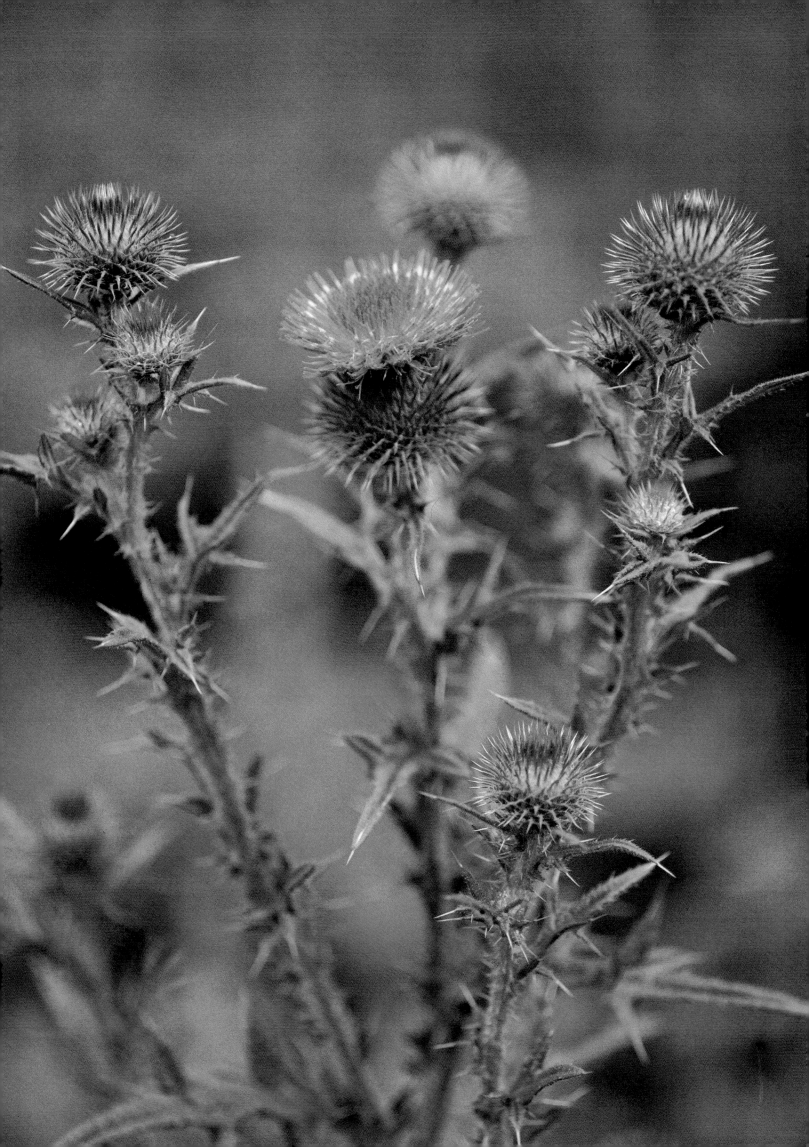

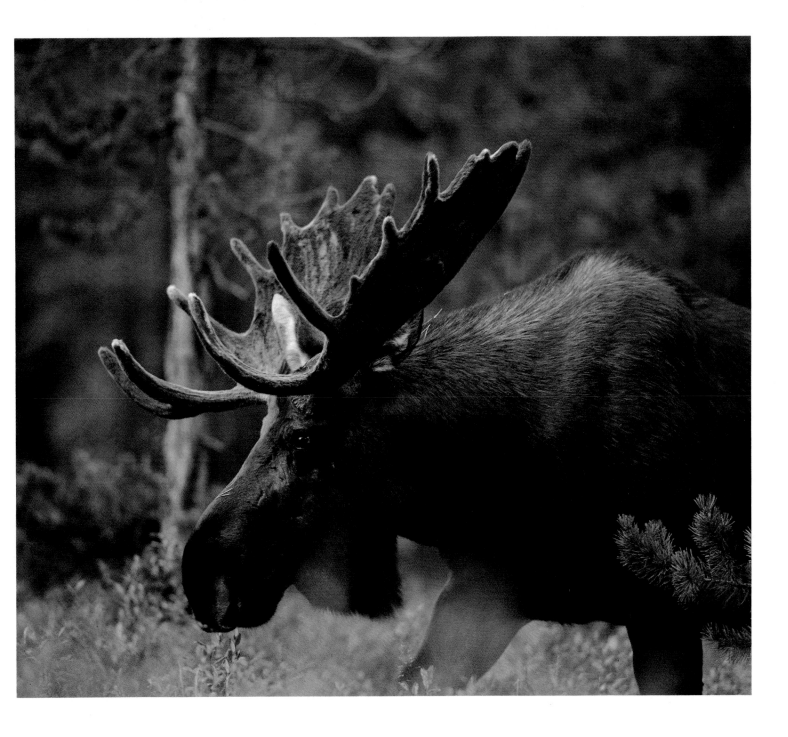

*Left:* Bull thistles are plentiful across Alberta.
*Above:* A bull moose with antlers in velvet browses in Jasper.
*Overleaf:* A dense stand of aspen near Kicking Horse Pass.

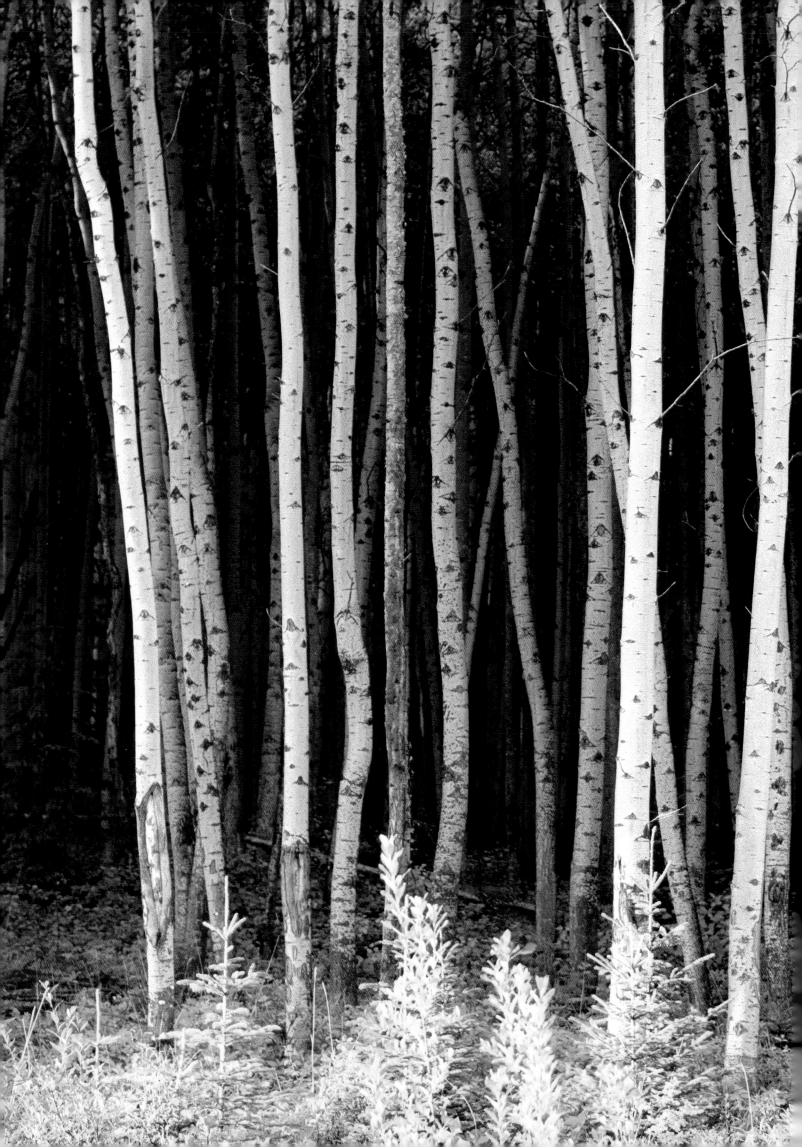

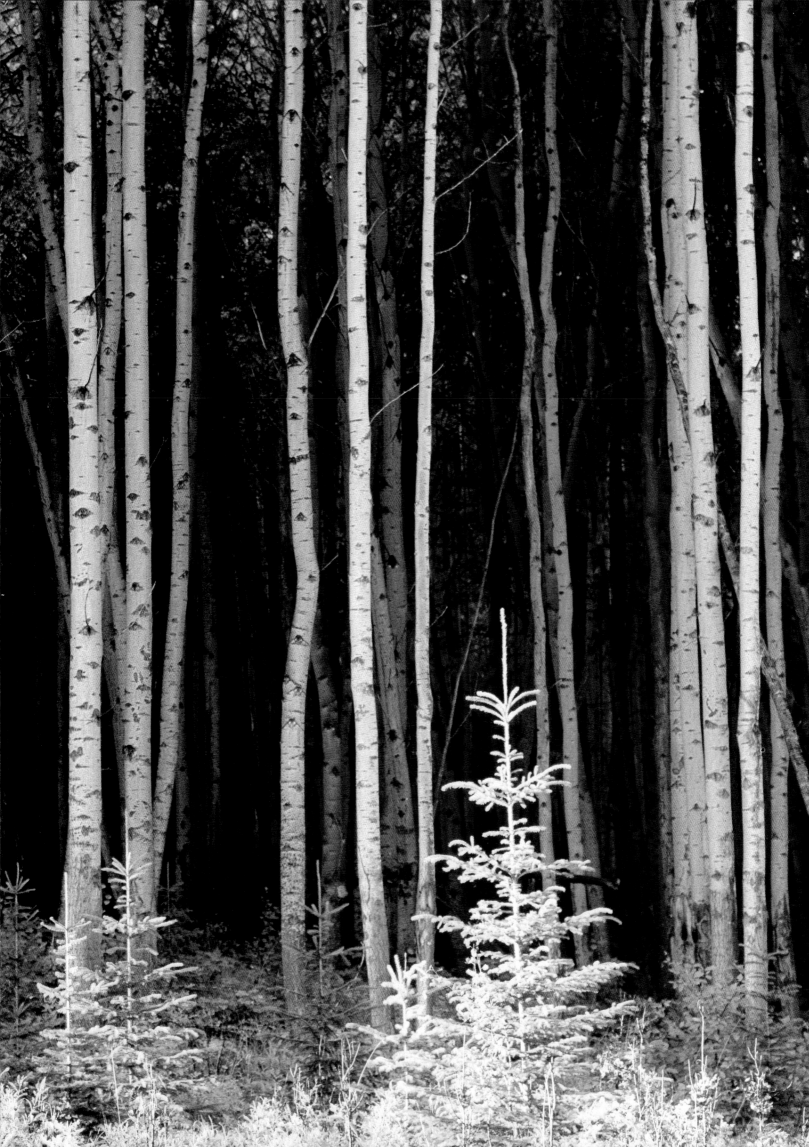

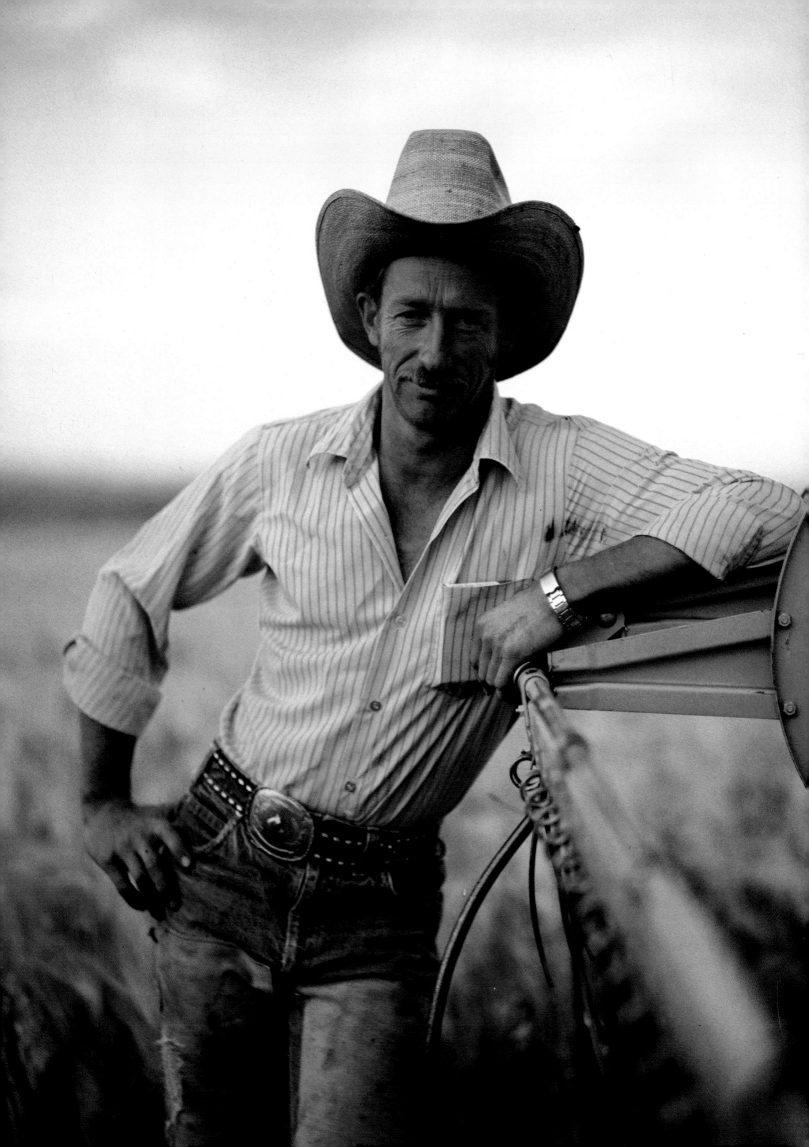

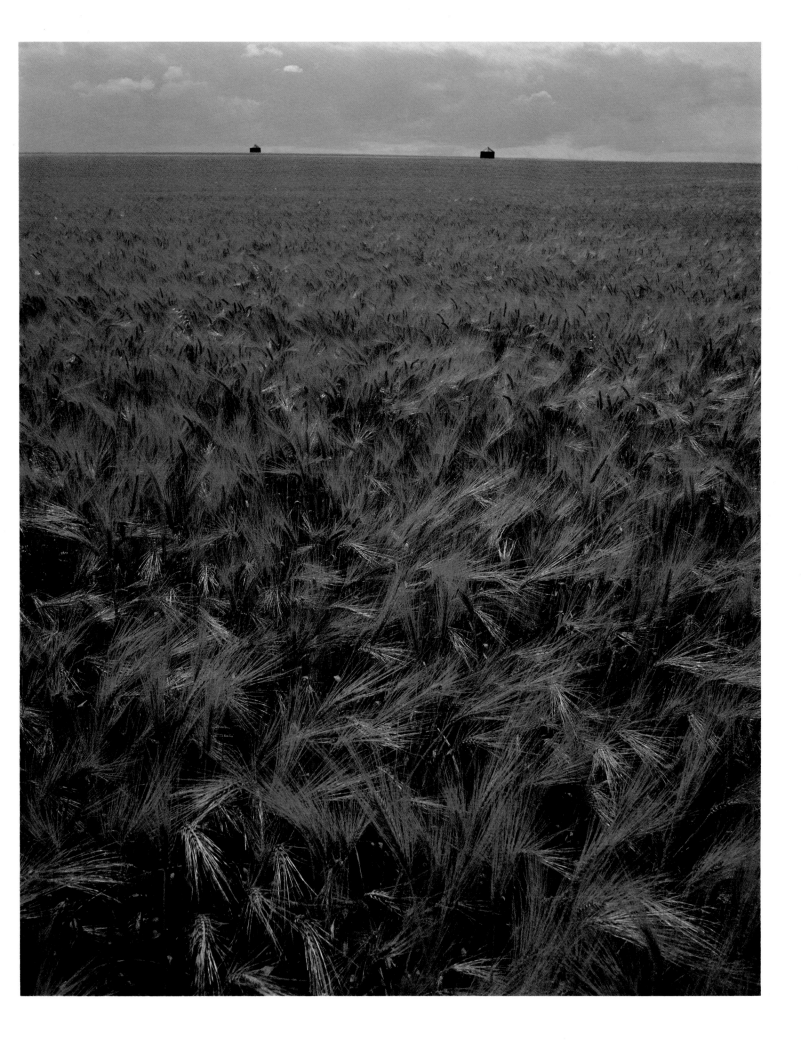

*Left:* Farming near Black Diamond.
*Above:* A field of barley stretches to the horizon.

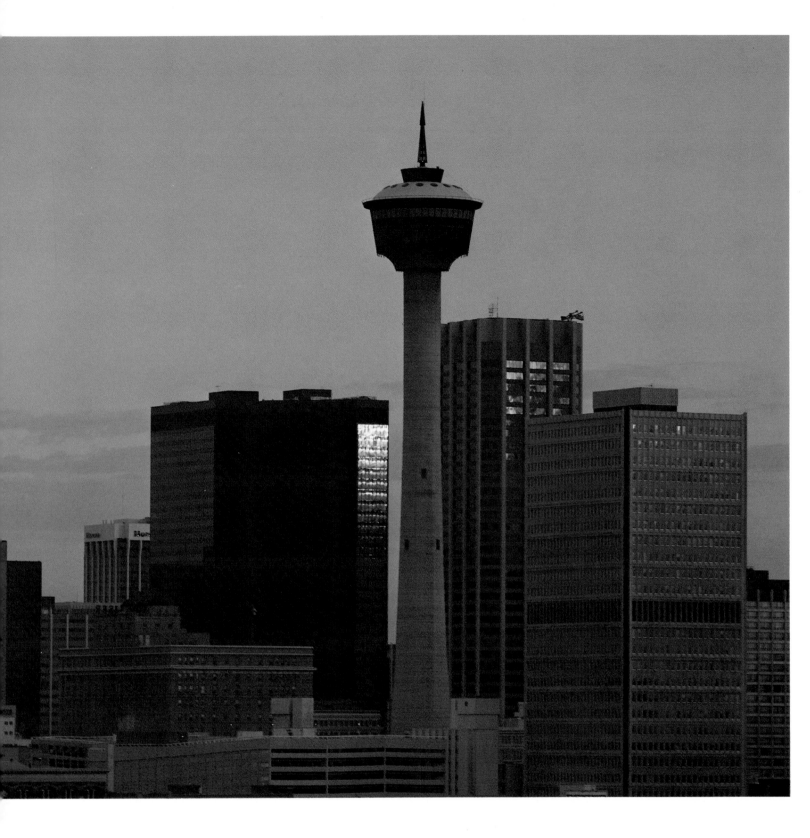

*Above:* The Calgary Tower punctuates the city's skyline.
*Right:* Colours and textures individualize each mountain.
*Overleaf left:* A brilliant sunset silhouettes the Wild Cat Hills oil plant.
*Overleaf right:* A marsh near Bow Lake.

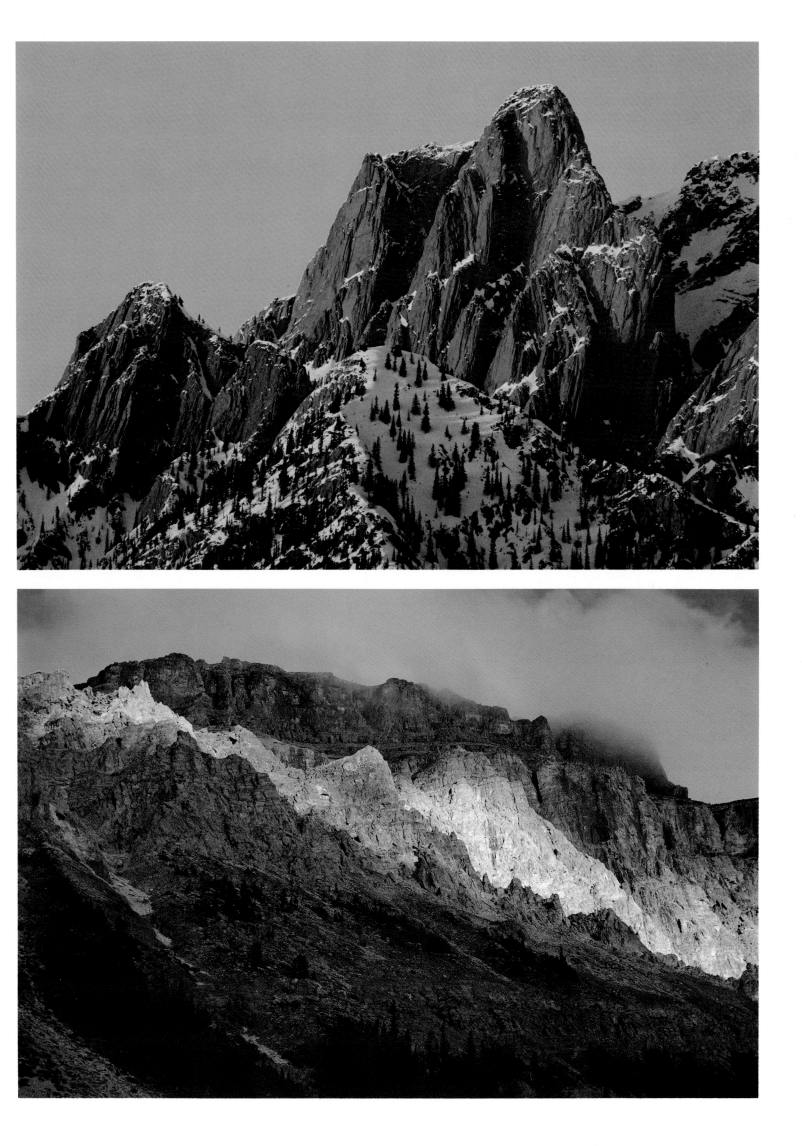

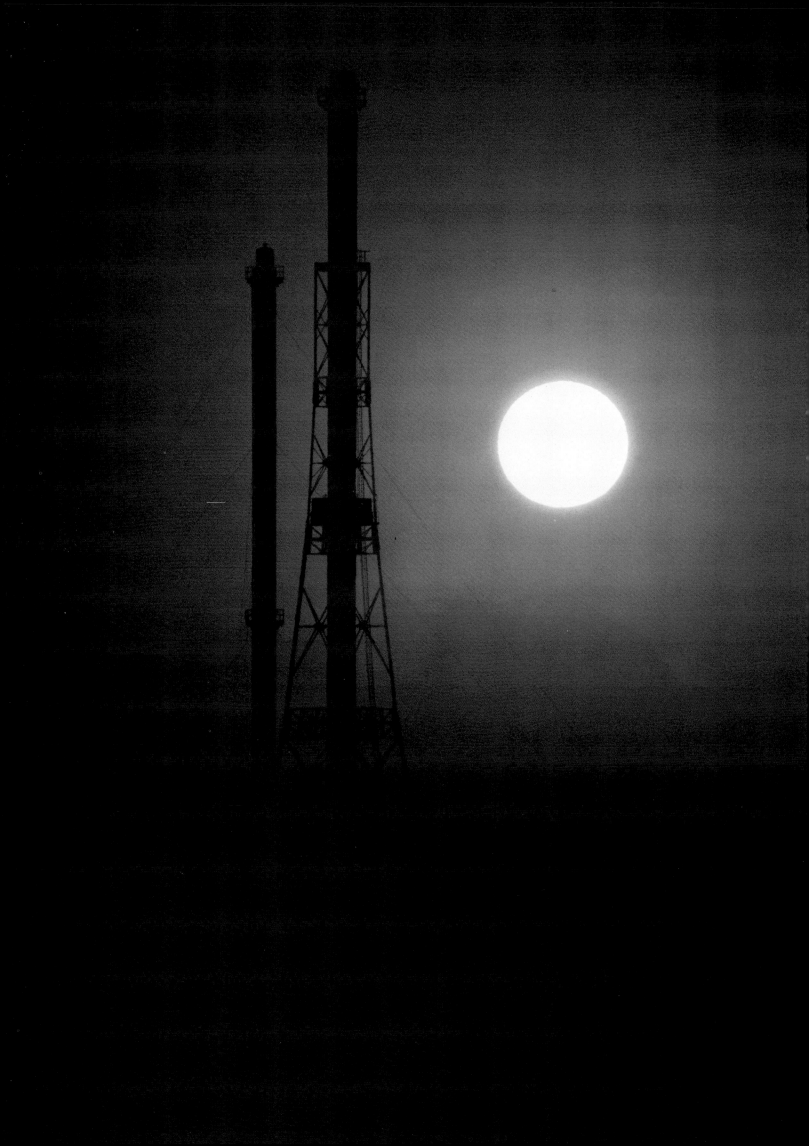

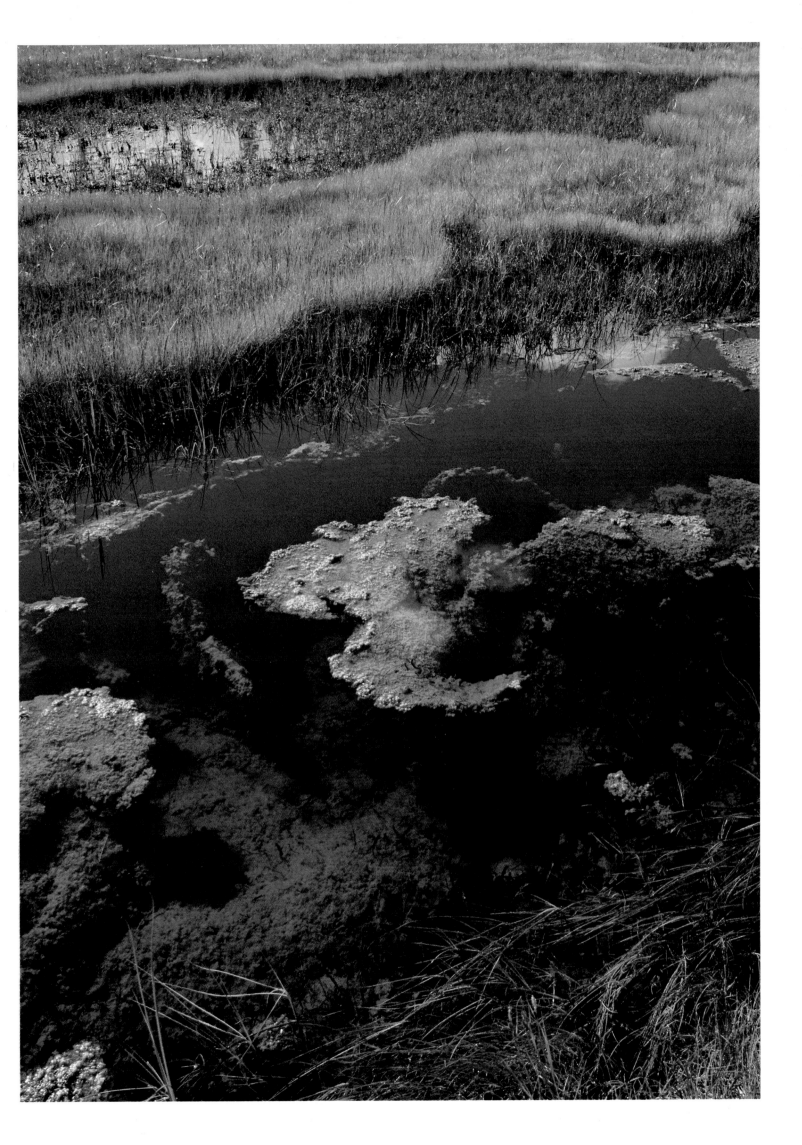

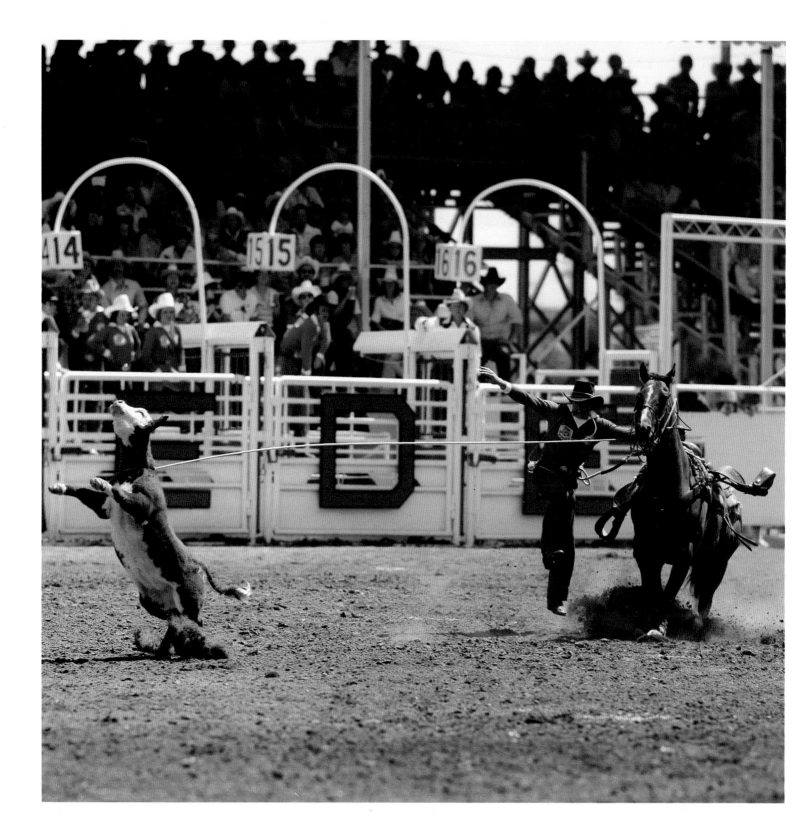

*Above:* A rider shows his skill in calf-roping at the Calgary Stampede.
*Right:* An old-timer at the Stampede's Indian Village.

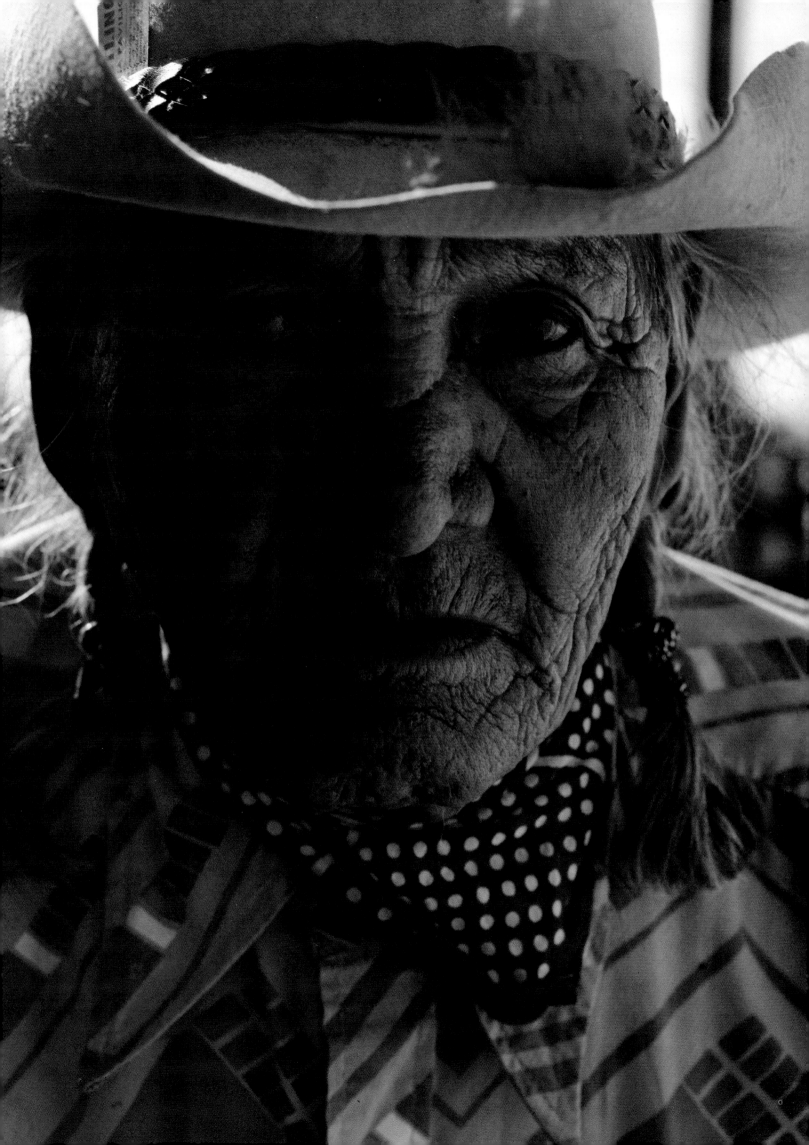

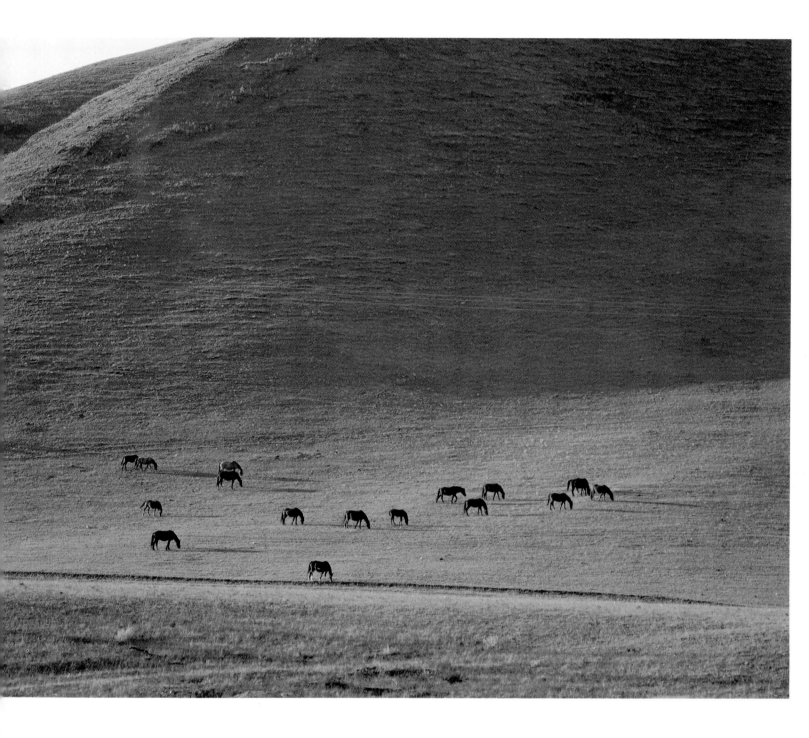

Horses graze contentedly on the Stoney Indian Reserve near the
old Calgary Highway.

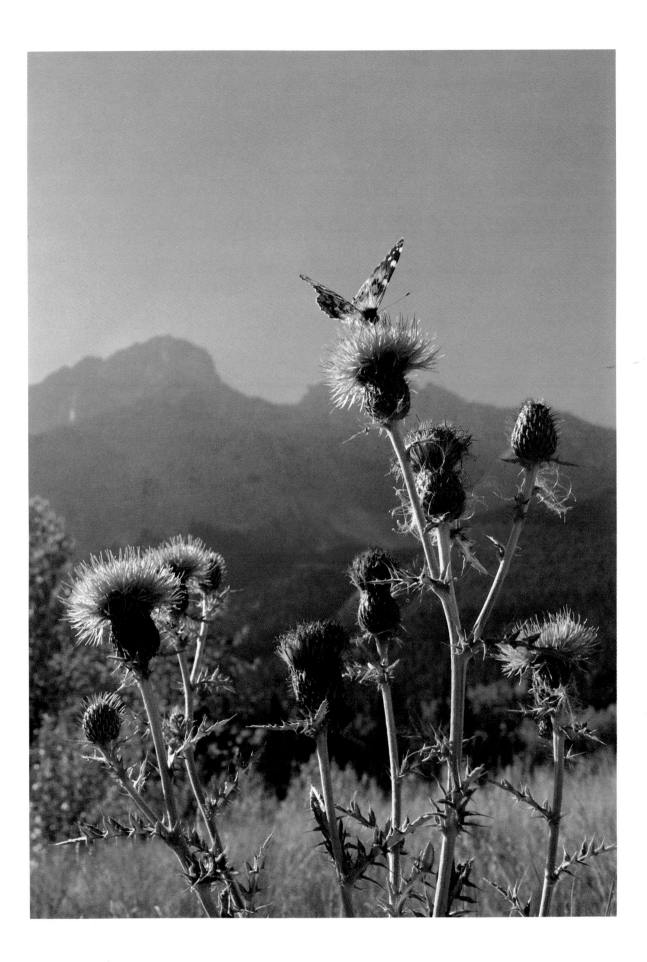

A butterfly alights on a thistle along the Minnewanka Lake Road.

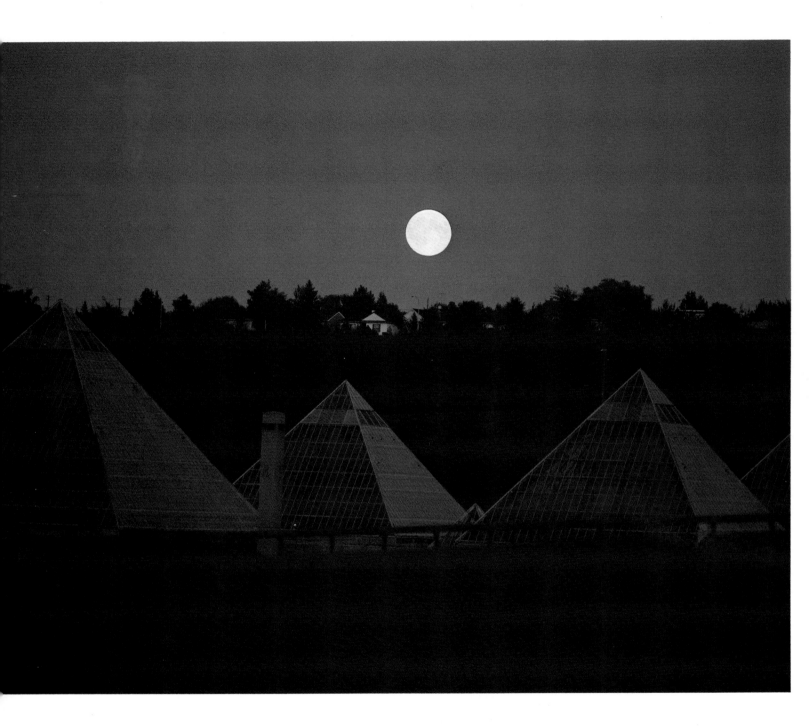

*Above:* A full moon rises over the Muttart Conservatory in Edmonton.
*Right:* The Hoodoos in the Drumheller region were sculpted by the elements eroding surrounding rock.

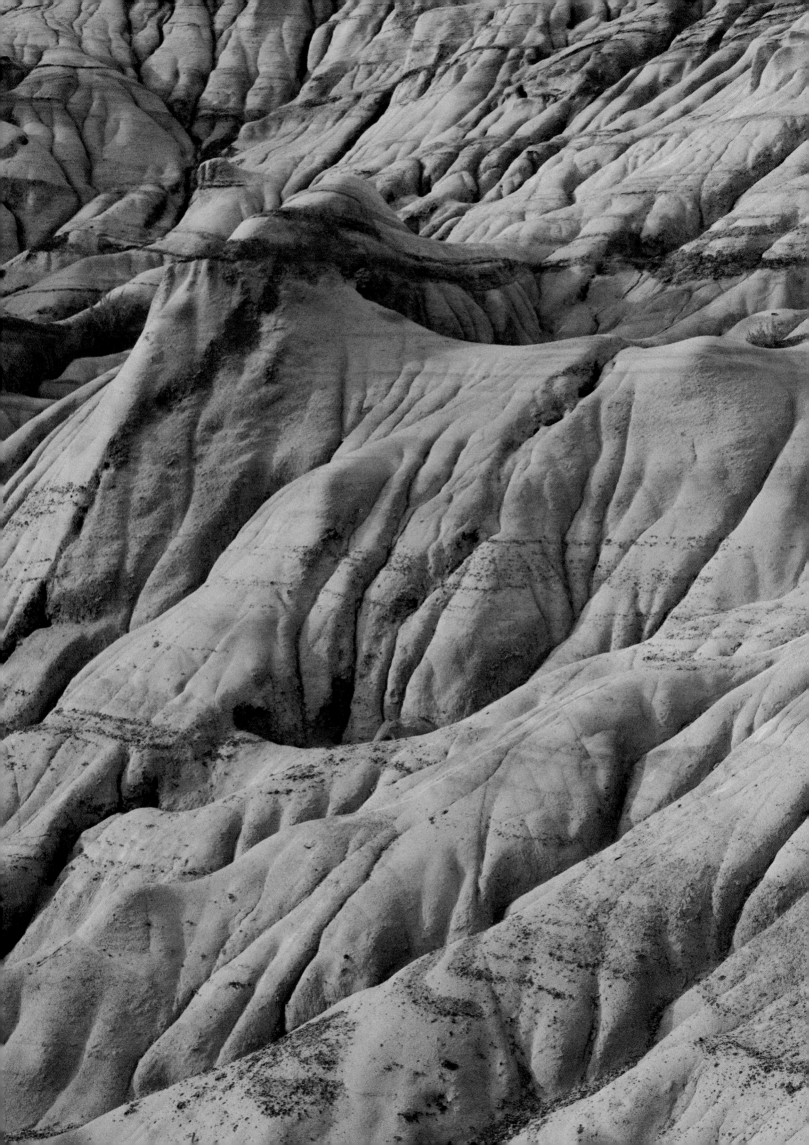

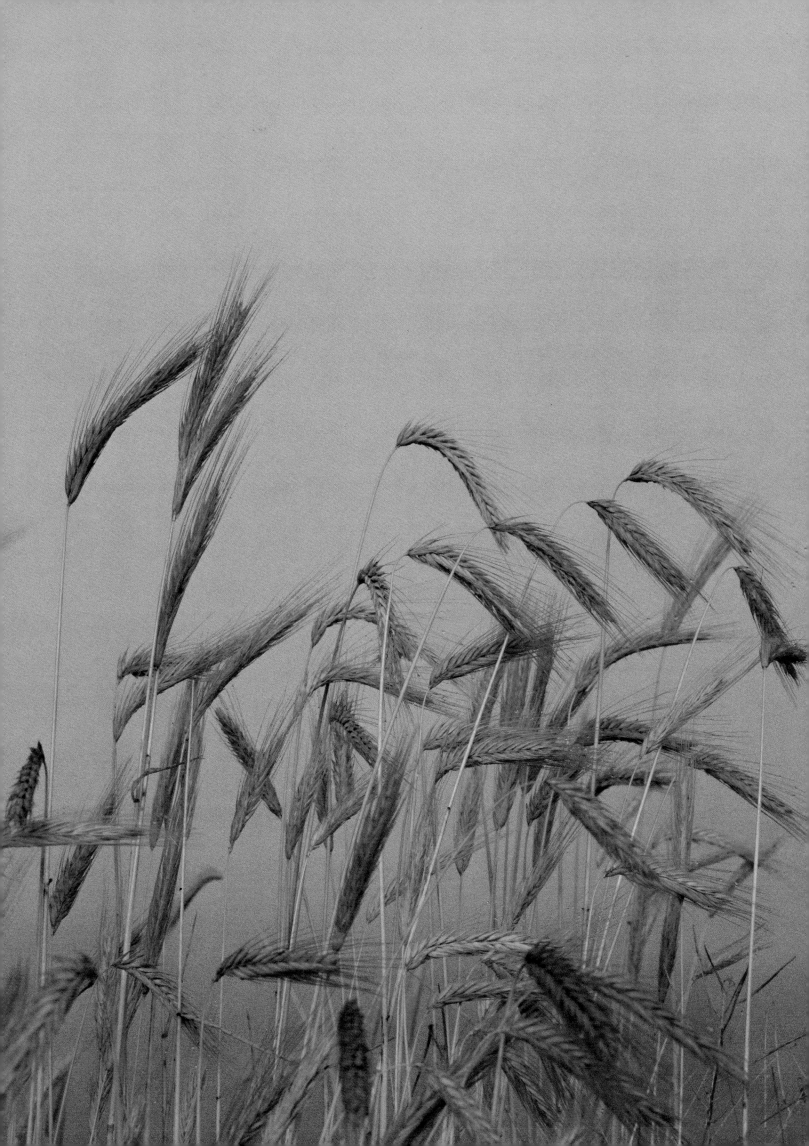

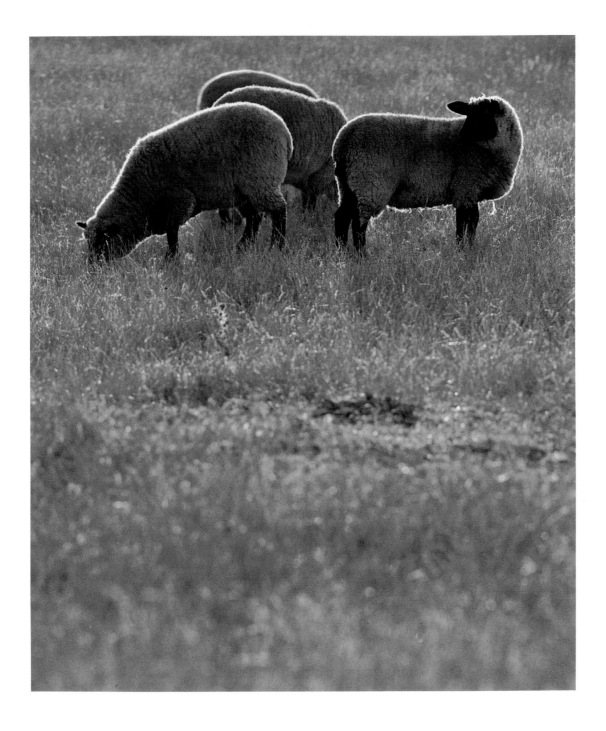

*Left:* Barley is one of Alberta's major agricultural crops.
*Above:* The setting sun casts a glow over a pastoral scene.

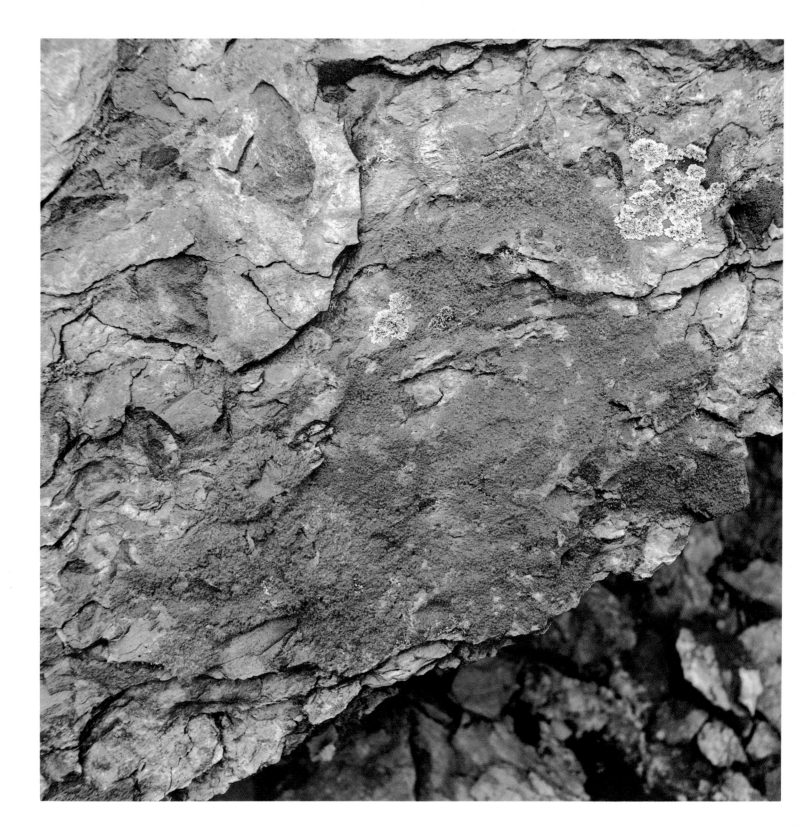

*Above:* Colourful lichen brighten a rock slide at the foot of
Moraine Lake.
*Right:* Frost silvers autumn leaves.

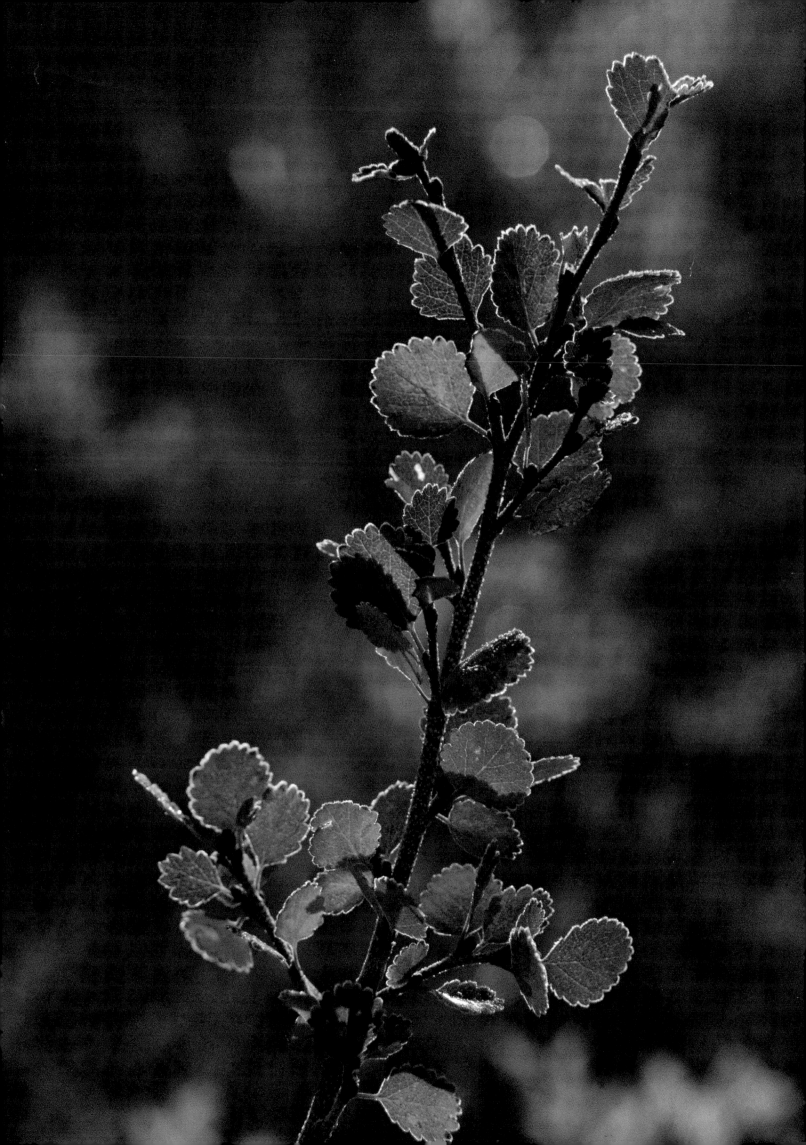

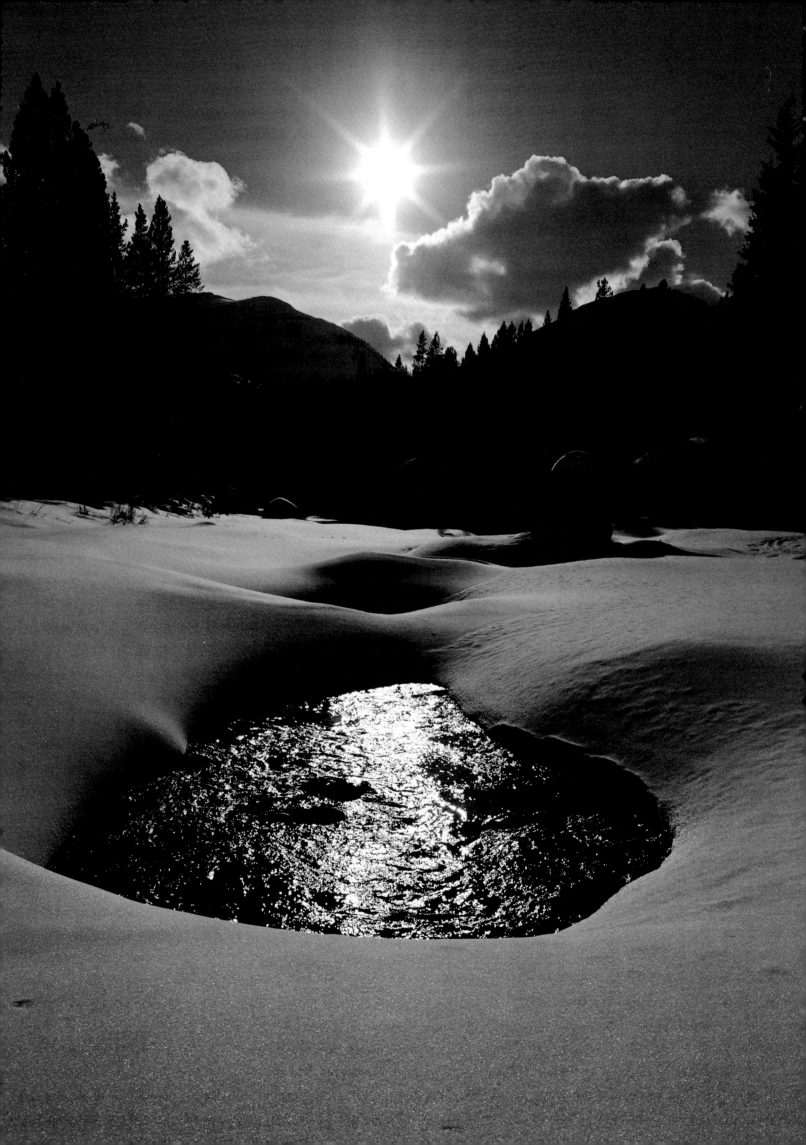

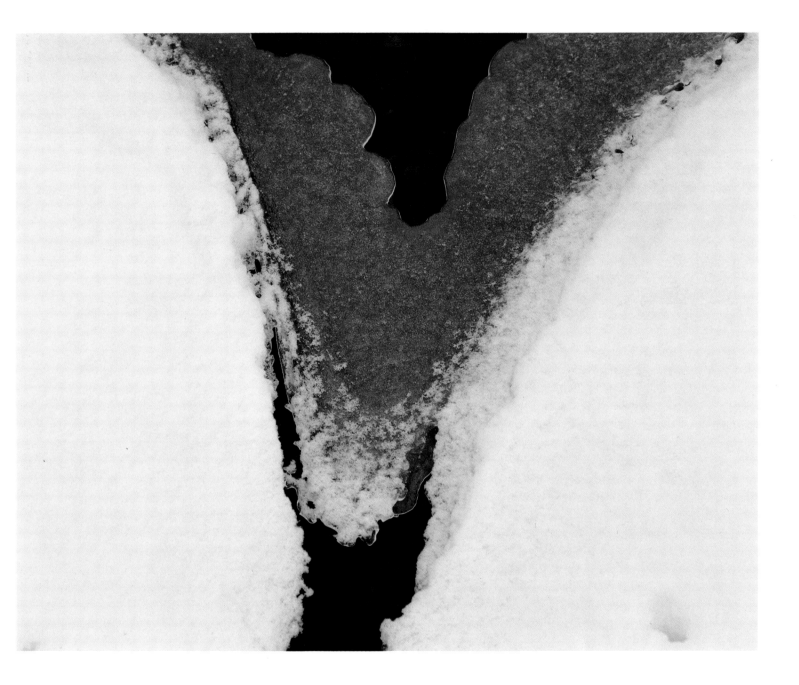

*Left:* The waters of a brook ripple in the sunlight along Maligne Lake Road.
*Above:* Ice forms an abstract design on the Cascade River.

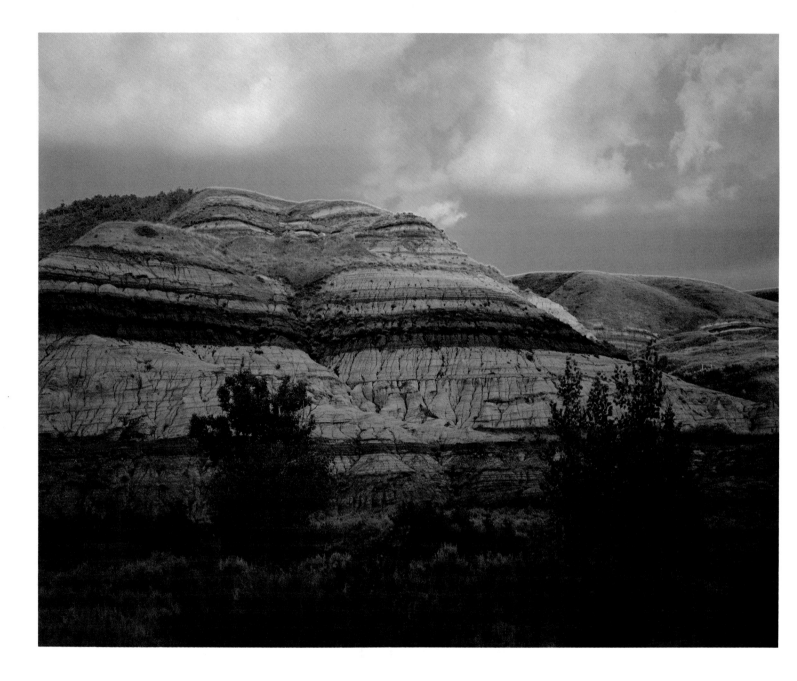

*Above:* The various strata of Drumheller Hoodoos are rich in fossils.
*Right:* Still life on Vermilion Lake.

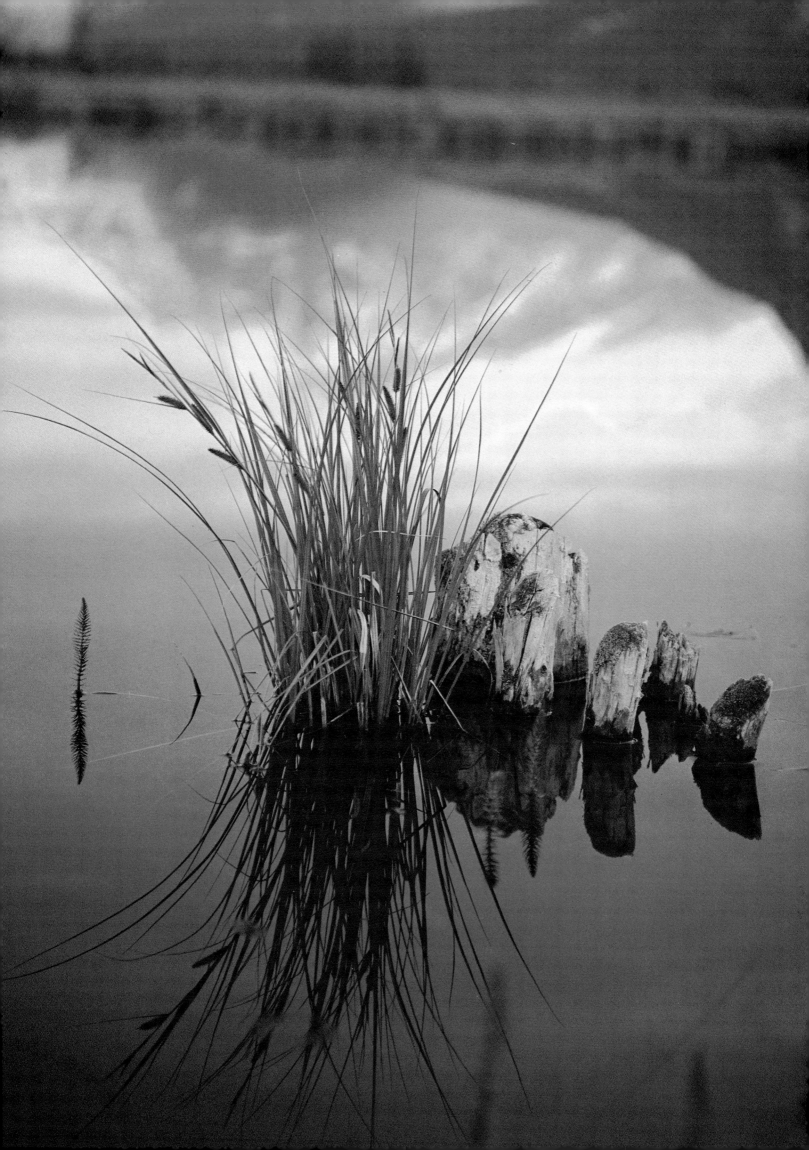

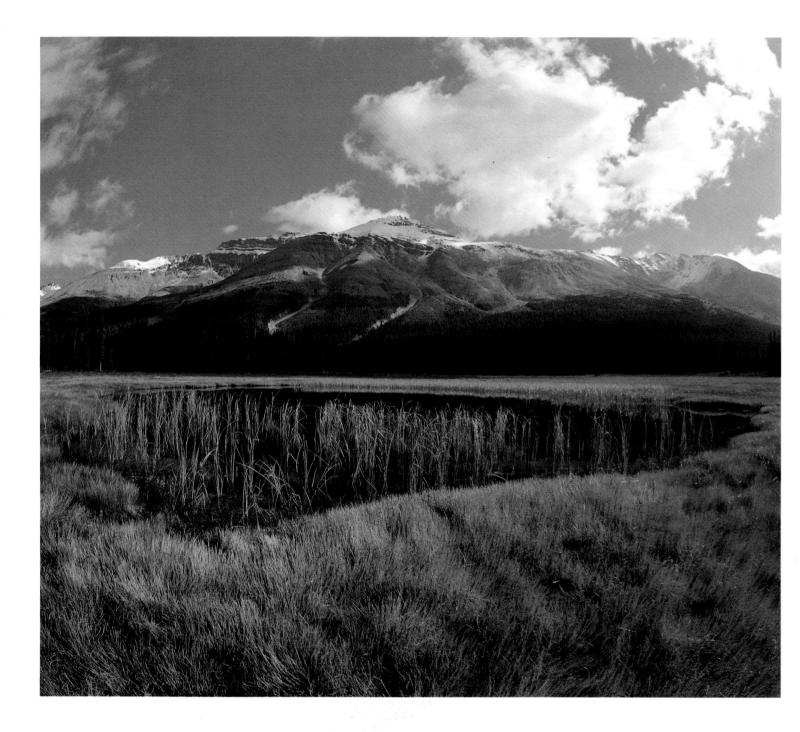

*Above:* A grass-encircled pond near Bow Lake.
*Right:* A typical farm scene - grain elevators. These are at Carstairs..

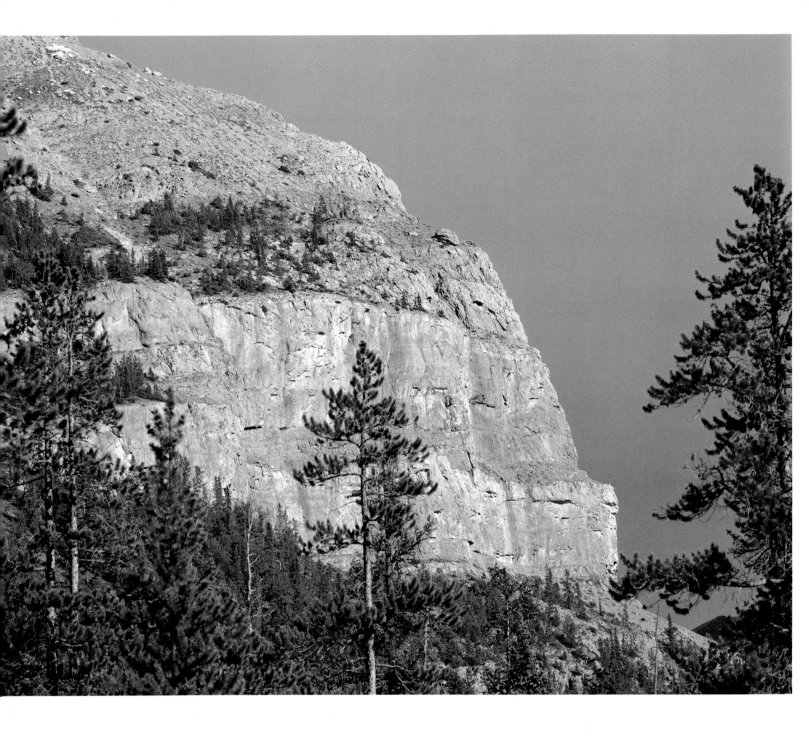

Pine trees gain a tenuous hold on a mountainside near the
buffalo compound, Banff.

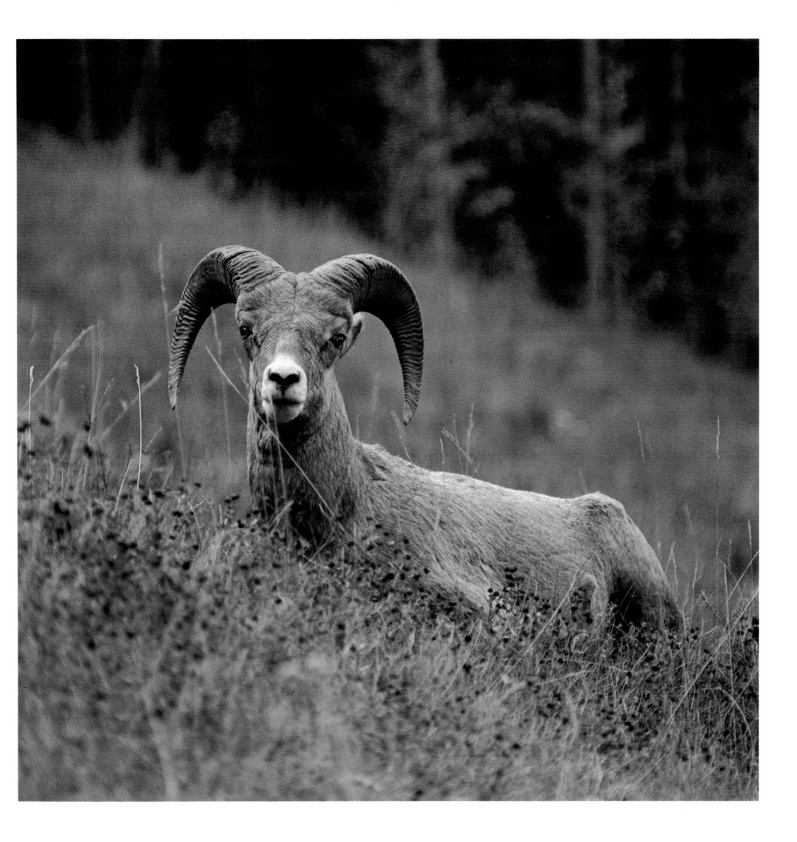

Big-horned sheep, Jasper Park.

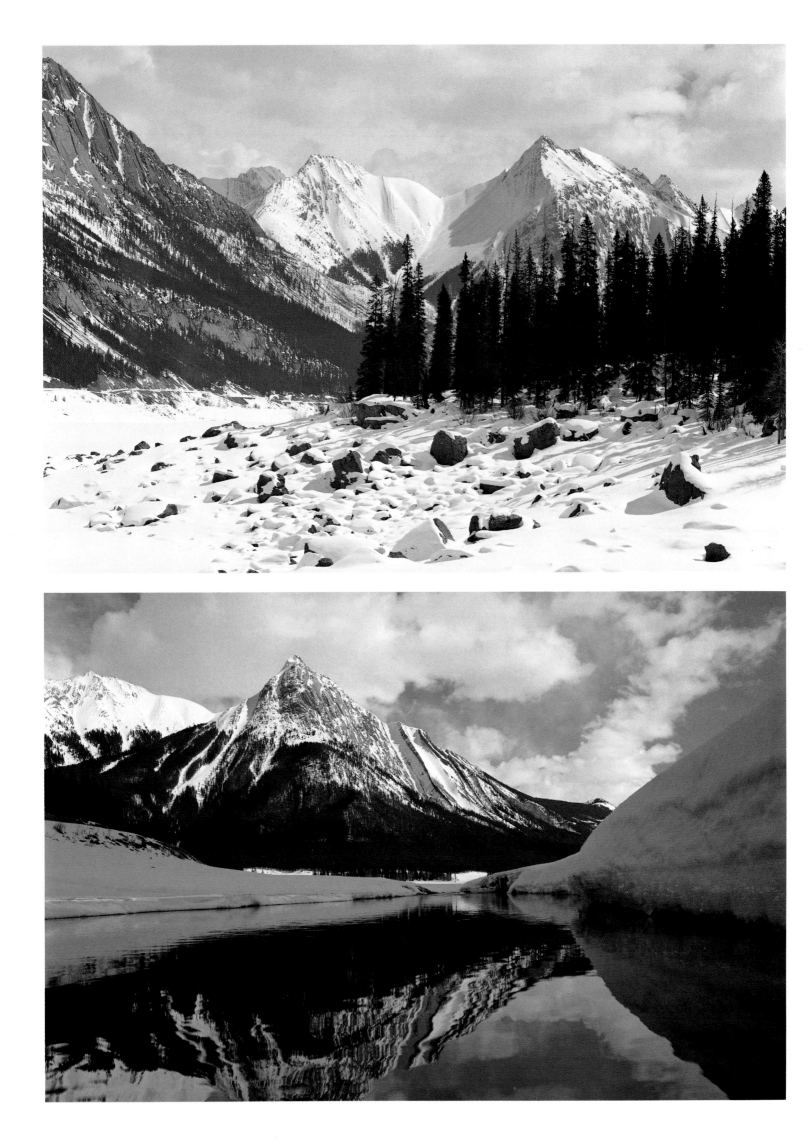

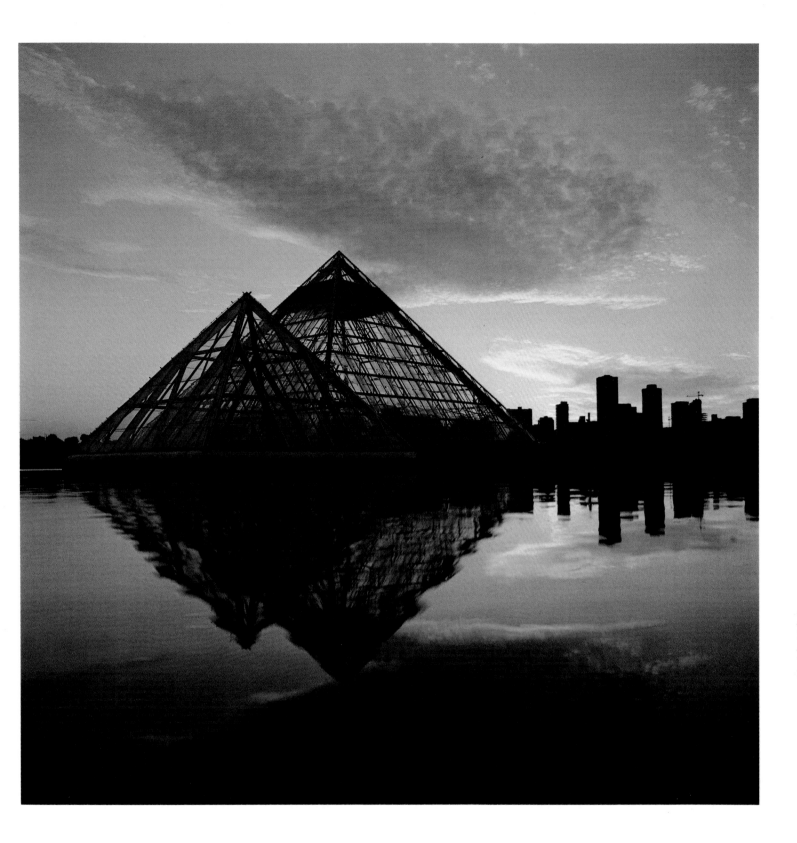

*Left top:* Winter overtakes Medicine Lake and the Queen Elizabeth range.
*Left bottom:* As winter releases its hold, ice on rivers is the first to melt.
*Above:* Reflecting pools dramatically showcase the pyramids at Edmonton's Muttart Conservatory.
*Overleaf:* A pond beside the town of Banff.

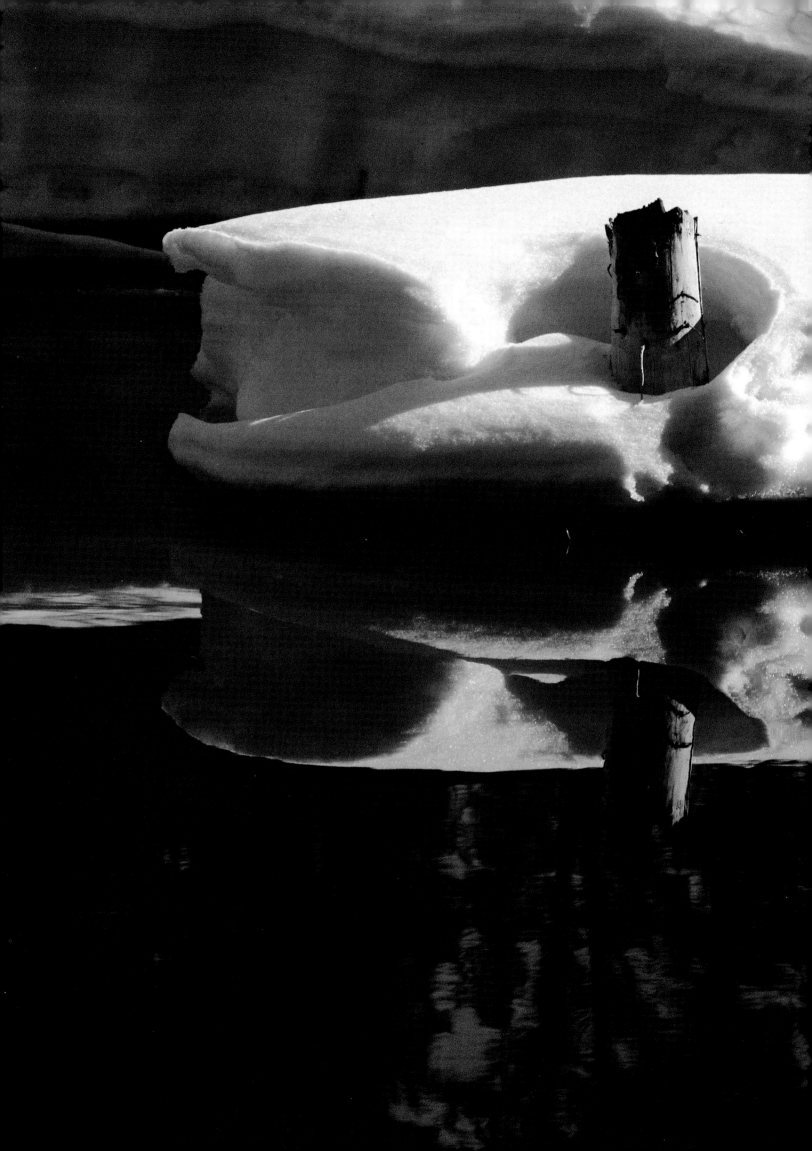

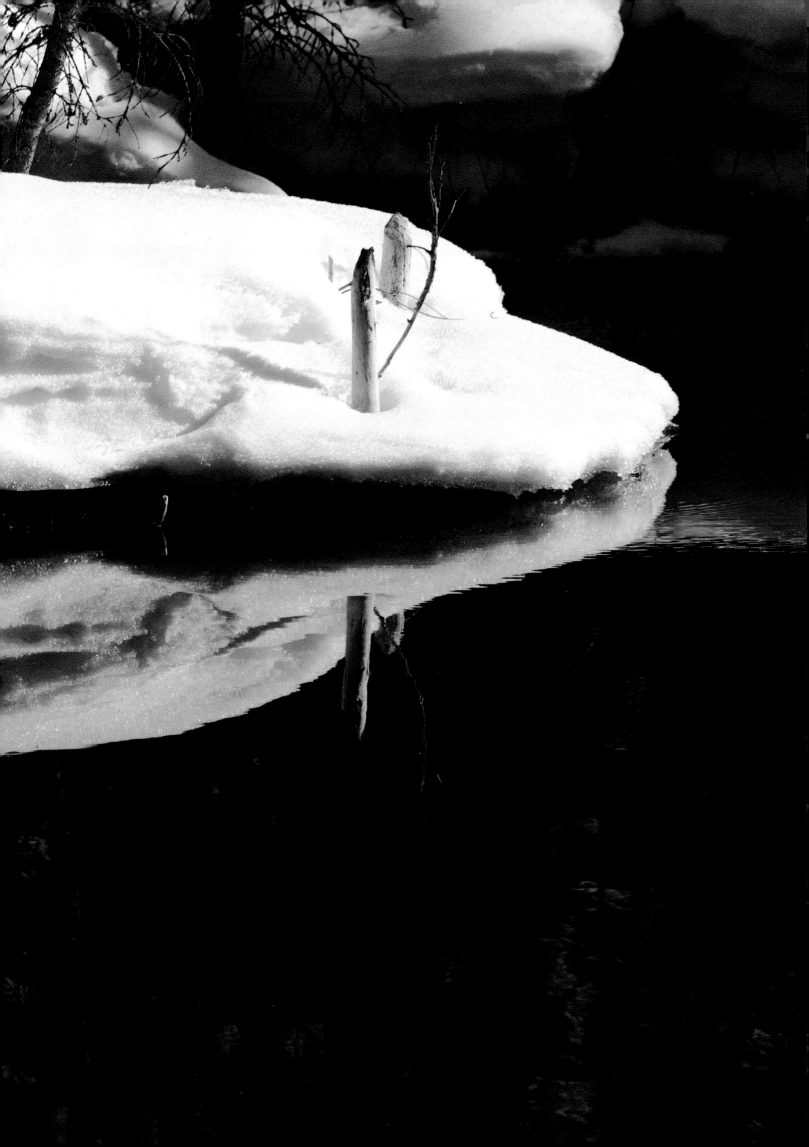

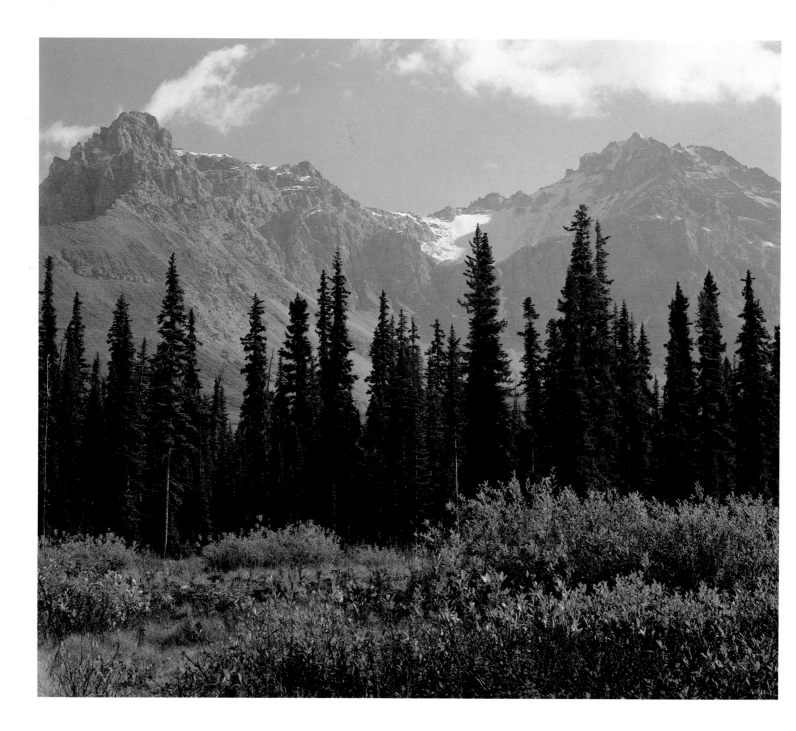

A fall day near Bow Lake.

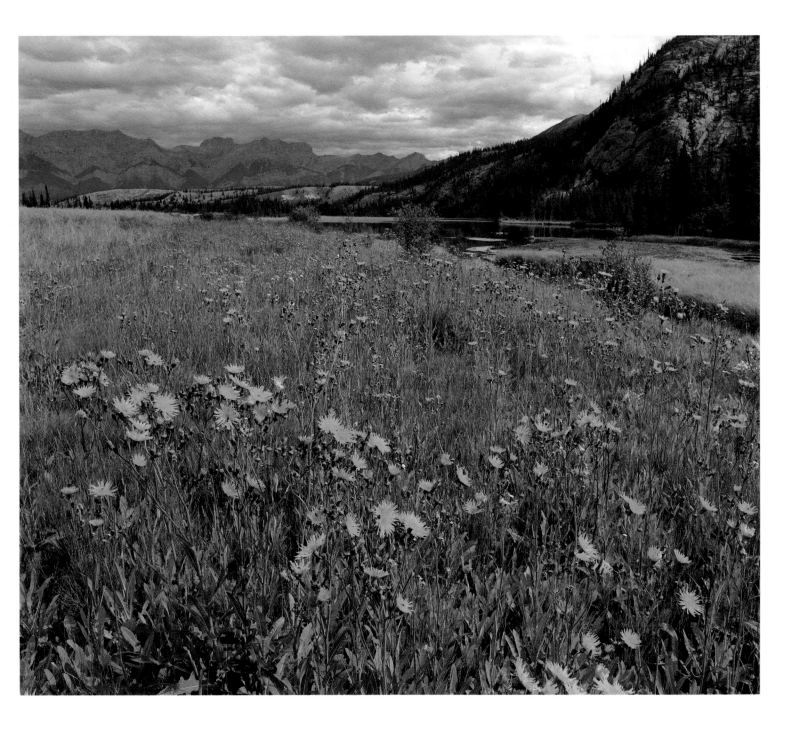

Late summer near the northern entrance to Jasper Park.

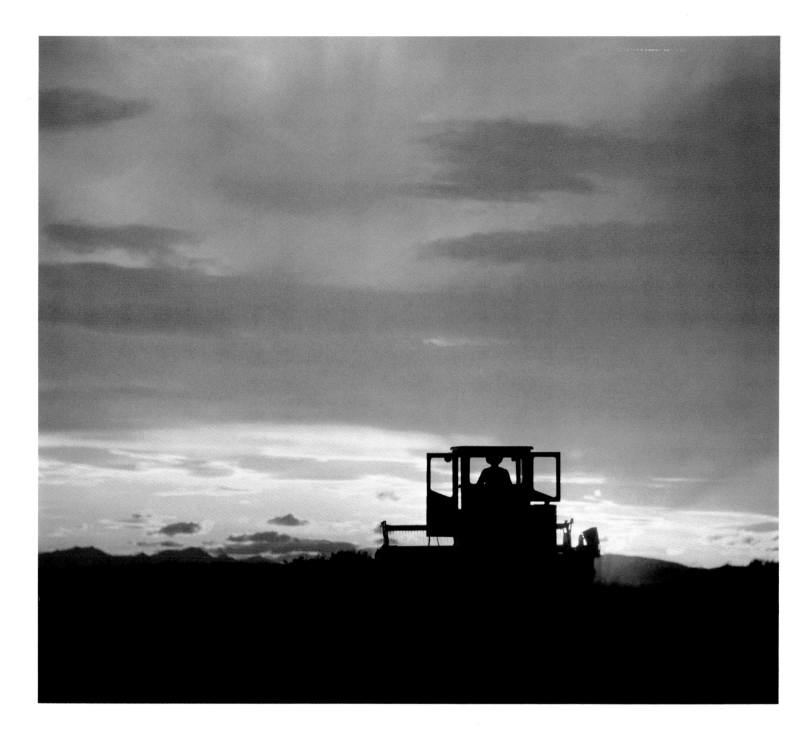

Harvesting continues long past dusk.

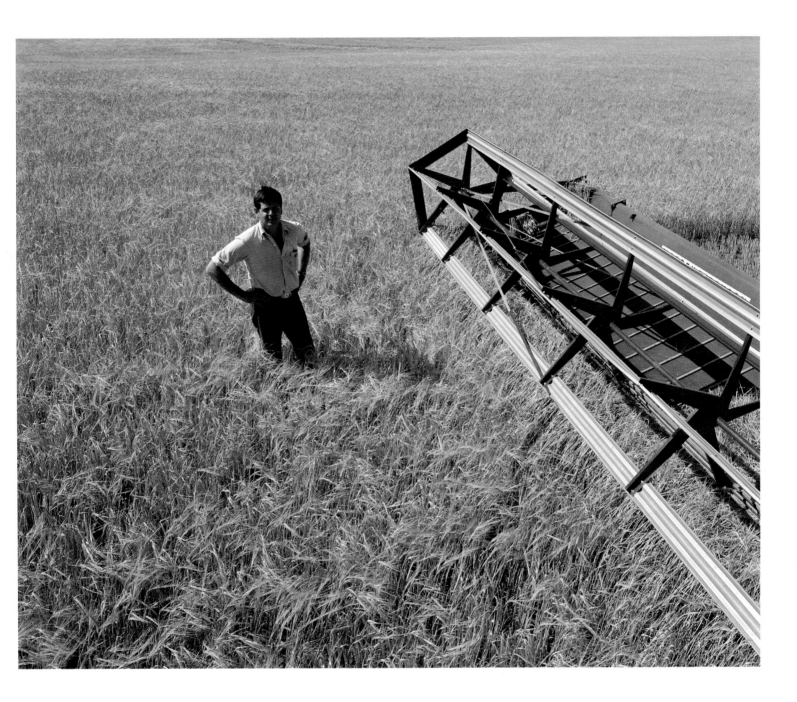

A good crop of barley, partially swathed.

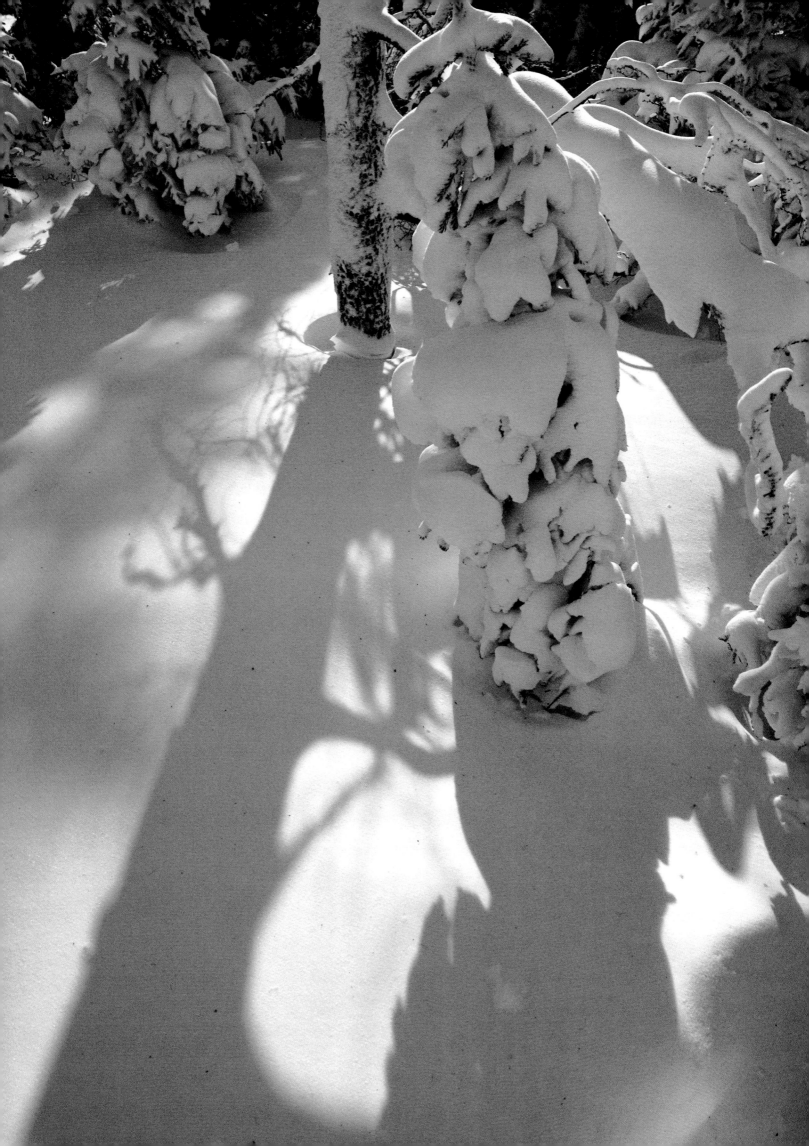

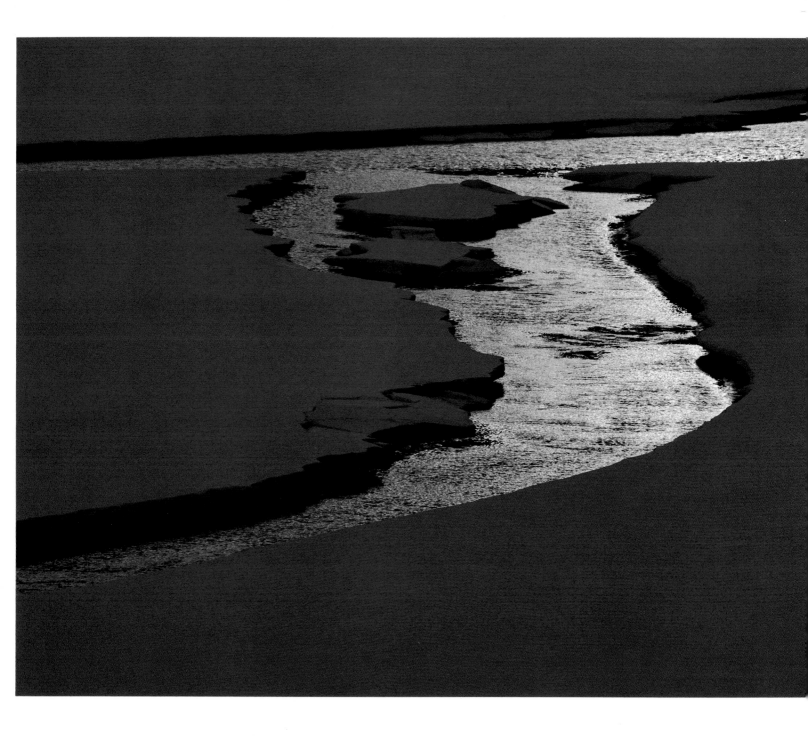

*Left:* Snow-laden trees cast eerie shadows on the snow.
*Above:* Spring comes to Medicine Lake.

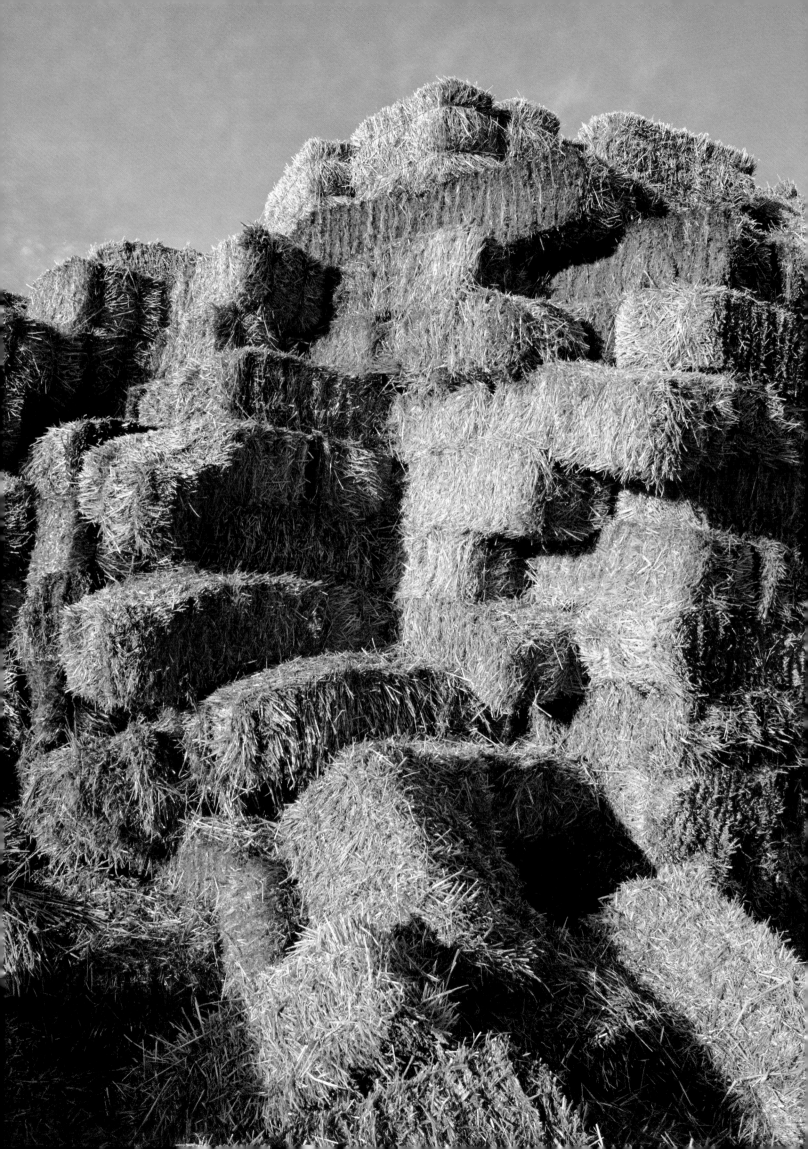

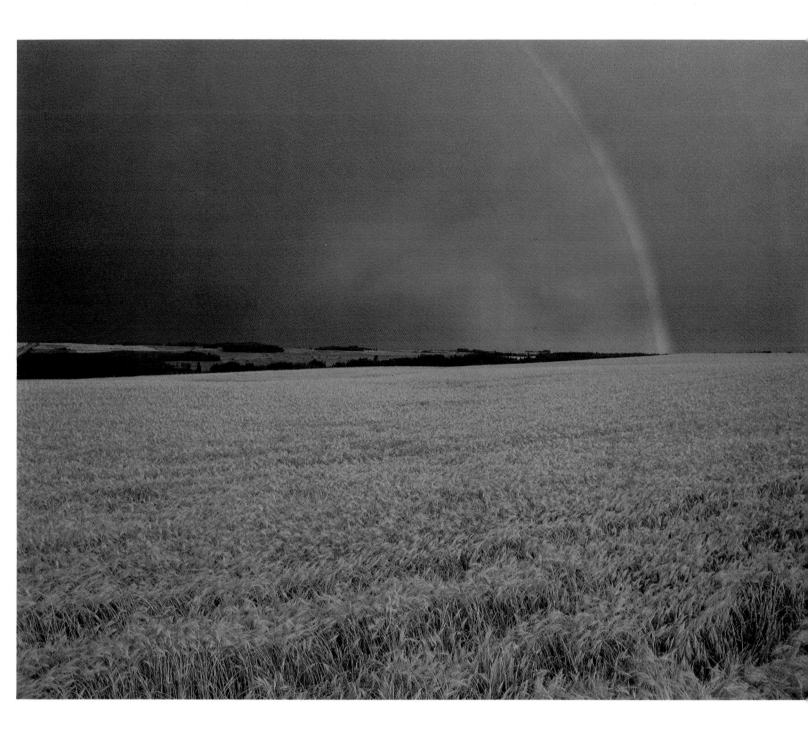

*Left:* Plentiful rain-free weather gives rich, golden tones to these
bales of straw.
*Above:* A rainbow rises above a barley field near Olds.

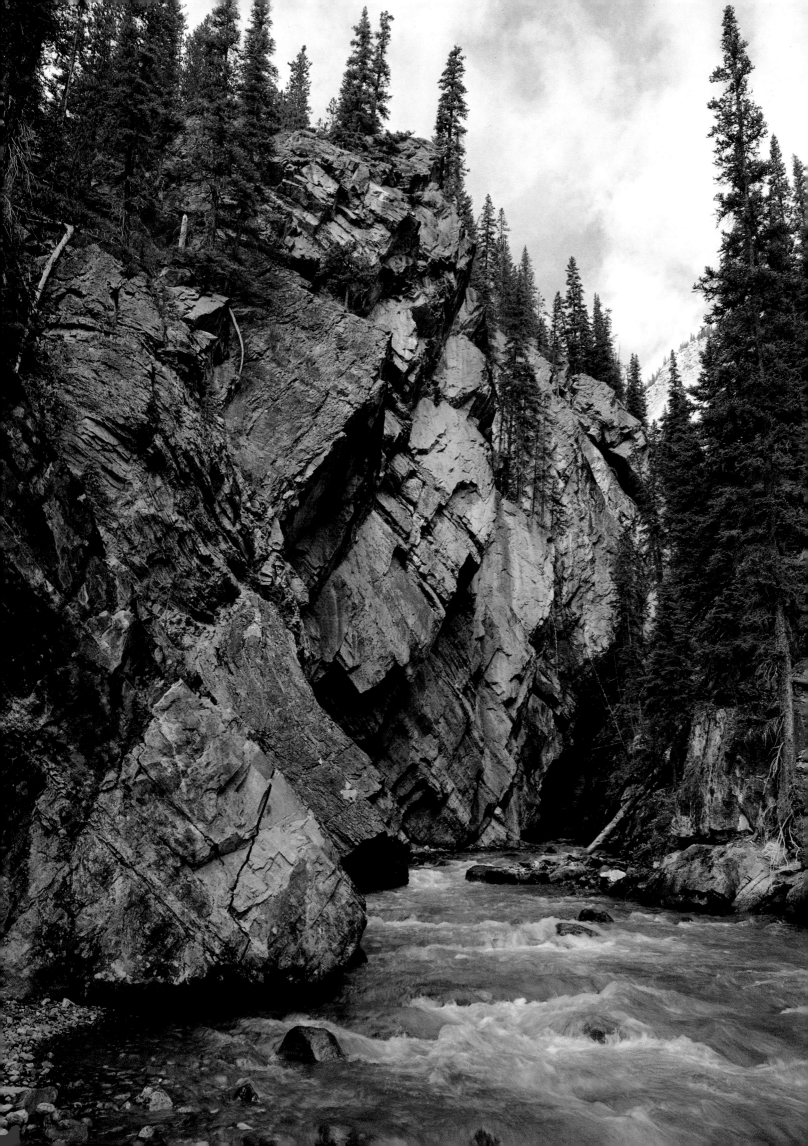

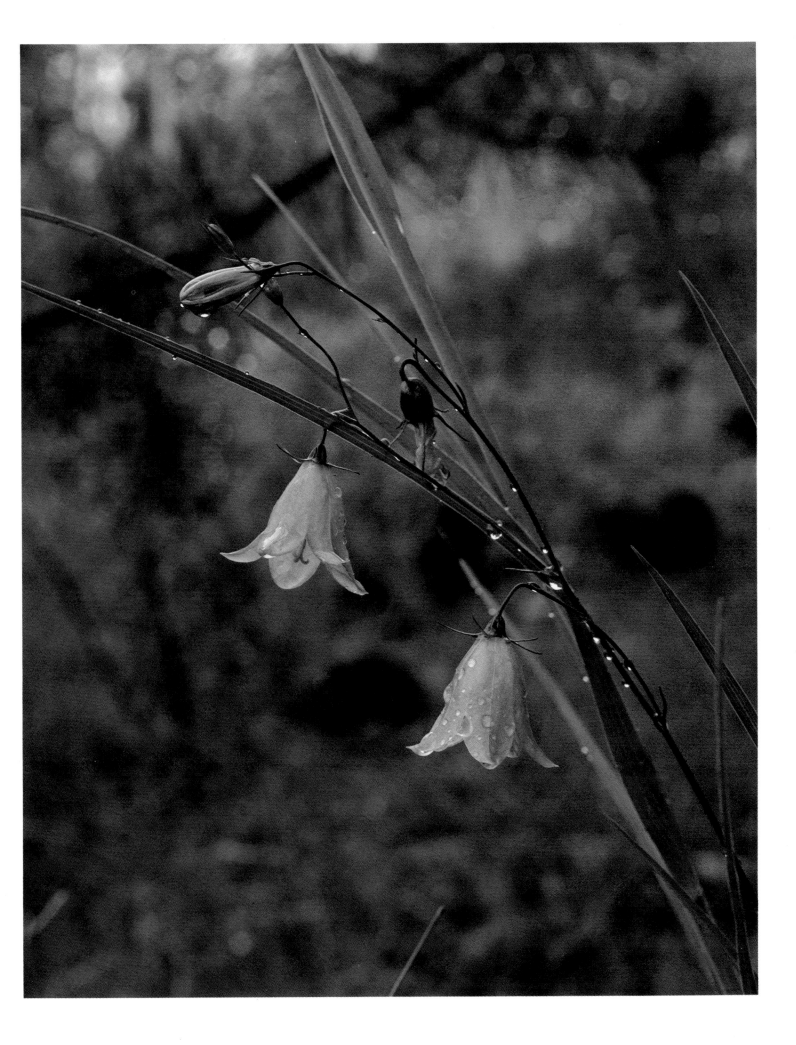

*Left:* A rushing mountain stream.
*Above:* Delicate harebells after the rain.

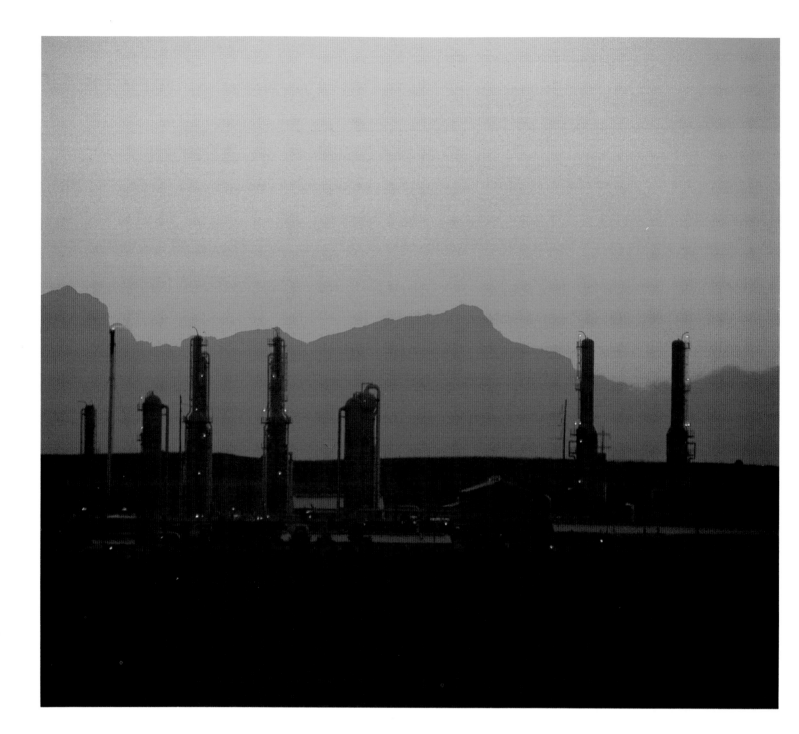

An oil refinery silhouetted against the mountains near Cochrane.

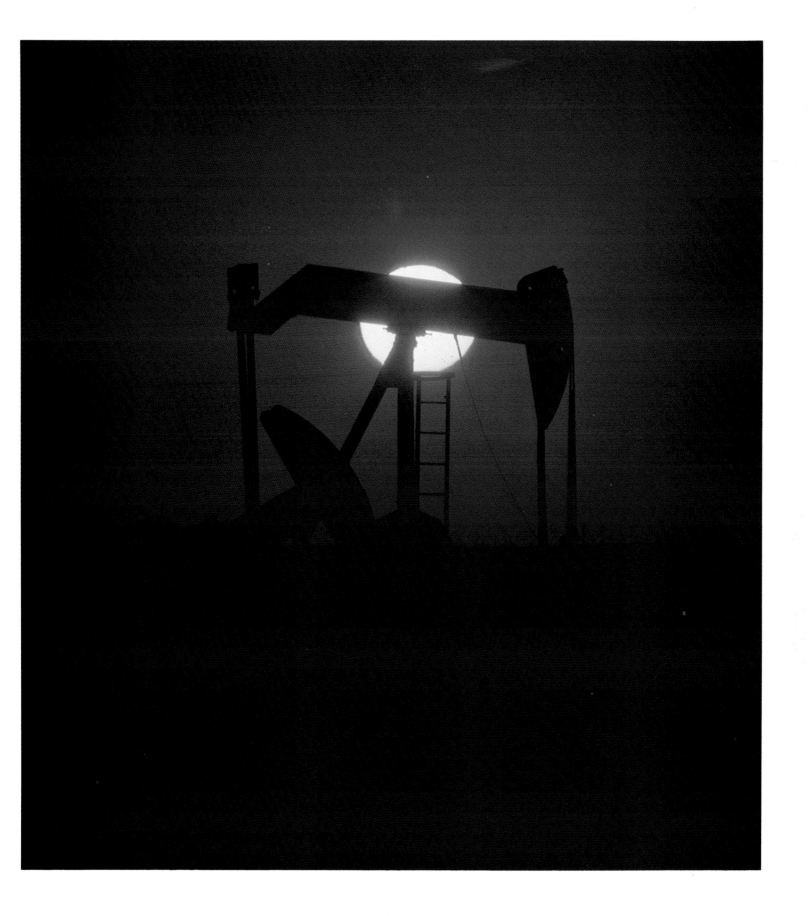

An oil donkey near Calgary.

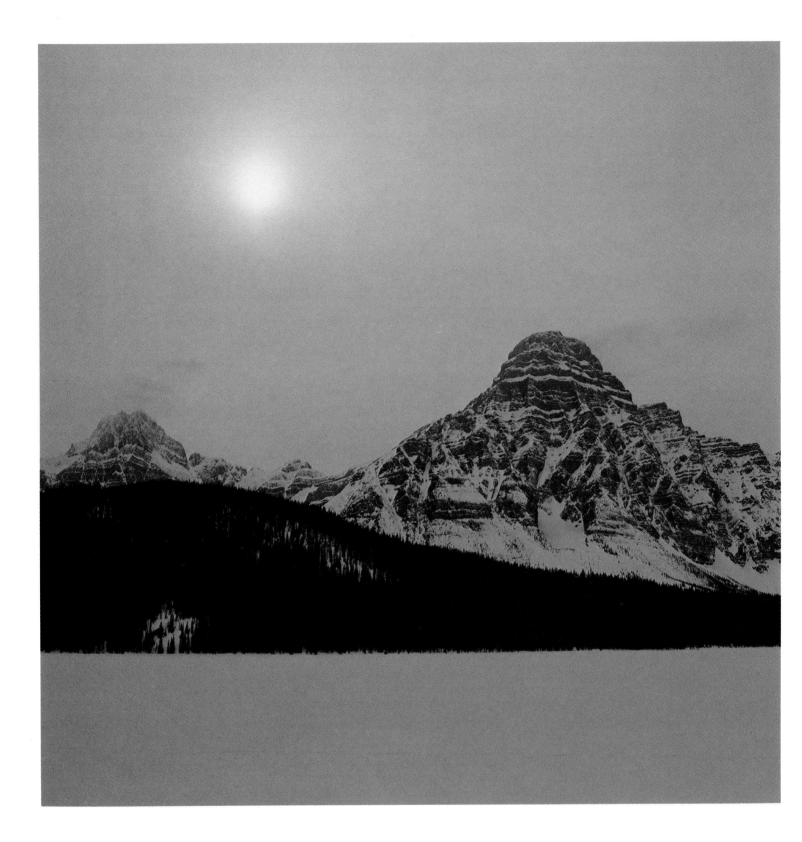

The winter sun offers little warmth to a scene near Silver Horn
Creek.

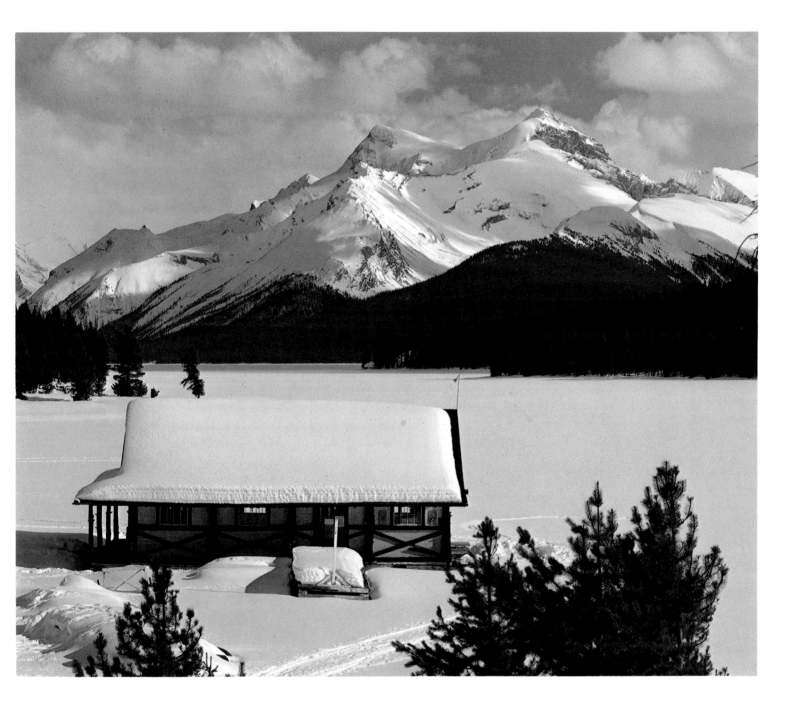

A boathouse marks the edge of frozen Maligne Lake.
*Overleaf:* Elbow Falls near Bragg Creek.

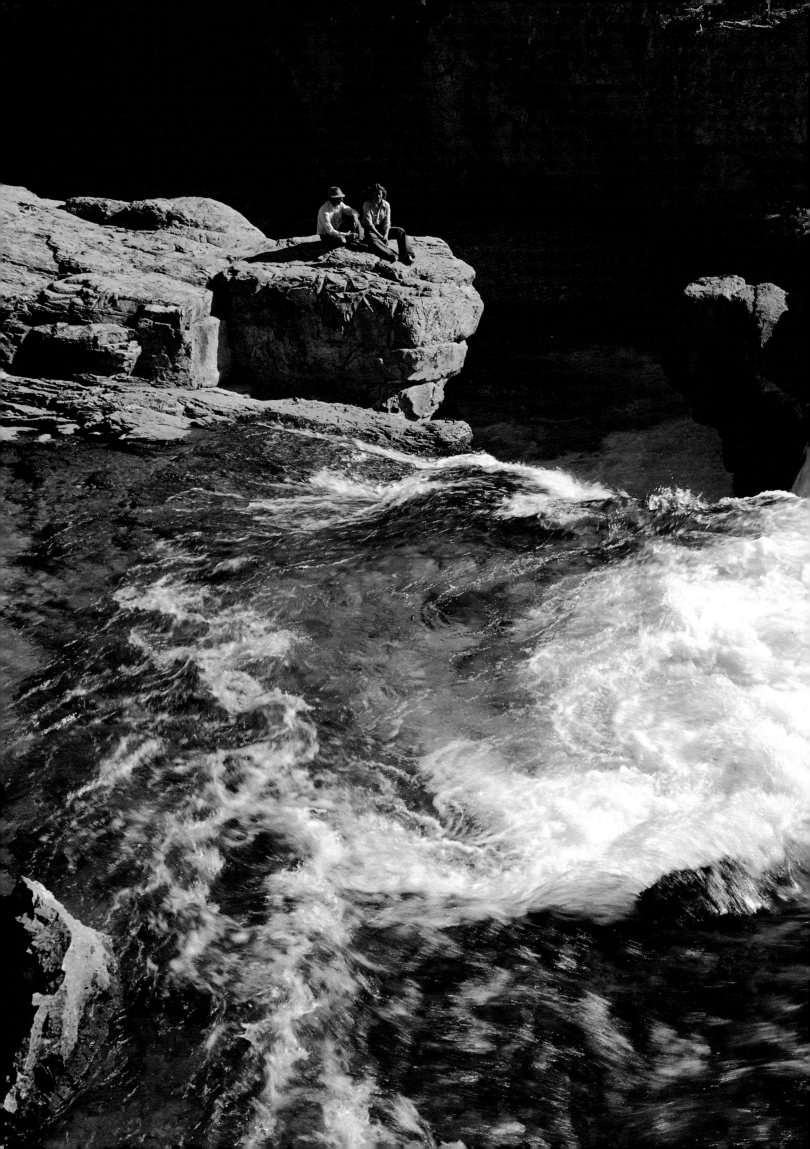

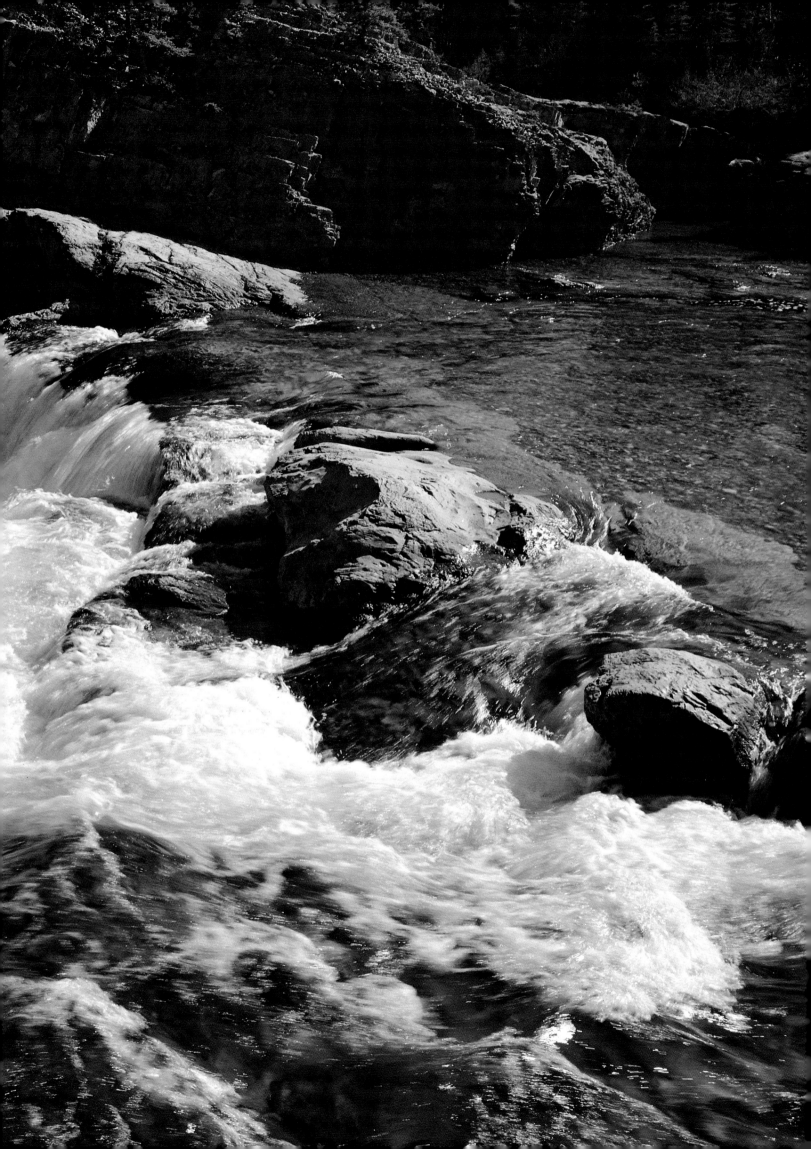

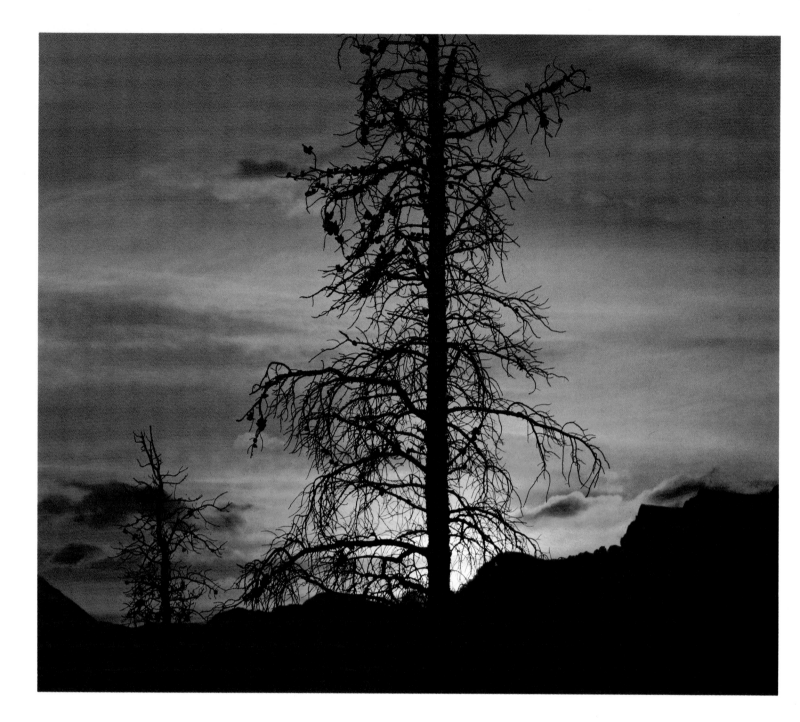

*Above:* Trees in stark relief along the Jasper Park Highway.
*Right:* Densely wooded shoreline of the Miette River in
Jasper Park.

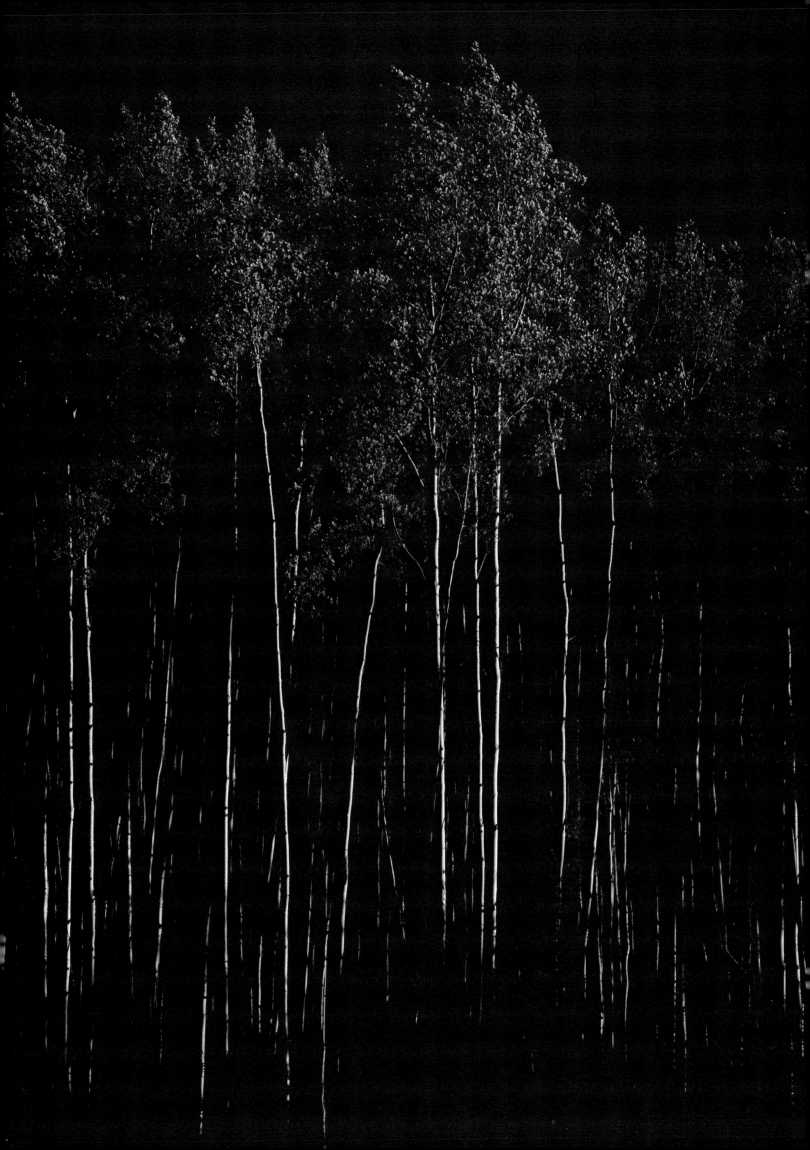

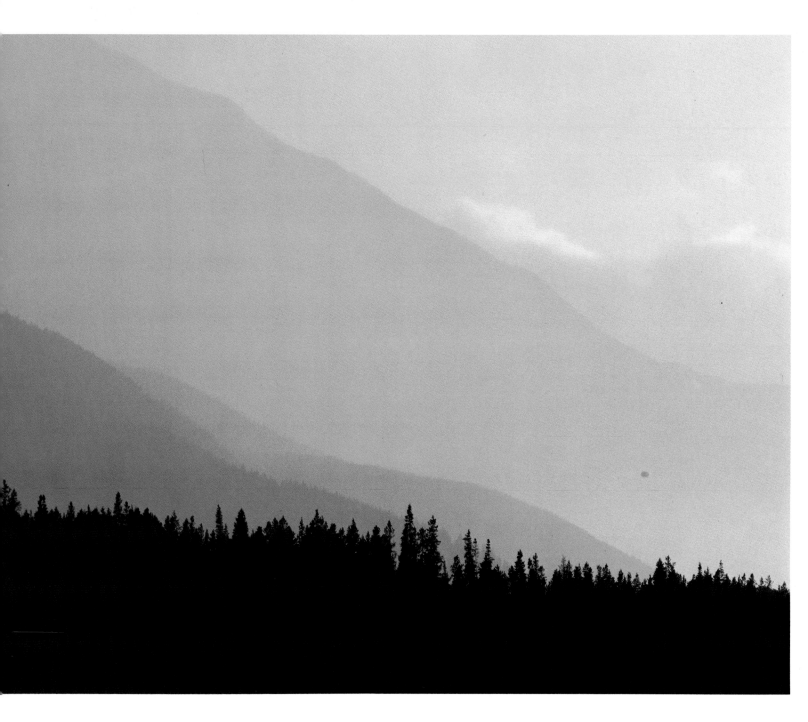

Mountains south of Jasper fade into the background on a
rainy day.

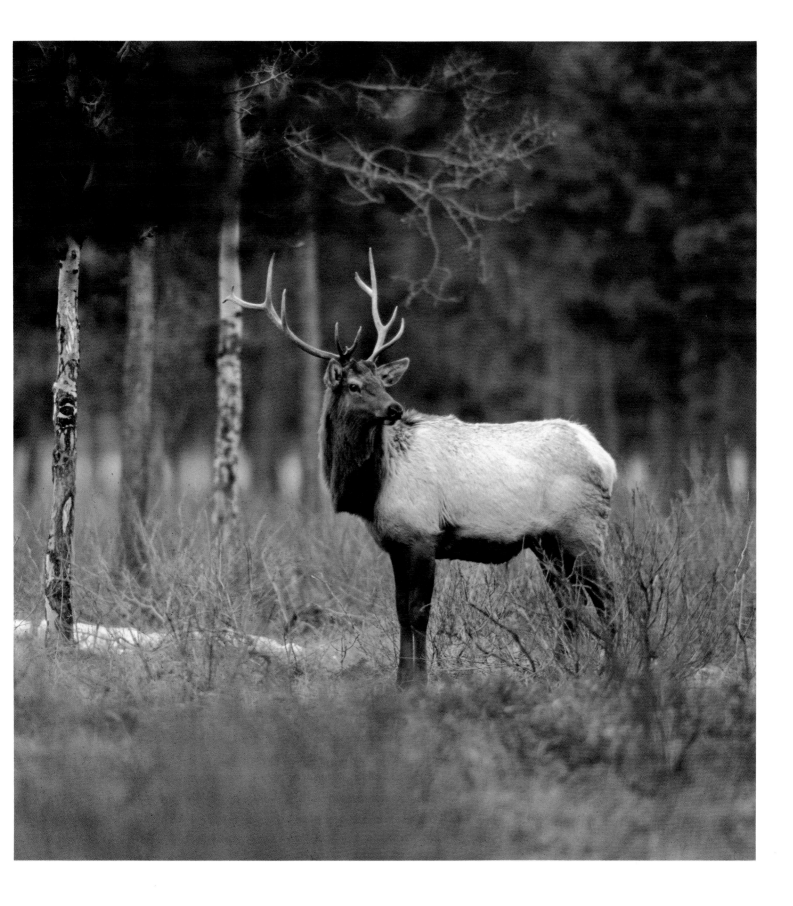

An elk (or wapati) in Jasper pauses to survey his surroundings.

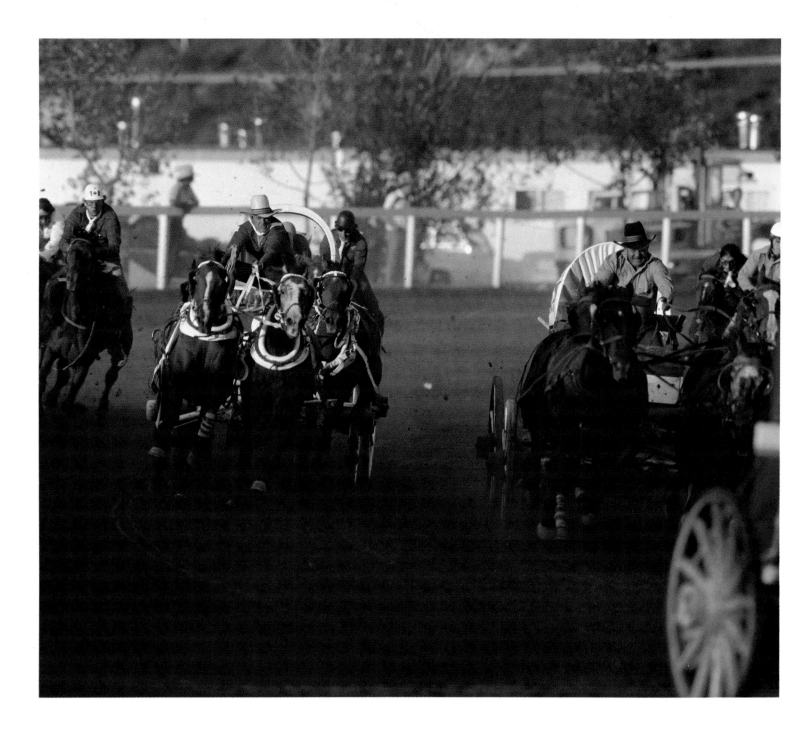

Chuckwagon races, the highlight of the Calgary Stampede.

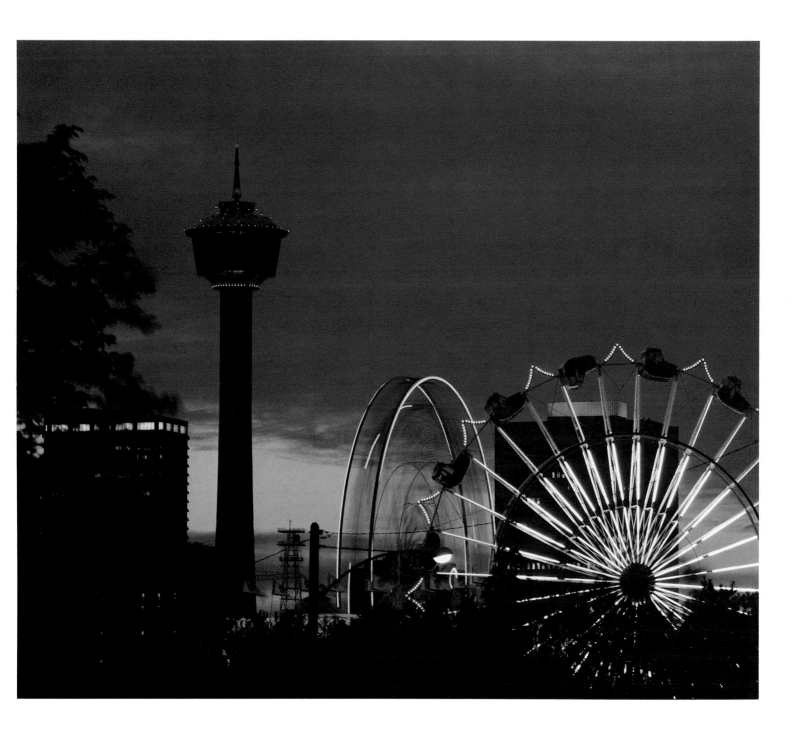

The Stampede's amusement park lights the evening sky.

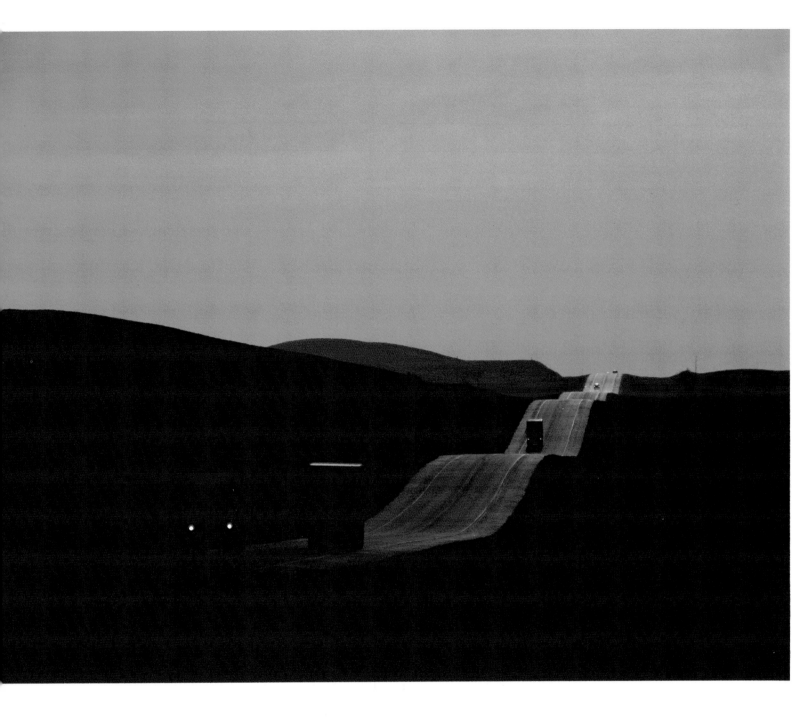

Trans Canada Highway undulates like a ribbon near the
Saskatchewan border.

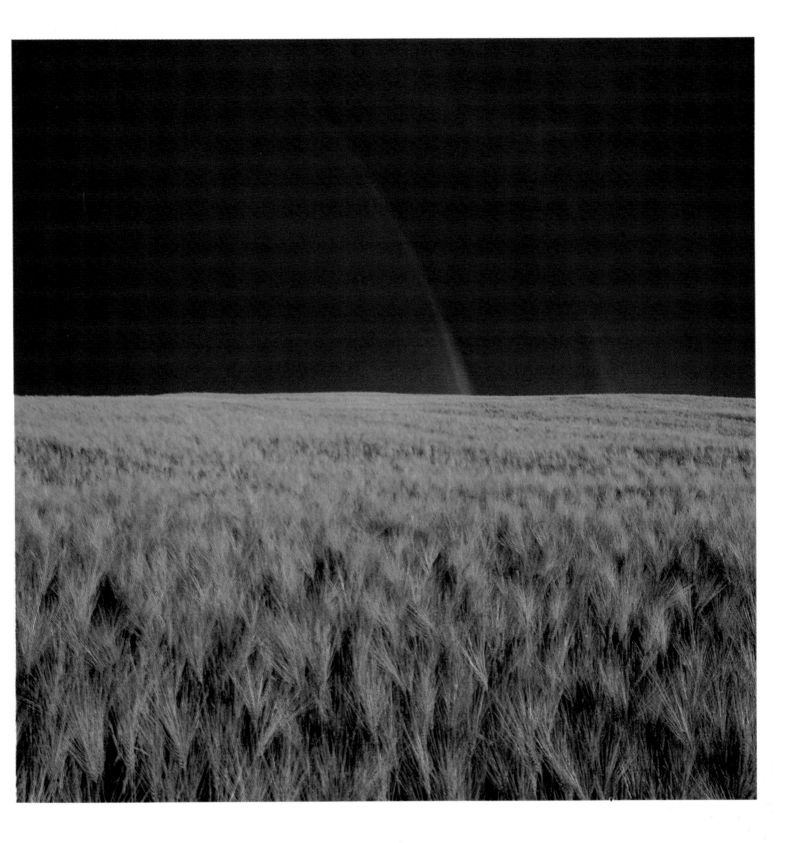

A stormy sky is brightened by a double rainbow.

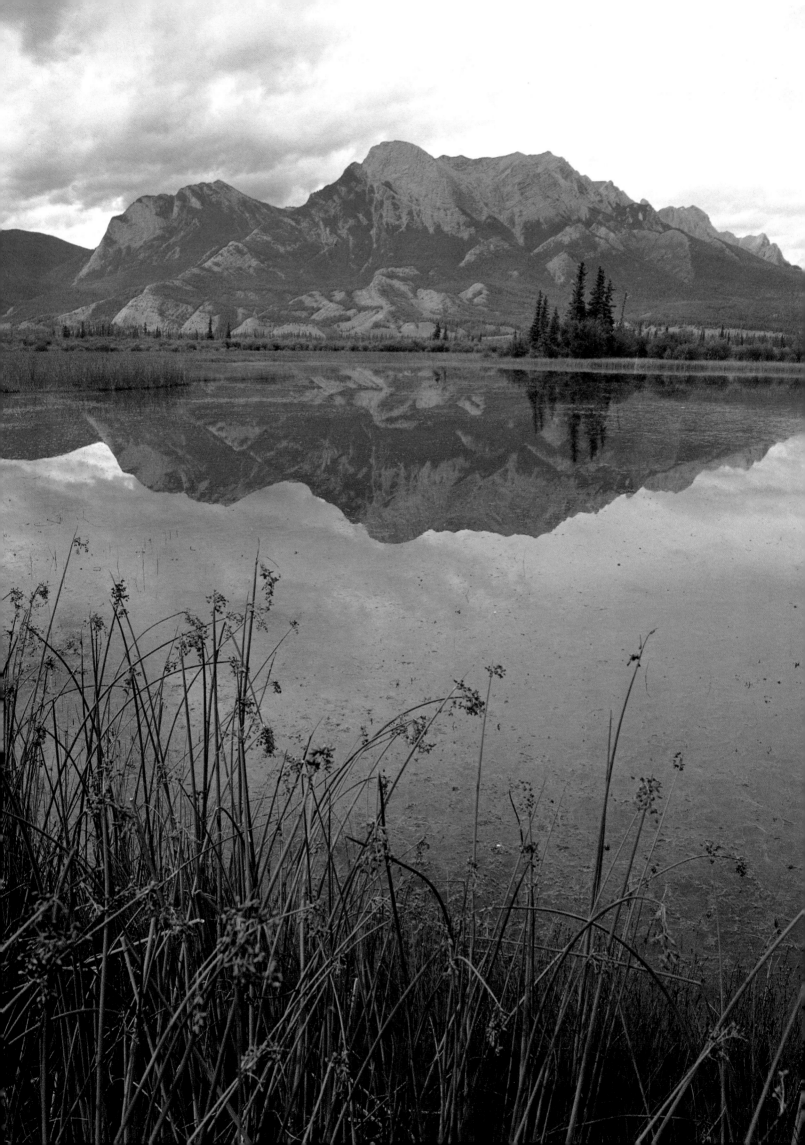

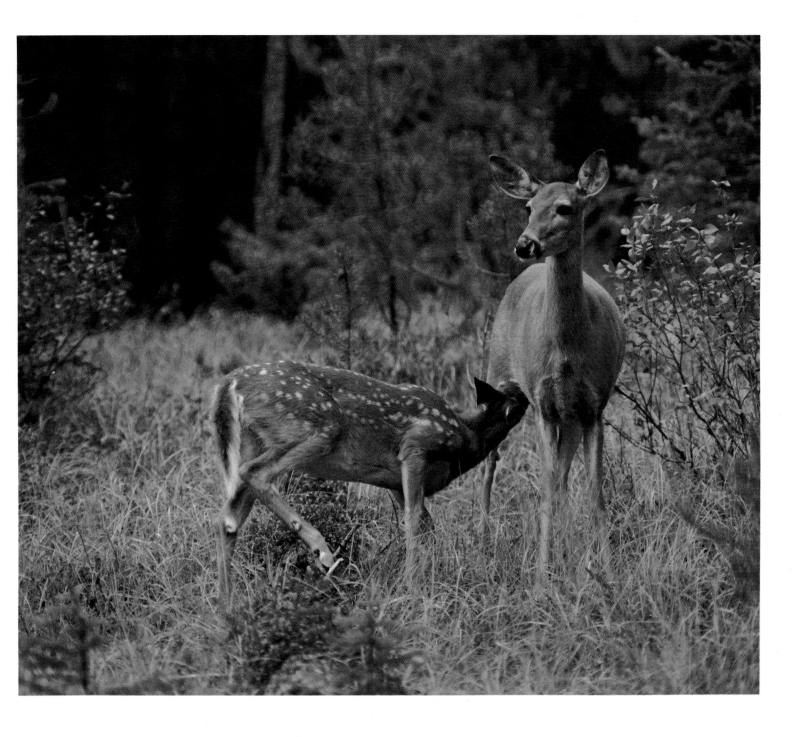

*Left:* Still waters reflect every detail of a summer scene.
*Right:* A white-tailed deer stays alert to danger as her offspring
suckles.
*Overleaf left:* Rugged rocks line the shore of Abraham Lake.
*Overleaf right:* Water flows over smooth stones in Paradise Creek,
on the Moraine Lake Road.

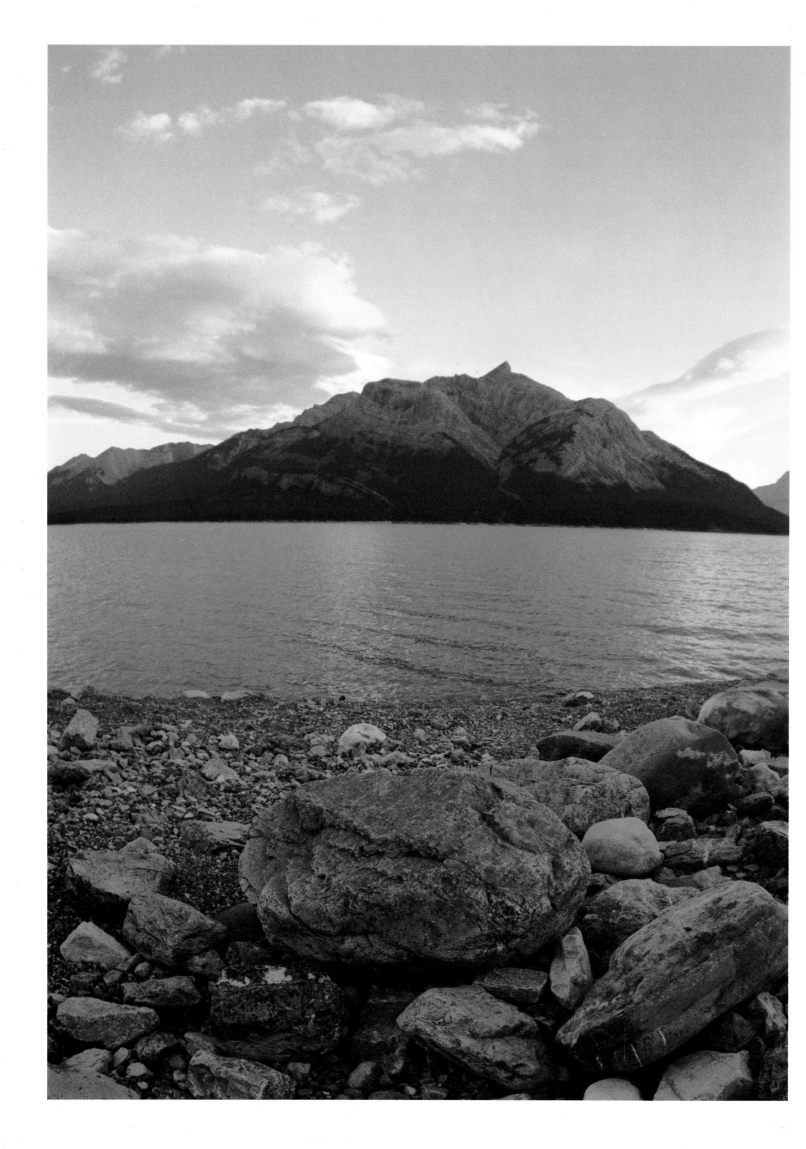

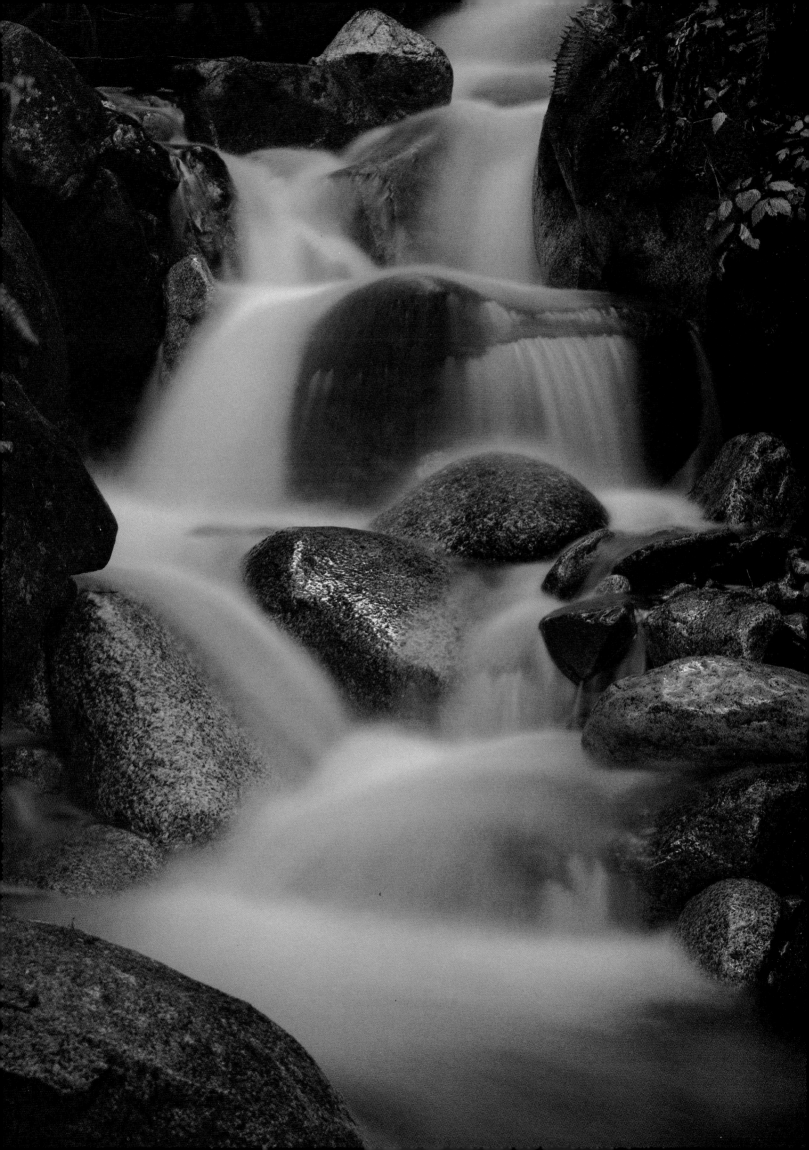

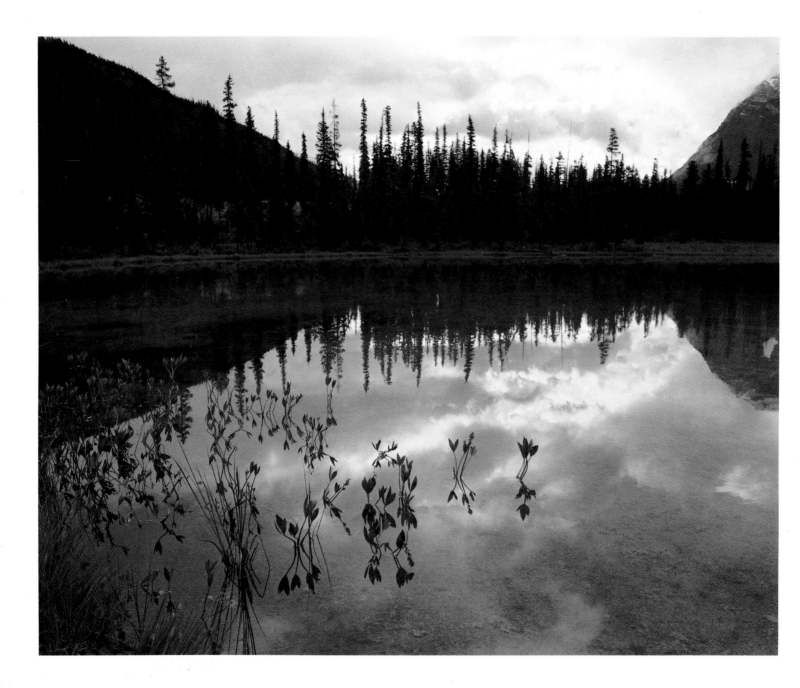

Barely a ripple disturbs the surface of a pond near Bow Lake.

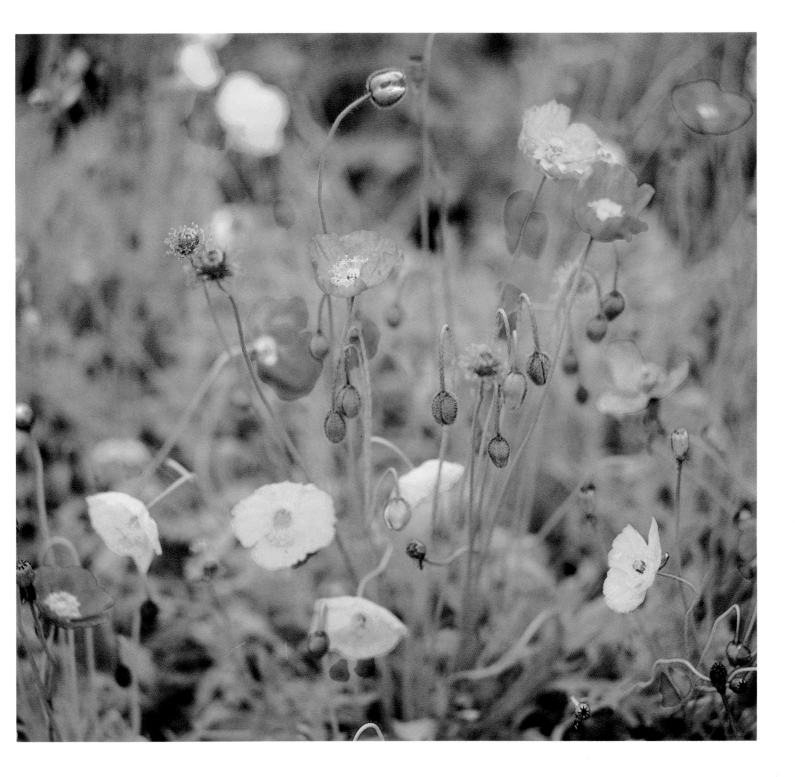

Colourful poppies herald summer at Lake Louise.
*Overleaf:* Winter at Medicine Lake.

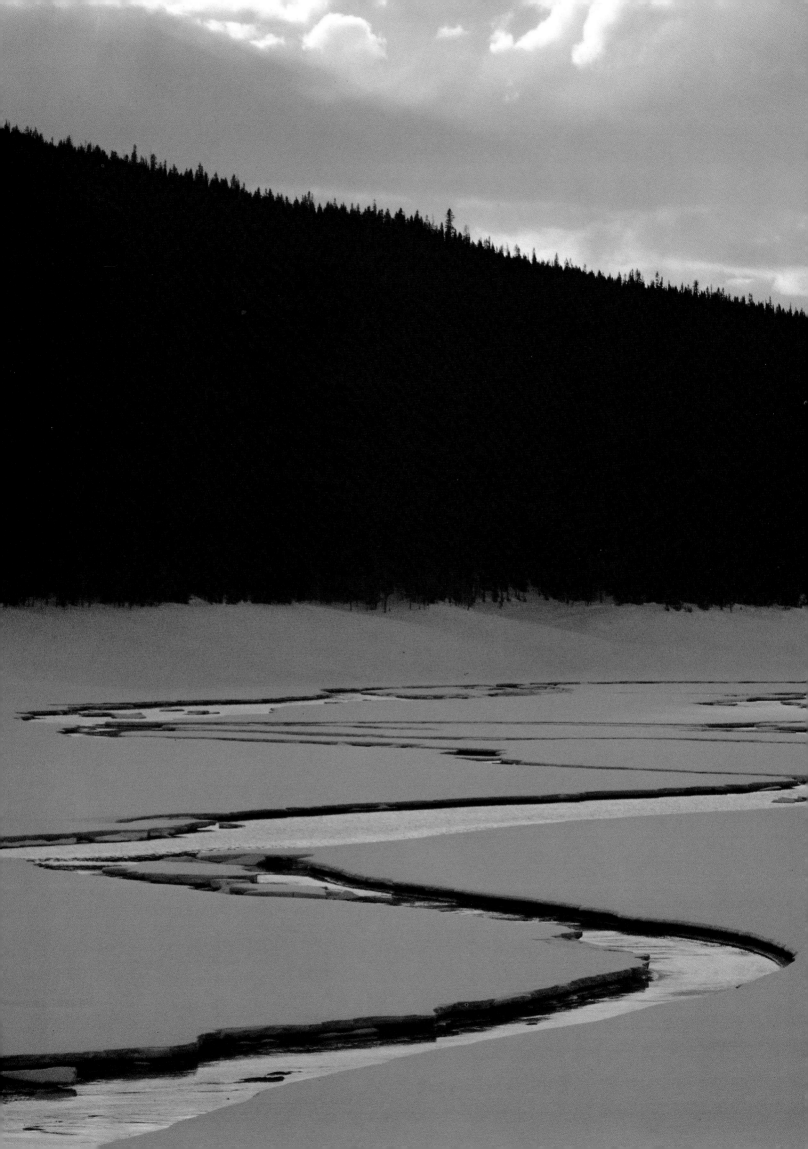

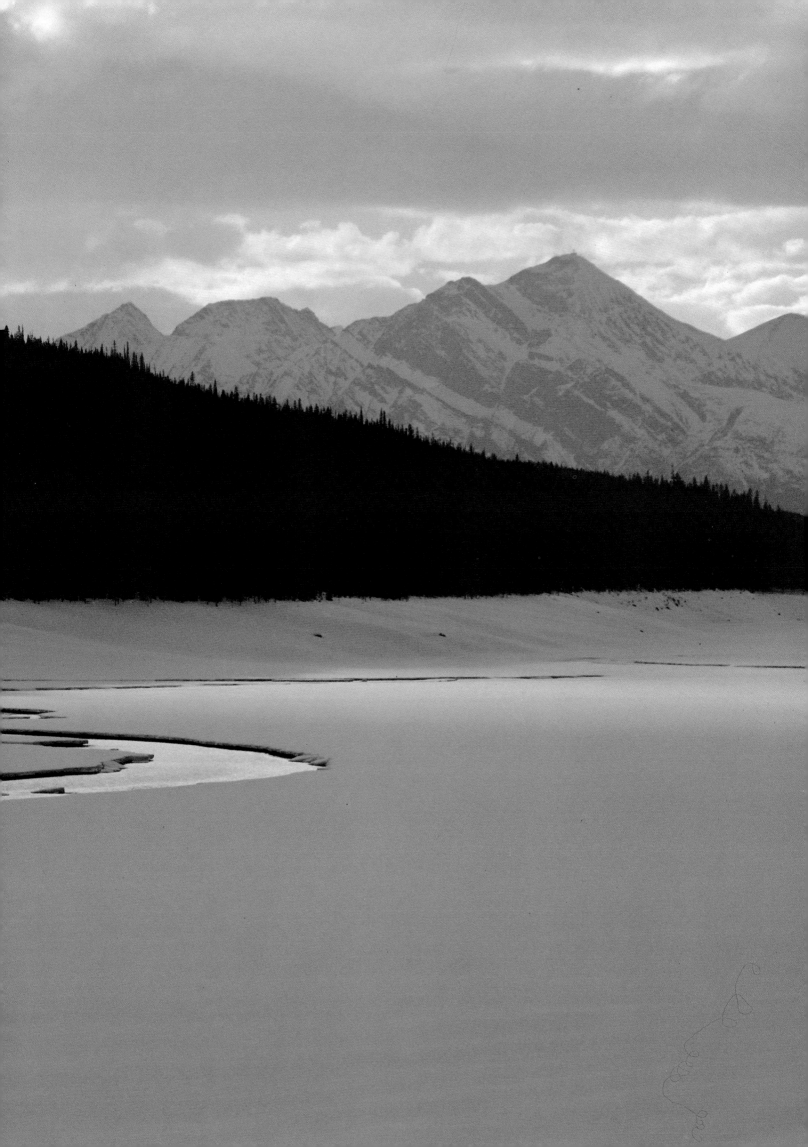

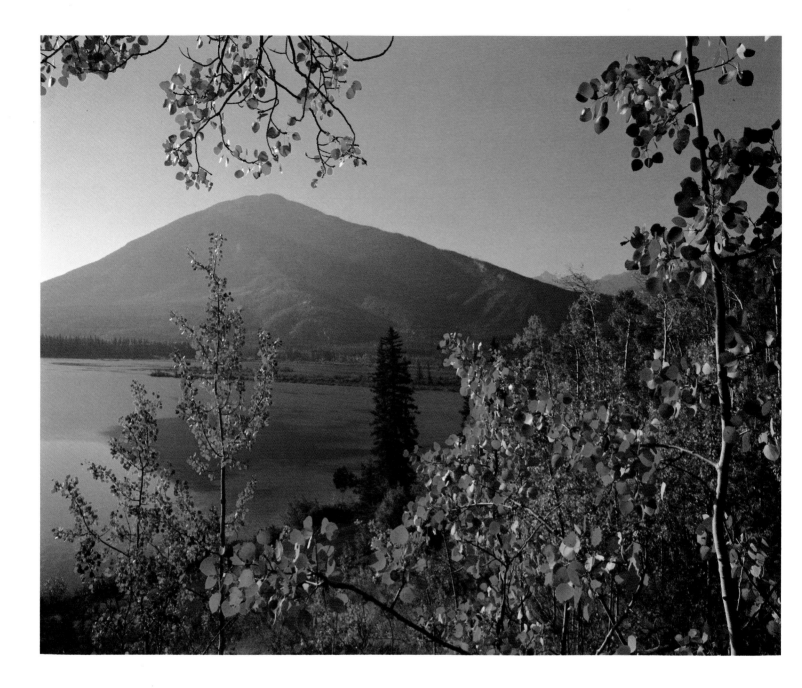

Sulphur Mountain and Vermilion Lake framed by autumn
colours.

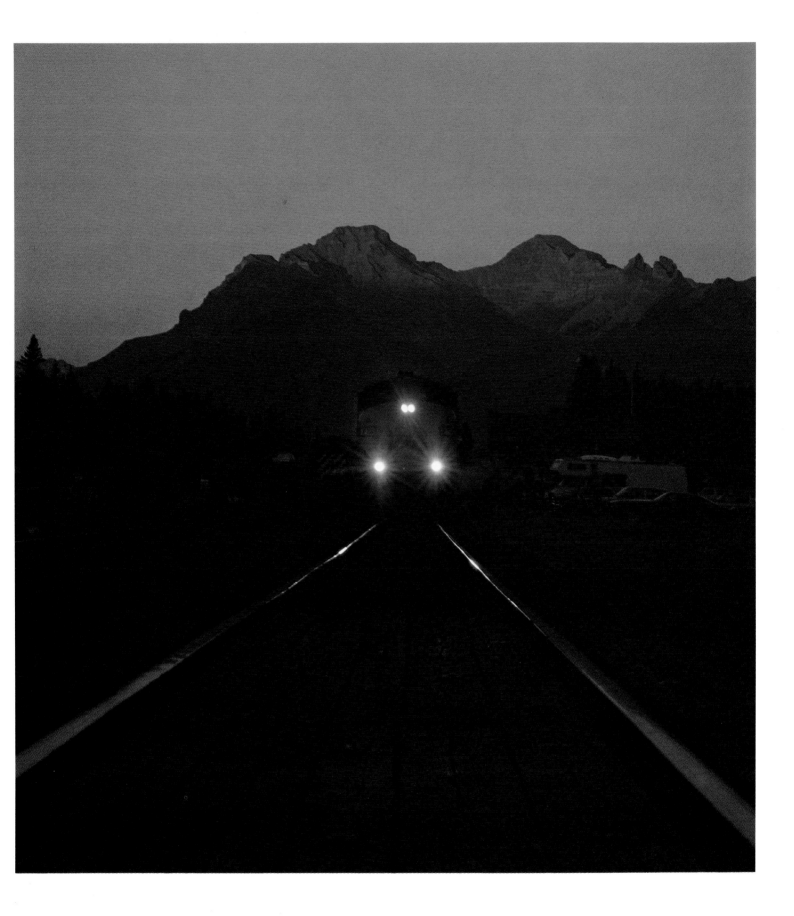

Train pulling into Banff station.

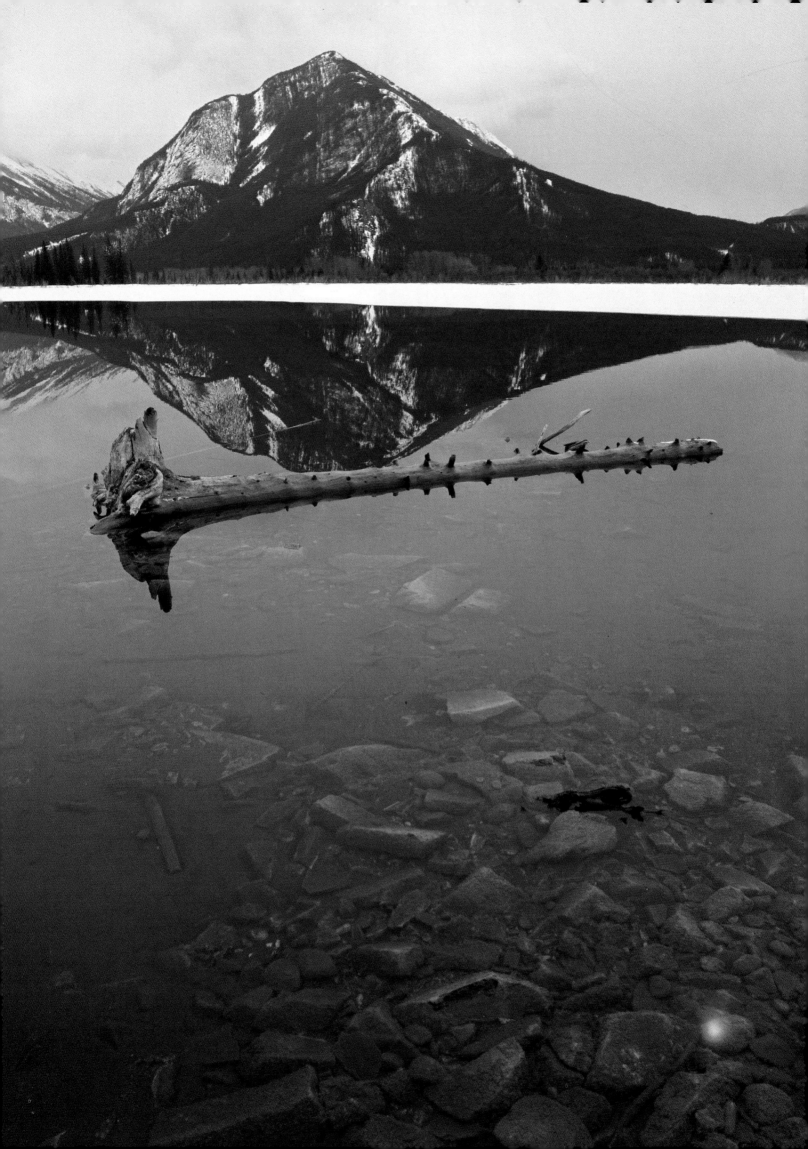

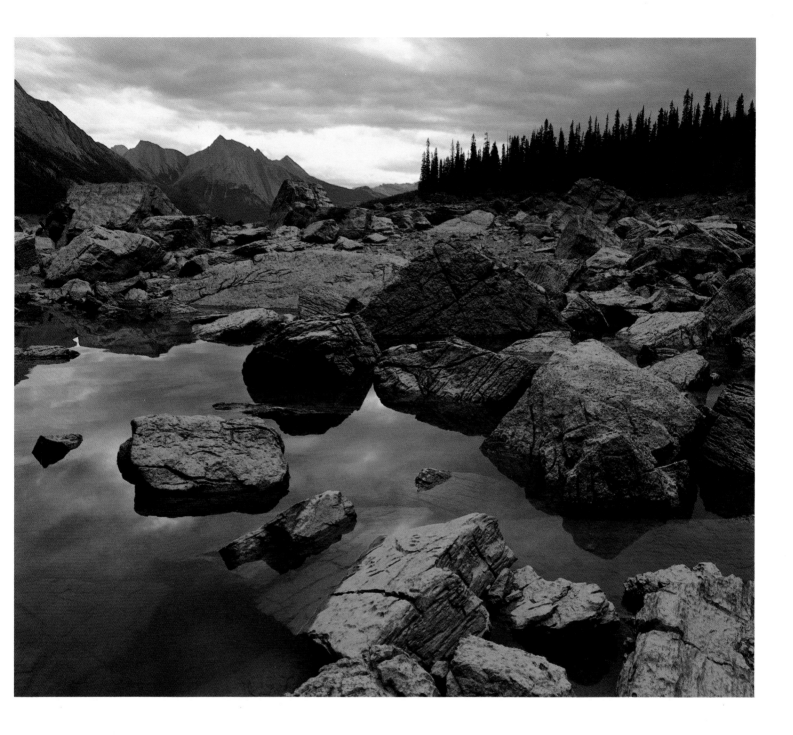

*Left:* Still water creates a mirror-like reflection.
*Above:* The rocky shoreline of Medicine Lake.

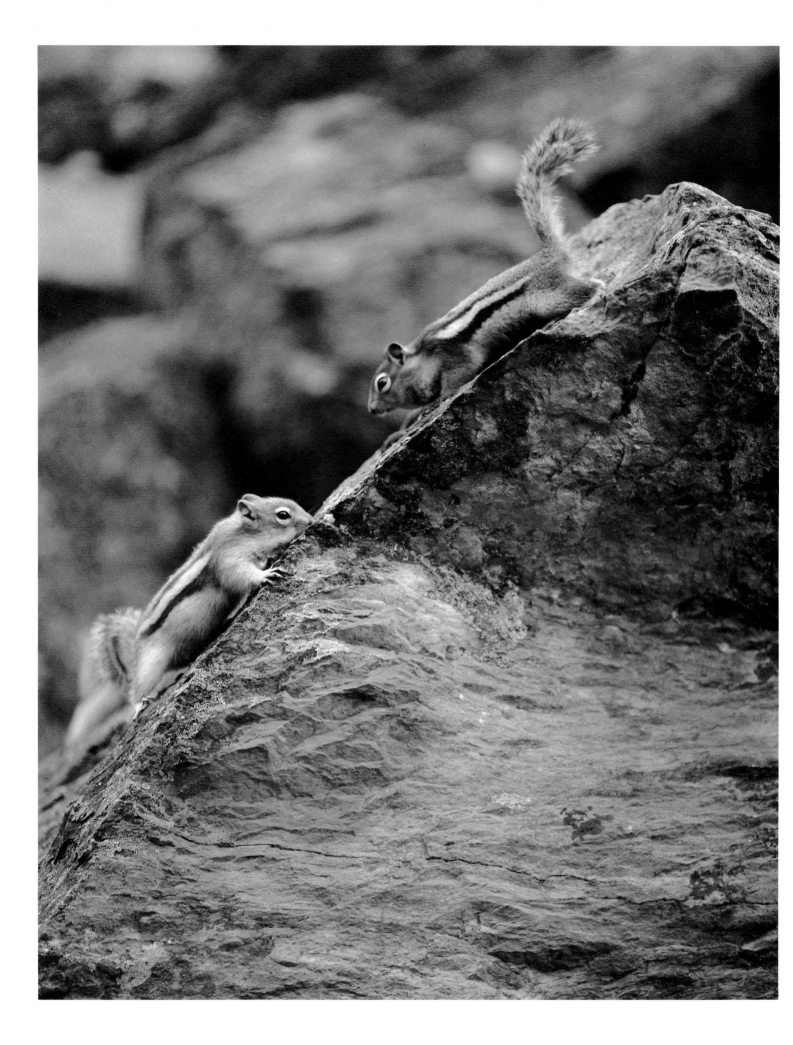

*Above:* Golden-mantled squirrels dart over a lichen-spotted rock
slide at Moraine Lake.
*Right:* Young male elk (or wapati) in Jasper.

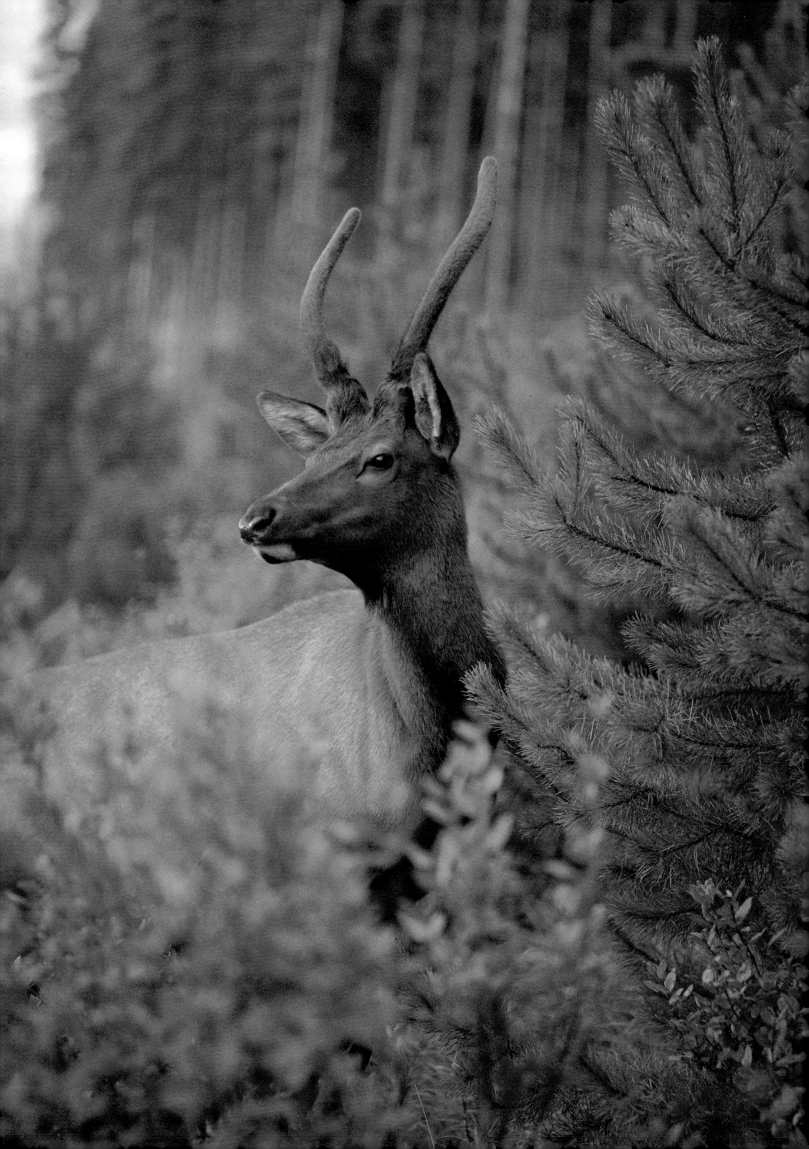

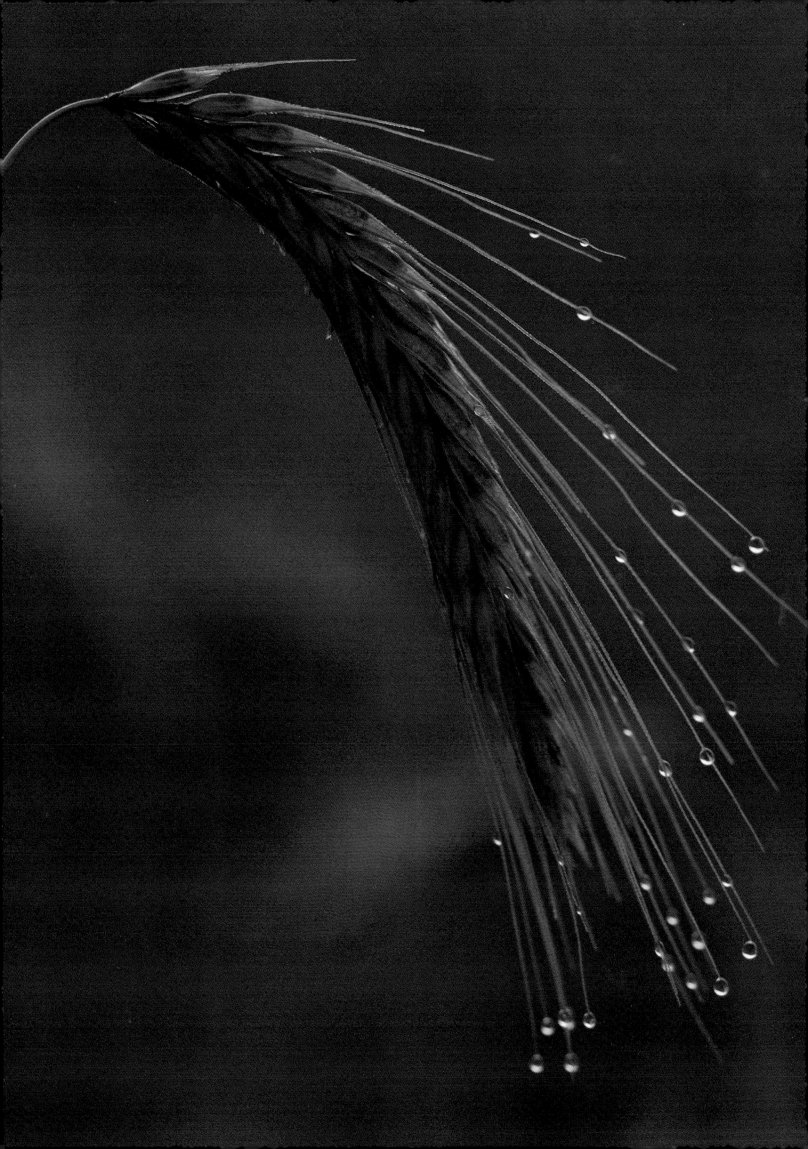

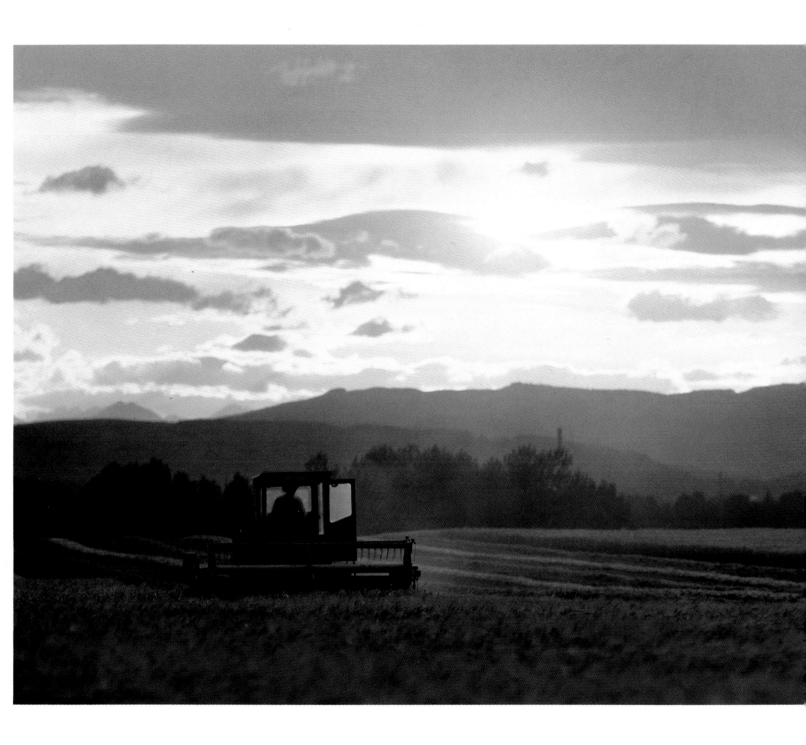

*Left:* Dew on barley.
*Above:* Harvest time at Black Diamond.

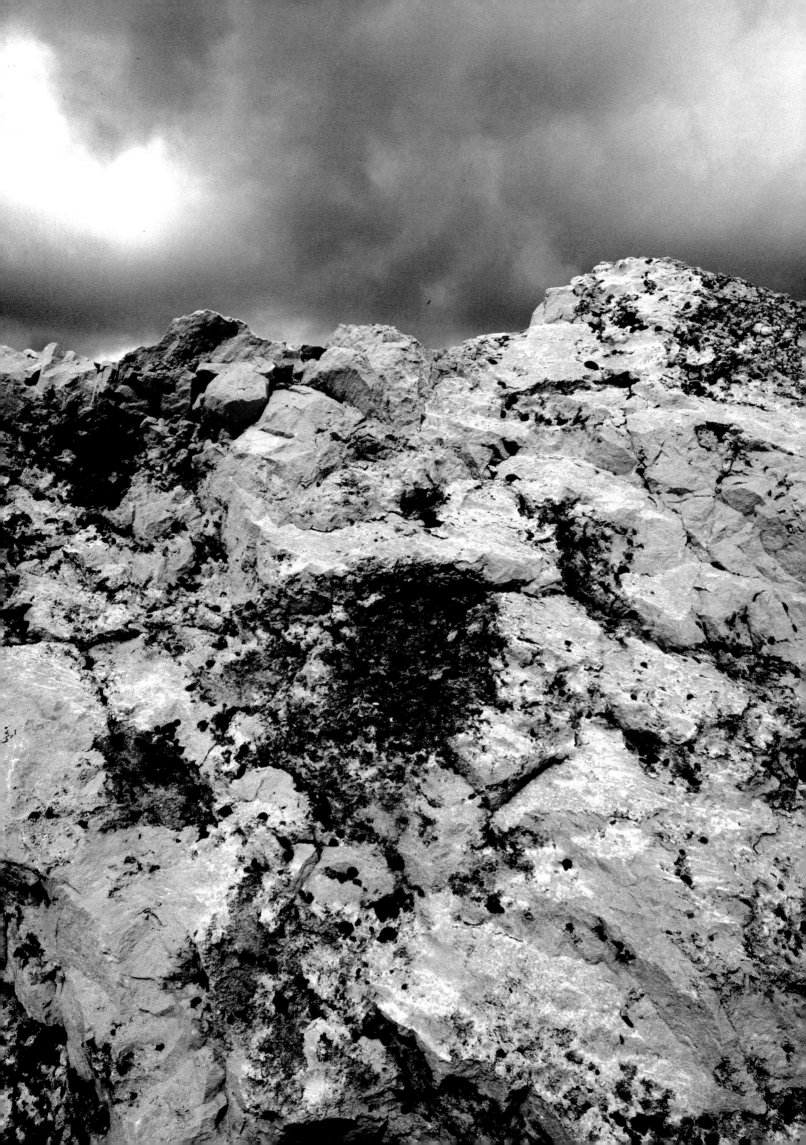

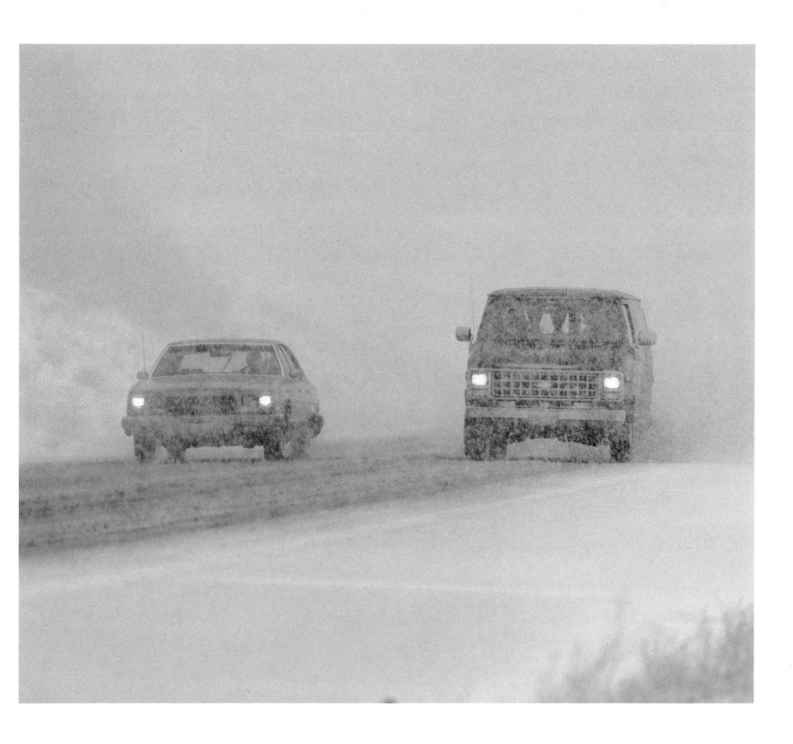

*Left:* Lichen taking hold at the Franks Slide, Blairmore.
*Above:* A snowstorm near Canmore.

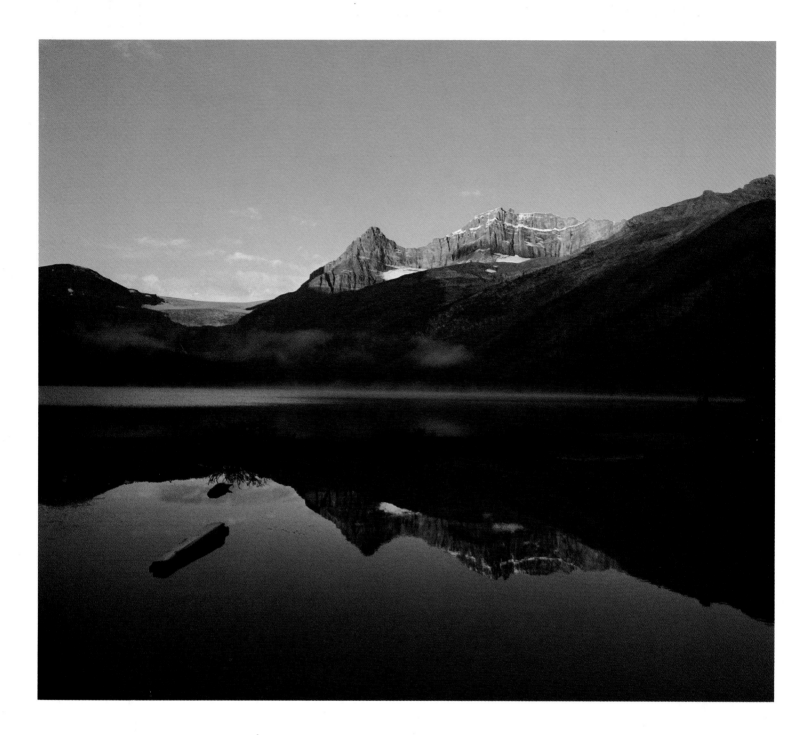

Tranquillity at Bow Lake.

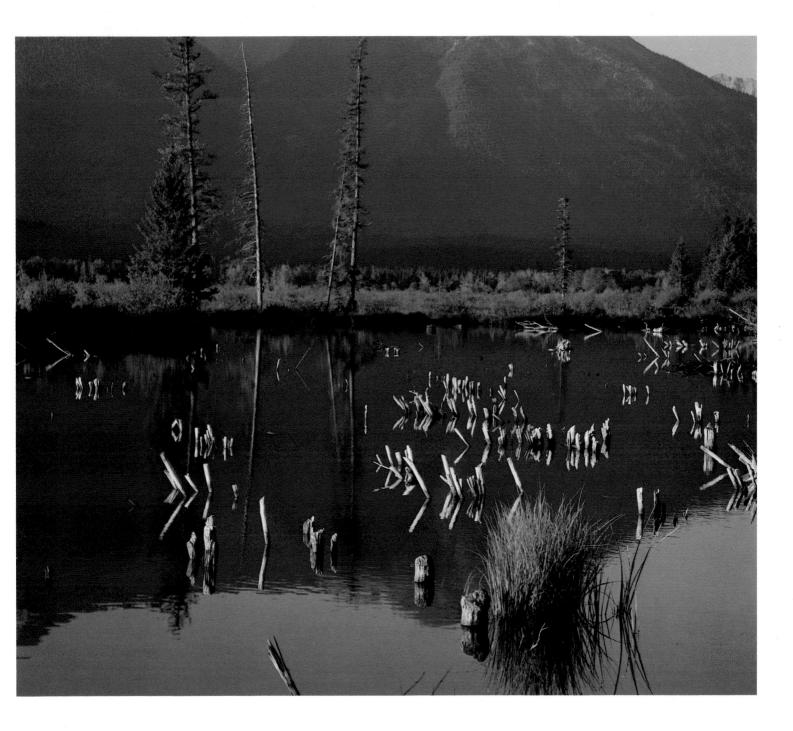

Stumps protrude from the shallow water of Vermilion Lake, Banff.

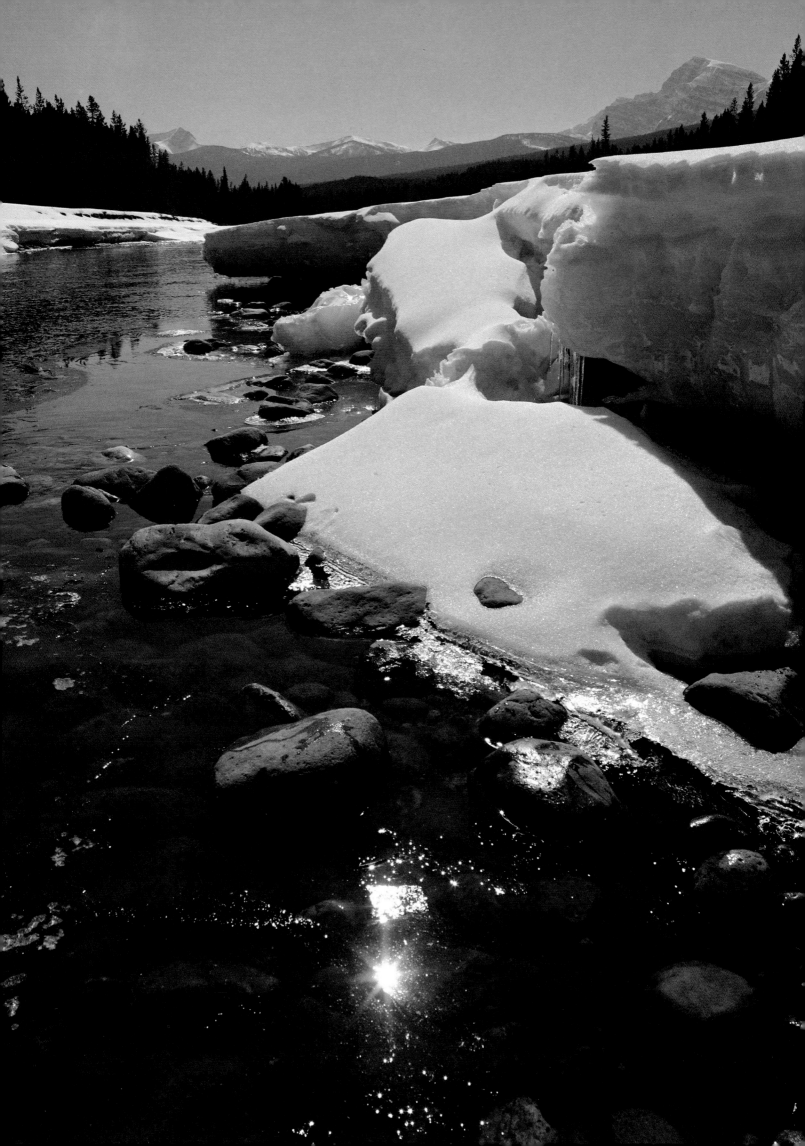

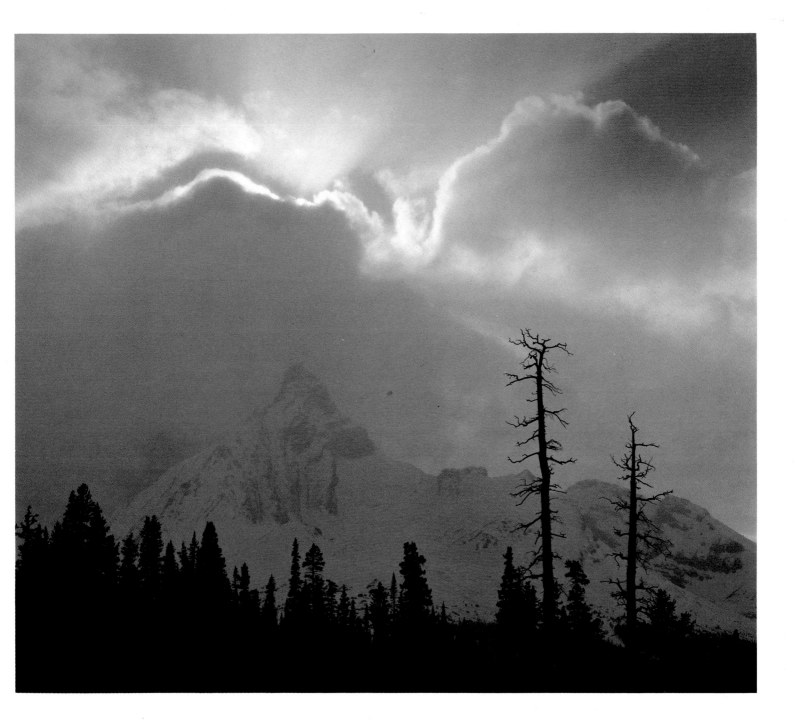

*Left:* Spring thaw on the Bow River.
*Above:* Clouds above the Sunwapta Pass, near Mount Athabasca.
*Overleaf:* Wheat remains Alberta's chief agricultural crop.

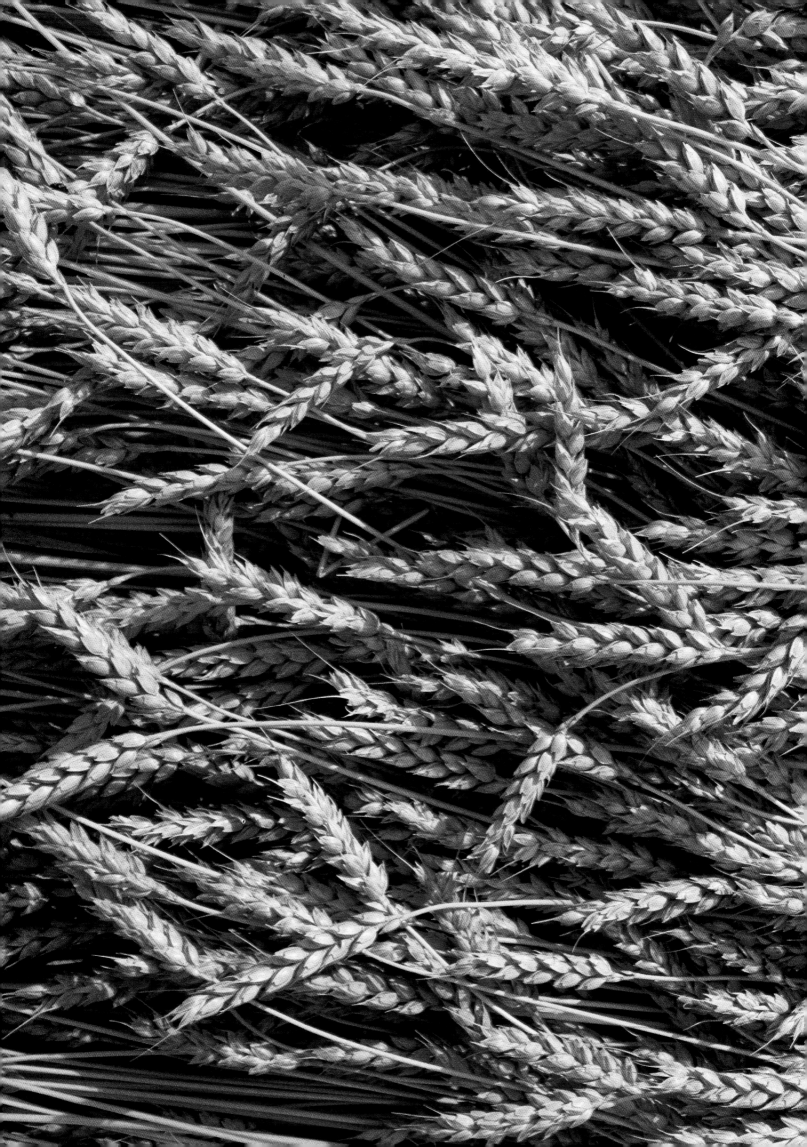

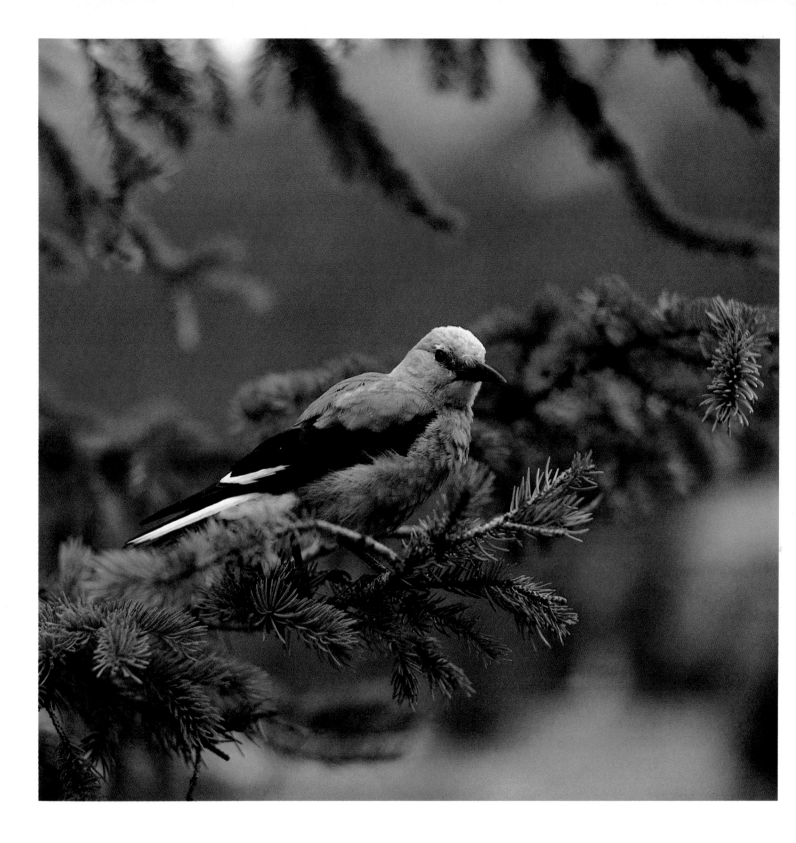

A sombre-coloured Clark's Nutcracker at Lake Louise.

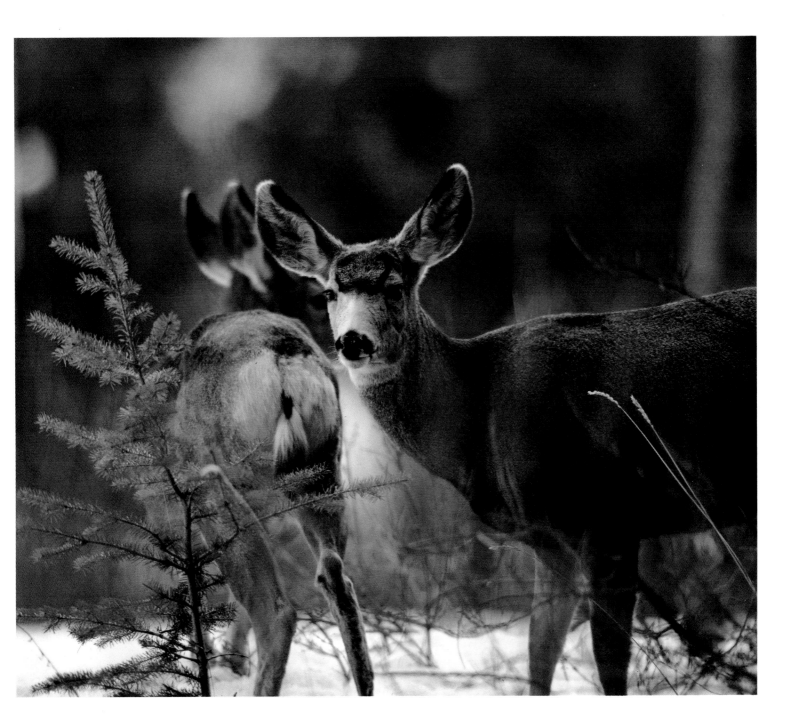

Mule deer at Jasper.
*Overleaf left:* Cattle skull caught in the salt deposit left on an evaporated pond floor near Altario.
*Overleaf right:* Herefords graze beneath a clear summer sky.

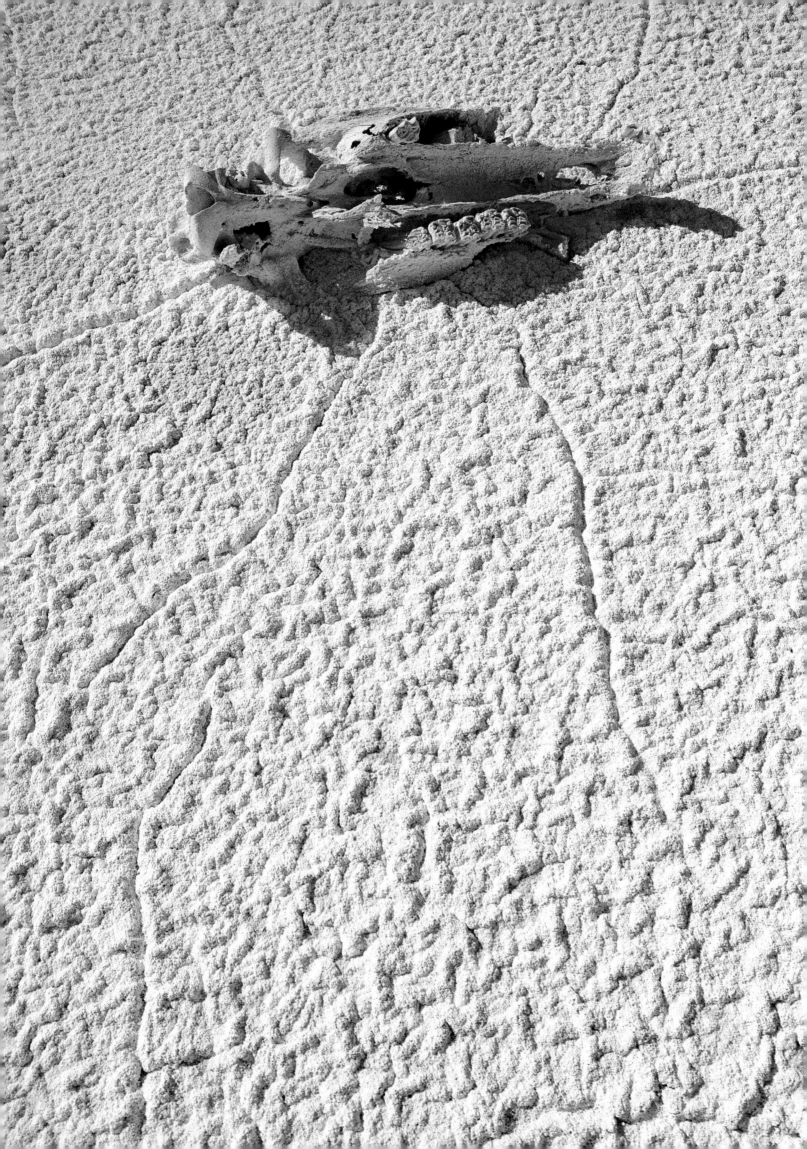

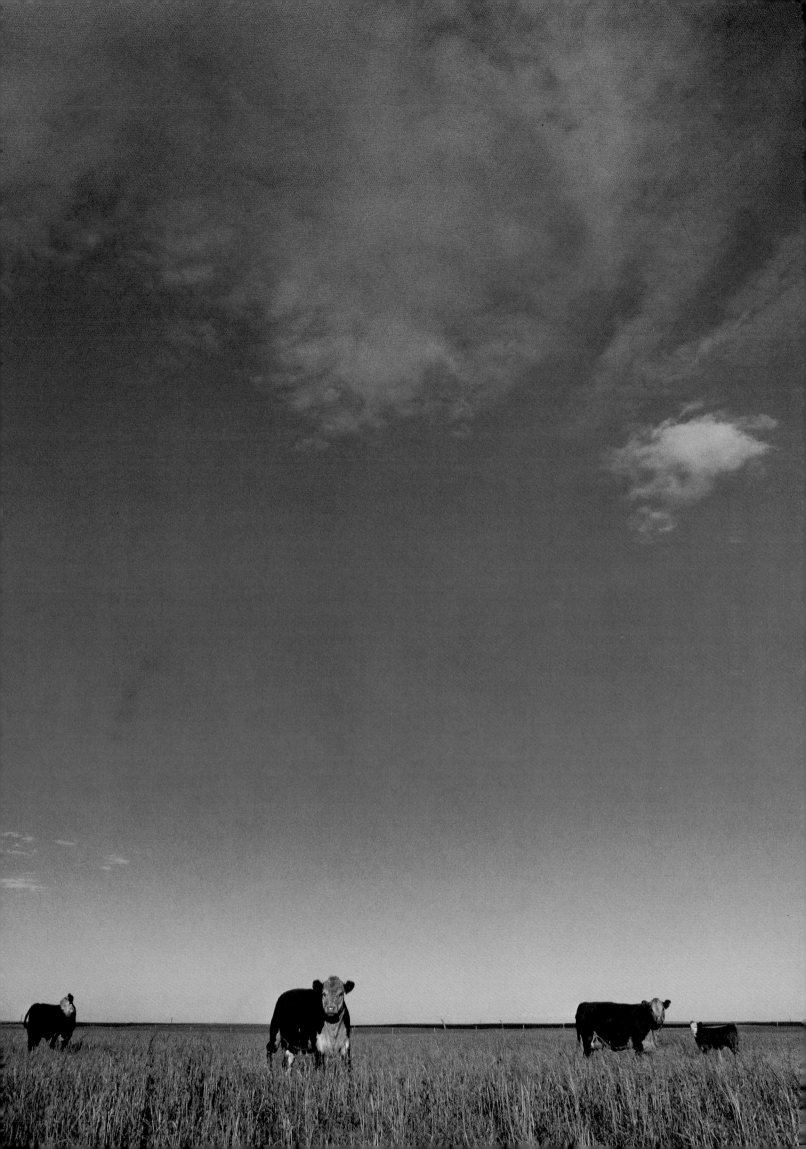

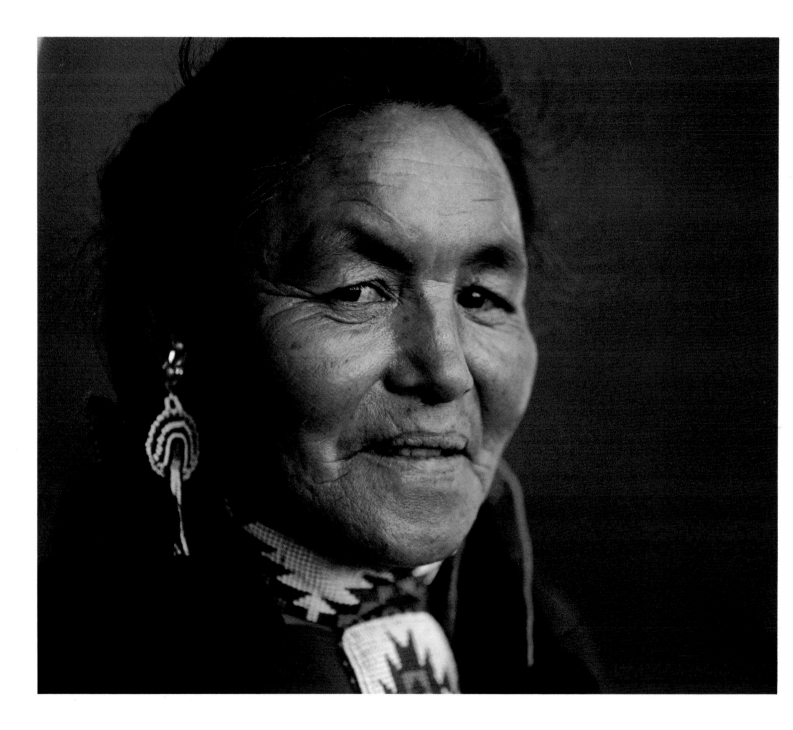

*Above:* An Indian woman at the Calgary Stampede.
*Right:* Ethnic dancers at the Calgary Stampede.

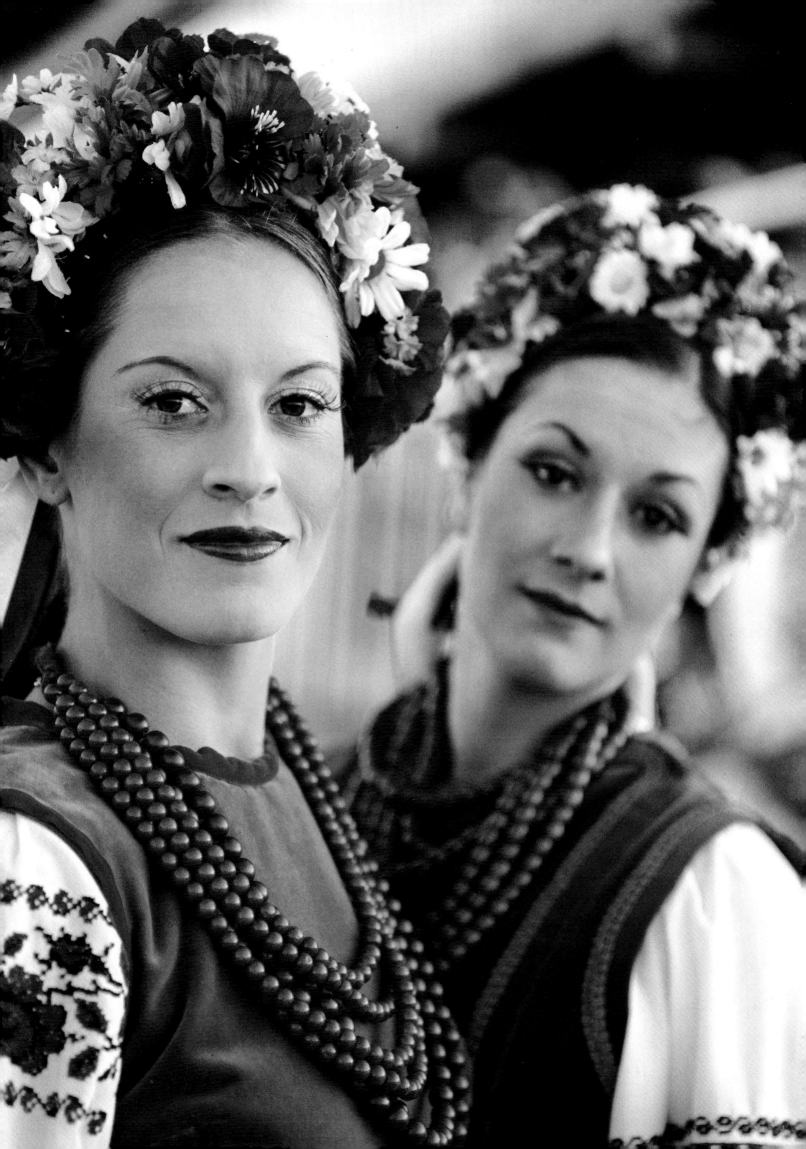

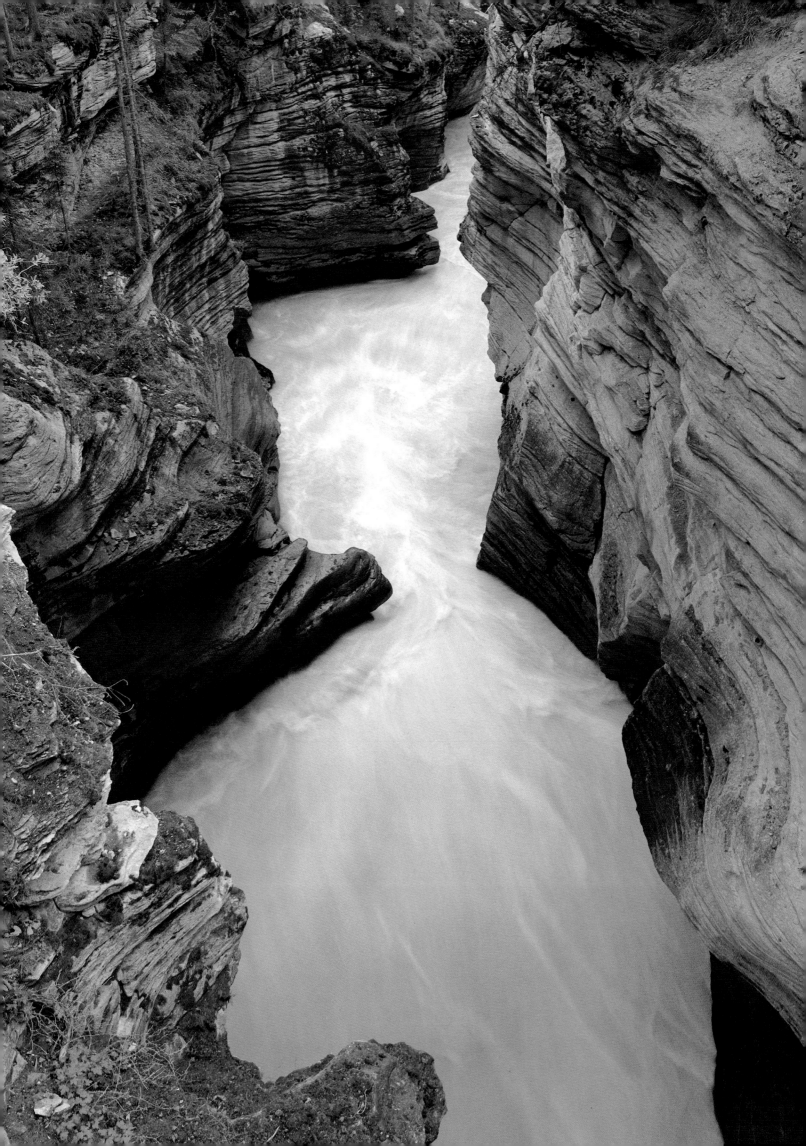

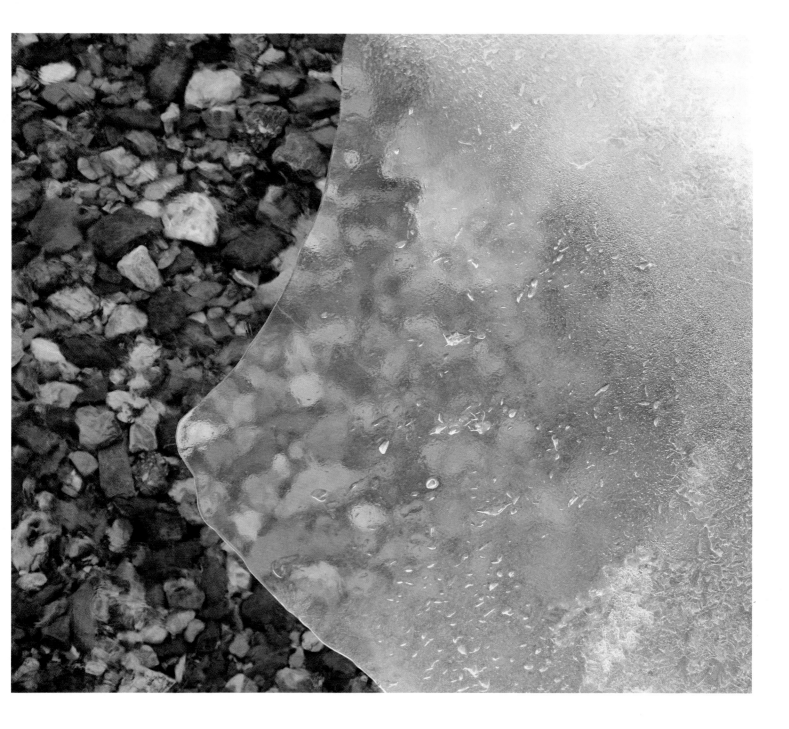

*Left:* Eroded rock formations at Athabasca Falls.
*Above:* An ice blanket creeps over pebbles.

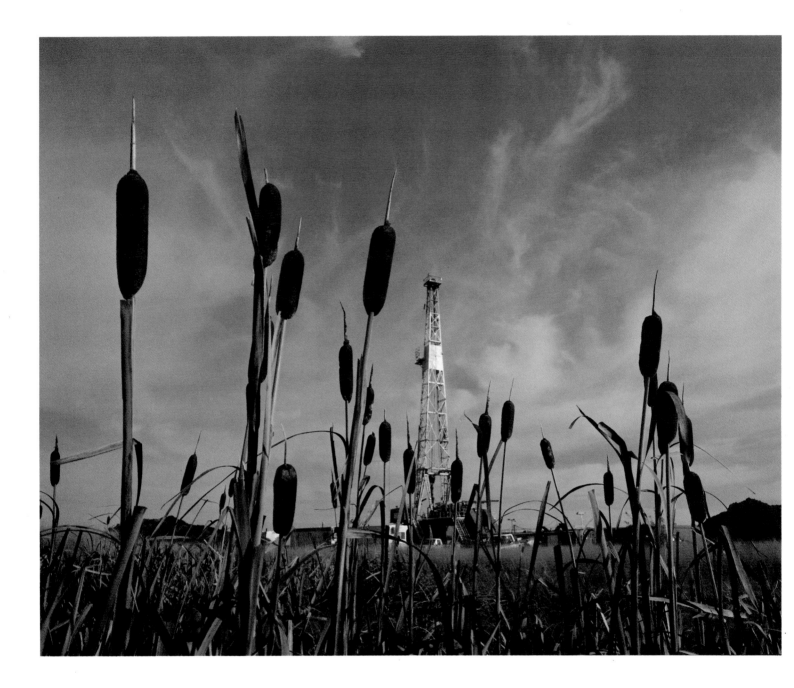

*Above:* An oil drilling rig seems dwarfed by cattails.
*Right:* Fire stack and block of sulphur produced from "sweetening" gas
at the Gulf plant at Nevis.

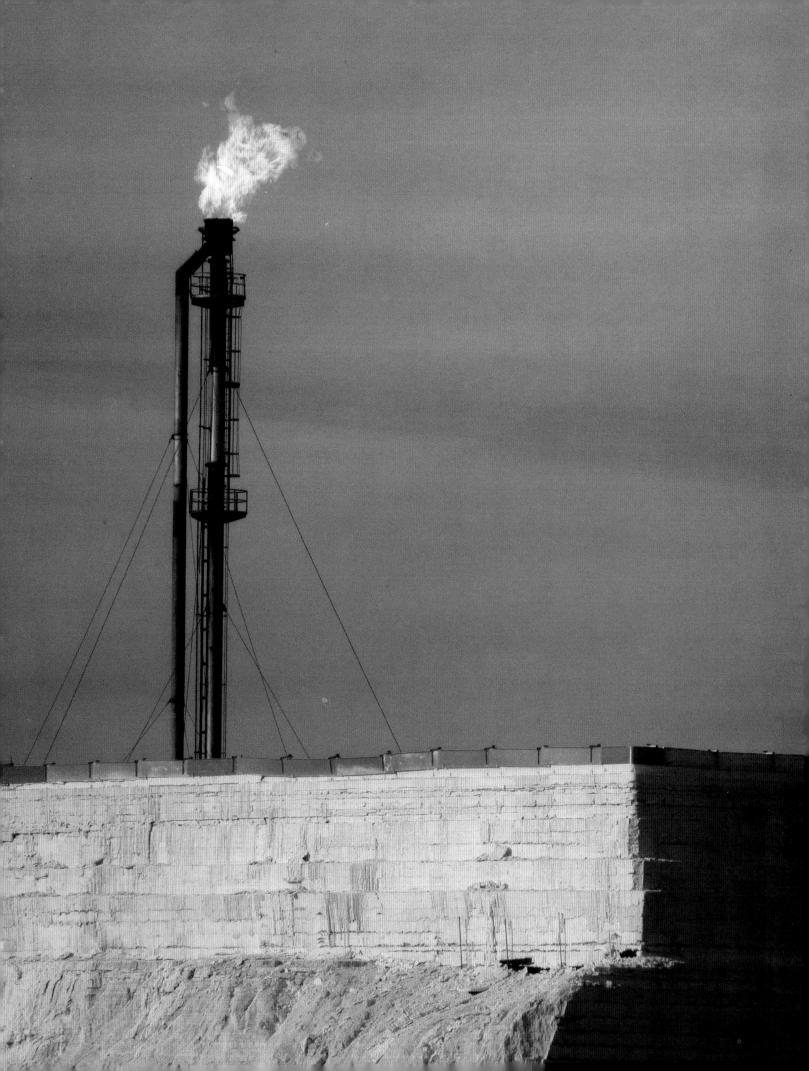

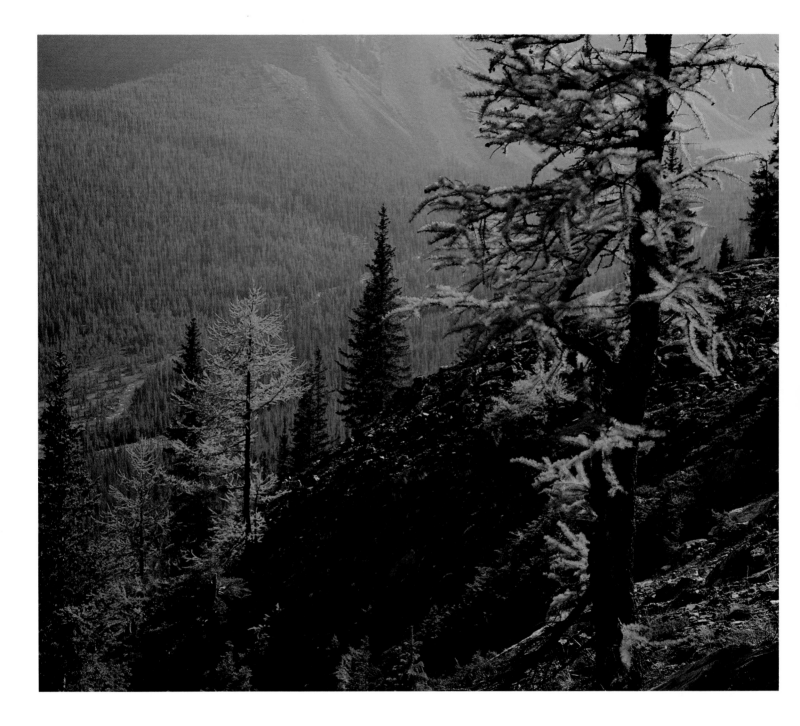

A forest-covered valley along Moraine Lake Road.

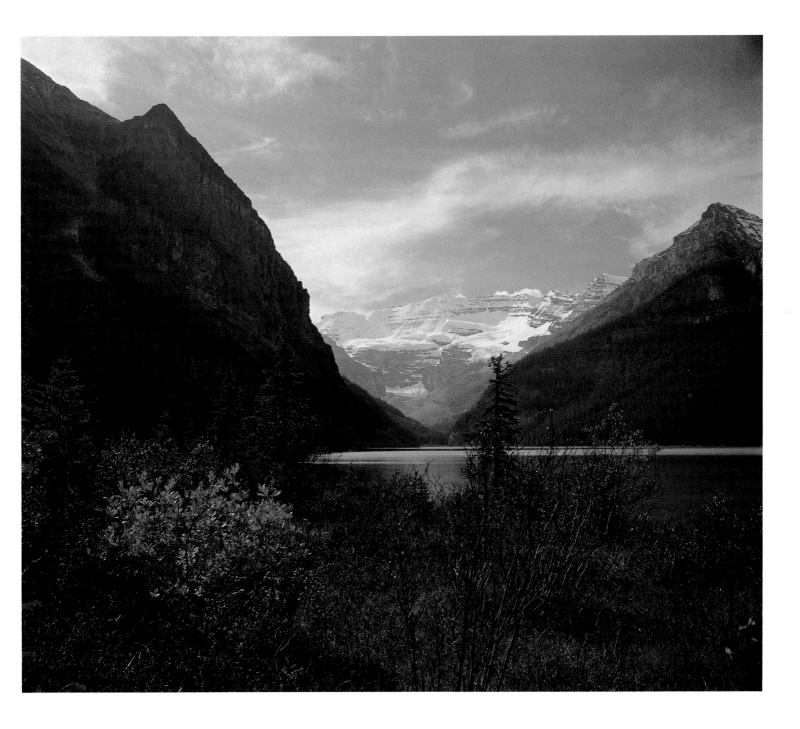

The startlingly blue waters of Lake Louise.

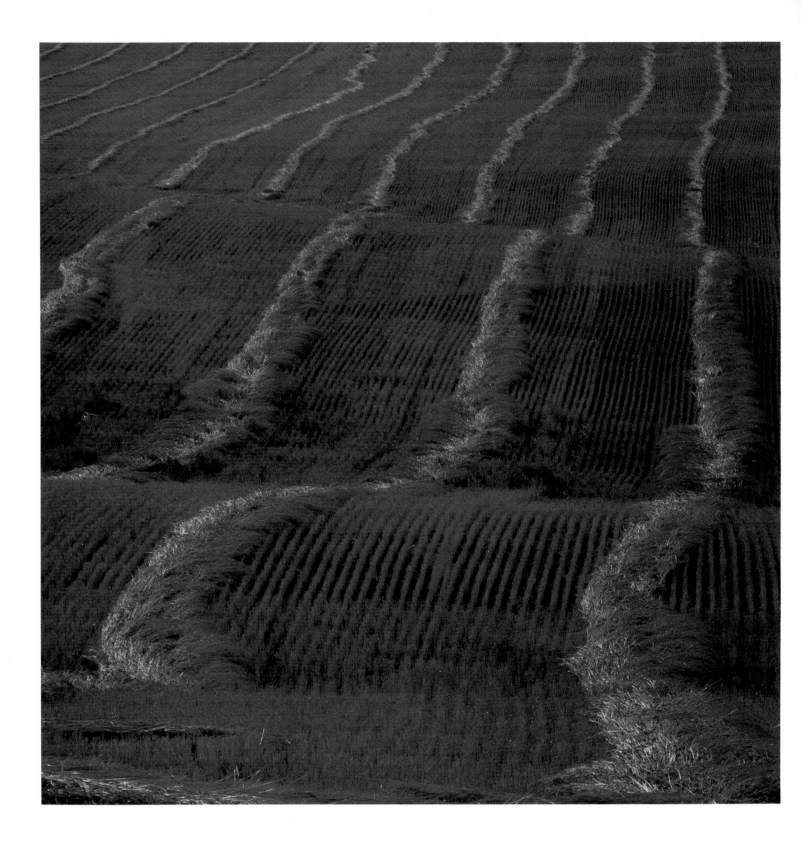

Row upon row of swathed grain awaits combining.

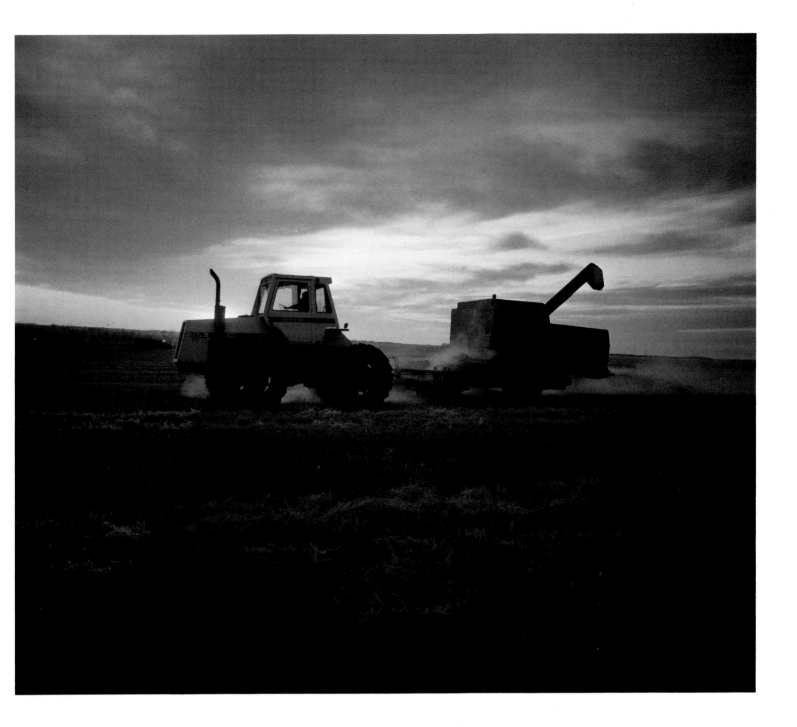

The sun sets behind a harvesting farmer near Red Deer.
*Overleaf:* Mount Athabasca is one of Jasper Park's special attractions.

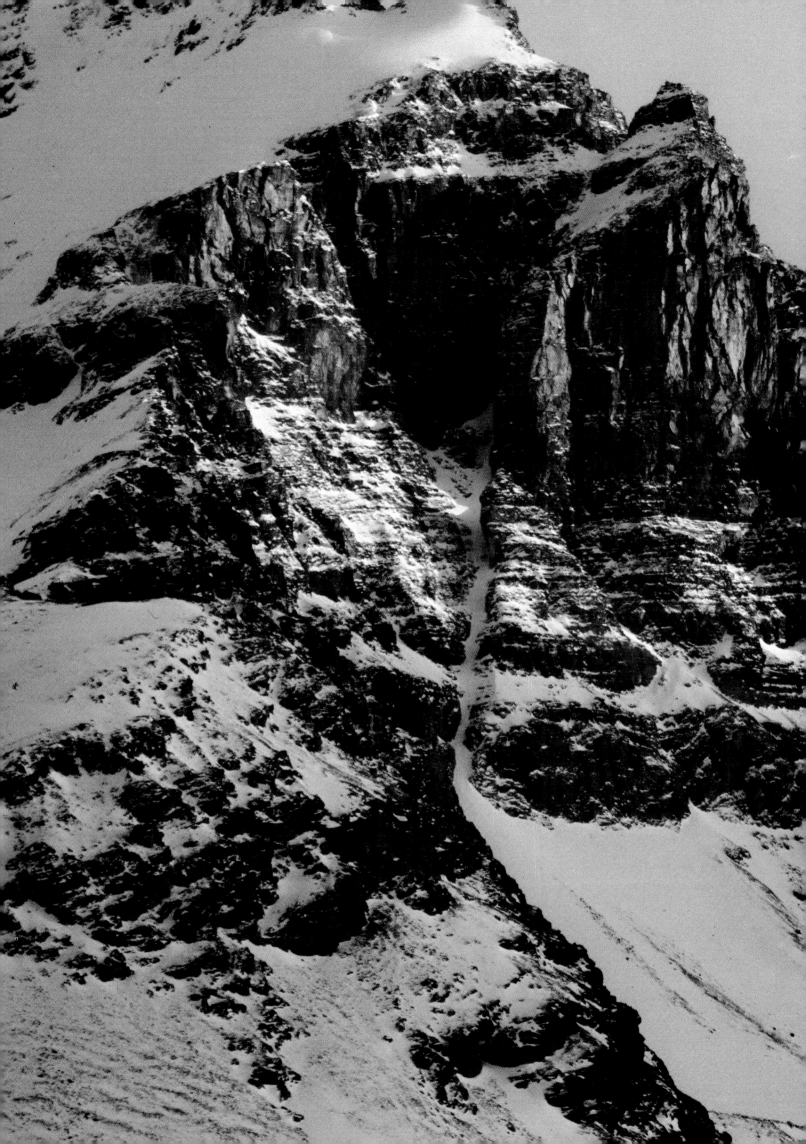

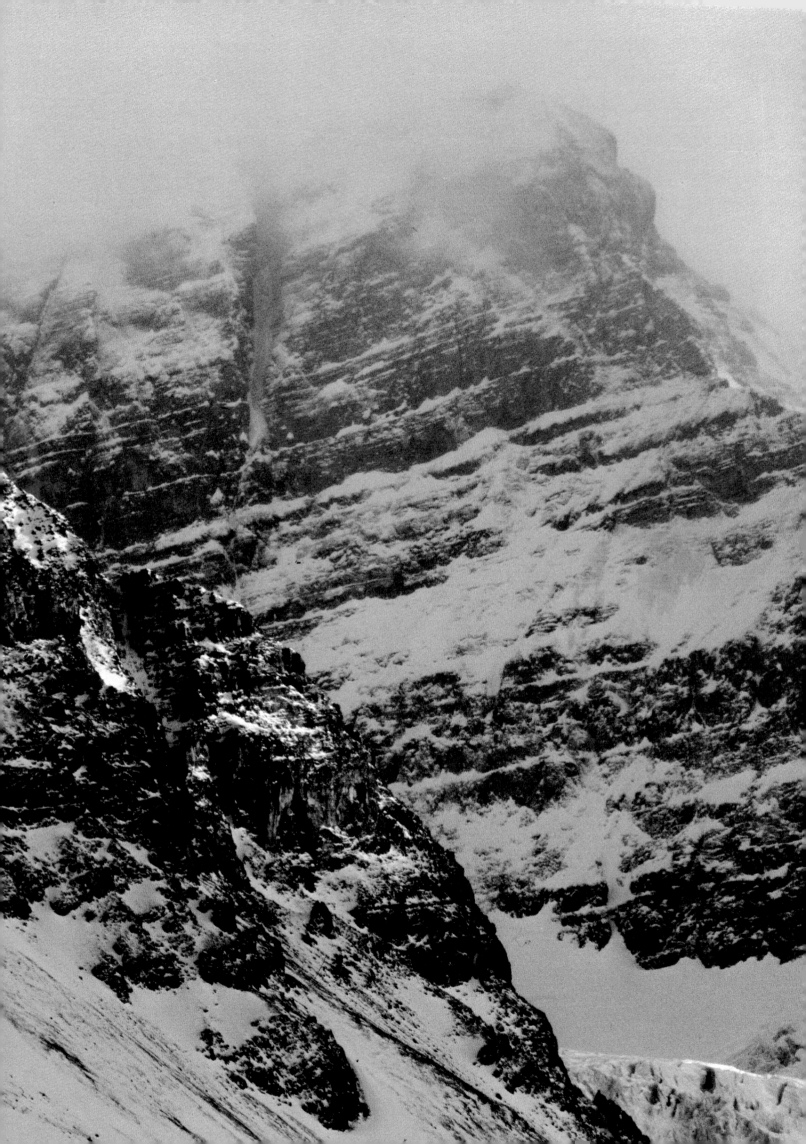

The sun breaks through storm clouds near Olds.

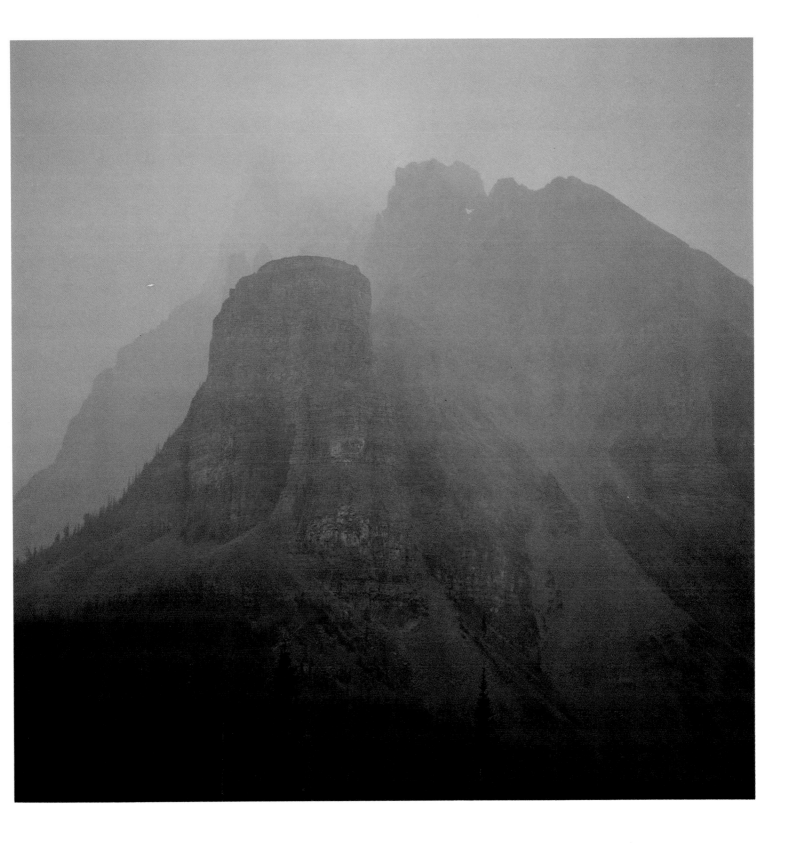

Mount Babel and the Tower of Babel shrouded in fog
along the Moraine Lake Road.

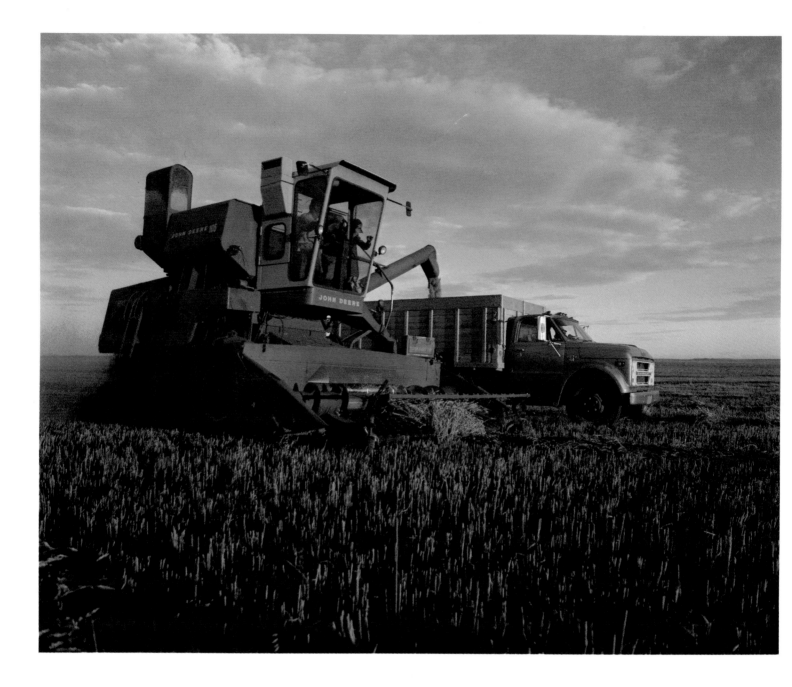

A plentiful crop keeps the combine busy near Olds.

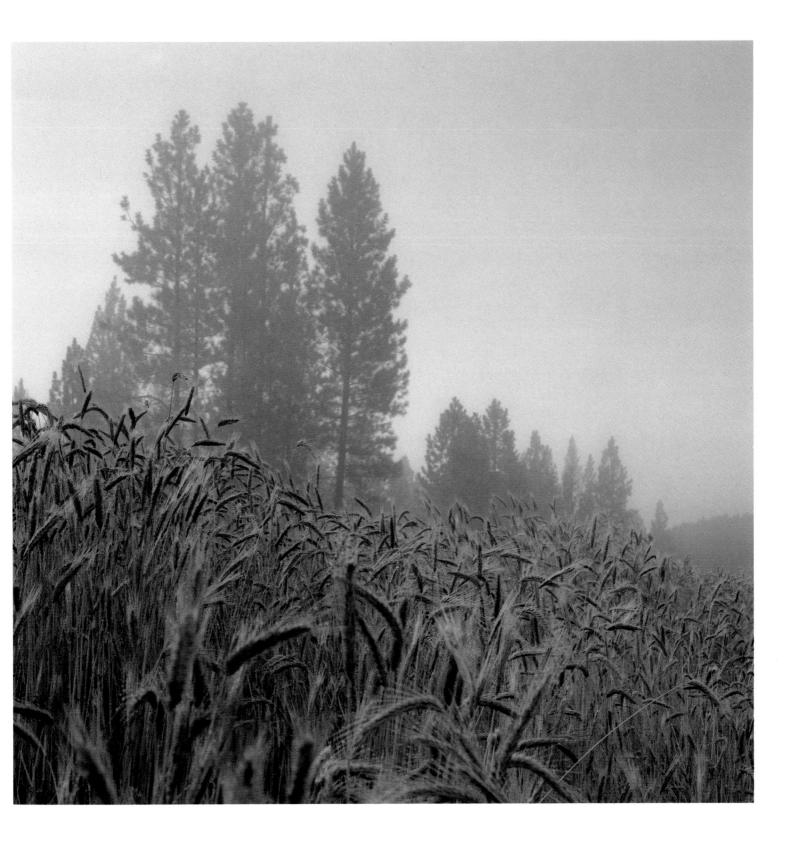

A field of barley promises bountiful harvest.

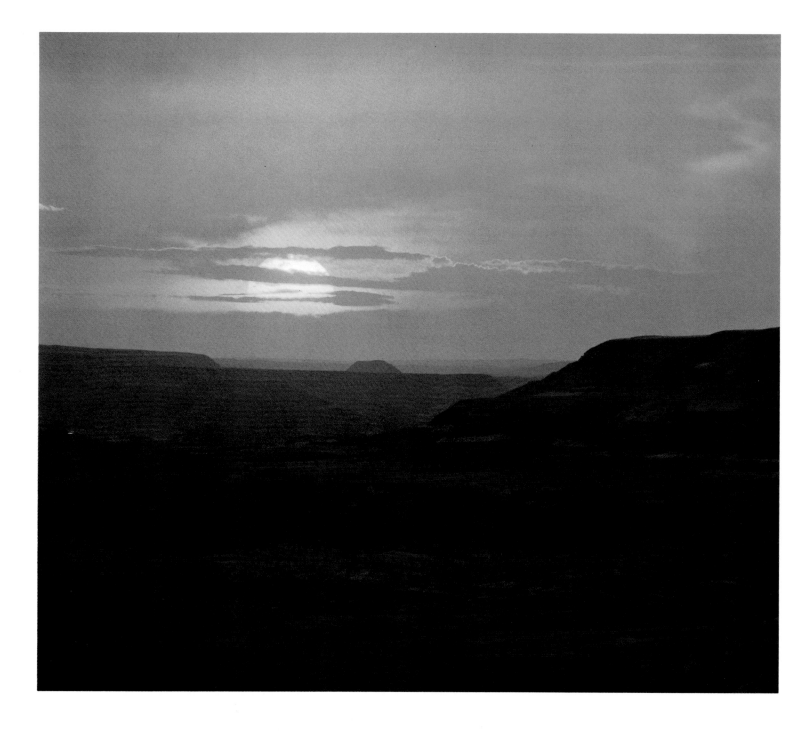

The sun casts a rosy glow over a bleak scene in the Badlands.

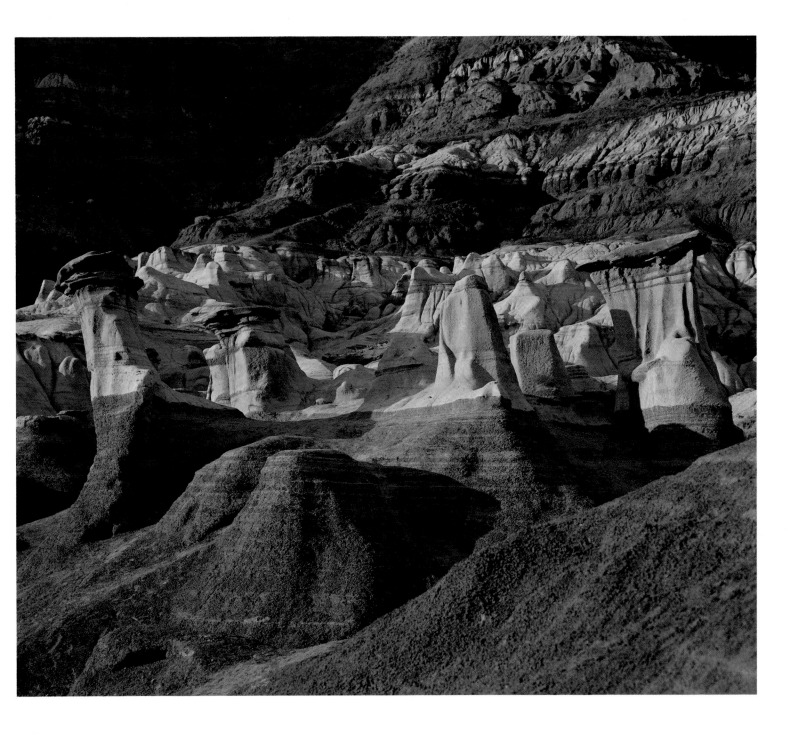

The Hoodoos, Drumheller, perched like giant mushrooms.

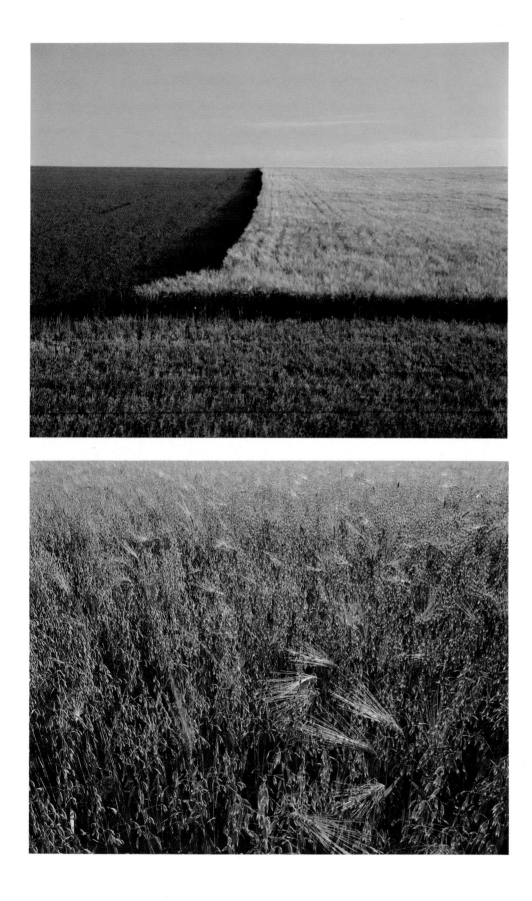

*Top:* Fields stretch beyond the horizon.
*Above:* A mixed grain field - a contrast in textures.
*Right:* Oats ripen in the summer sun.

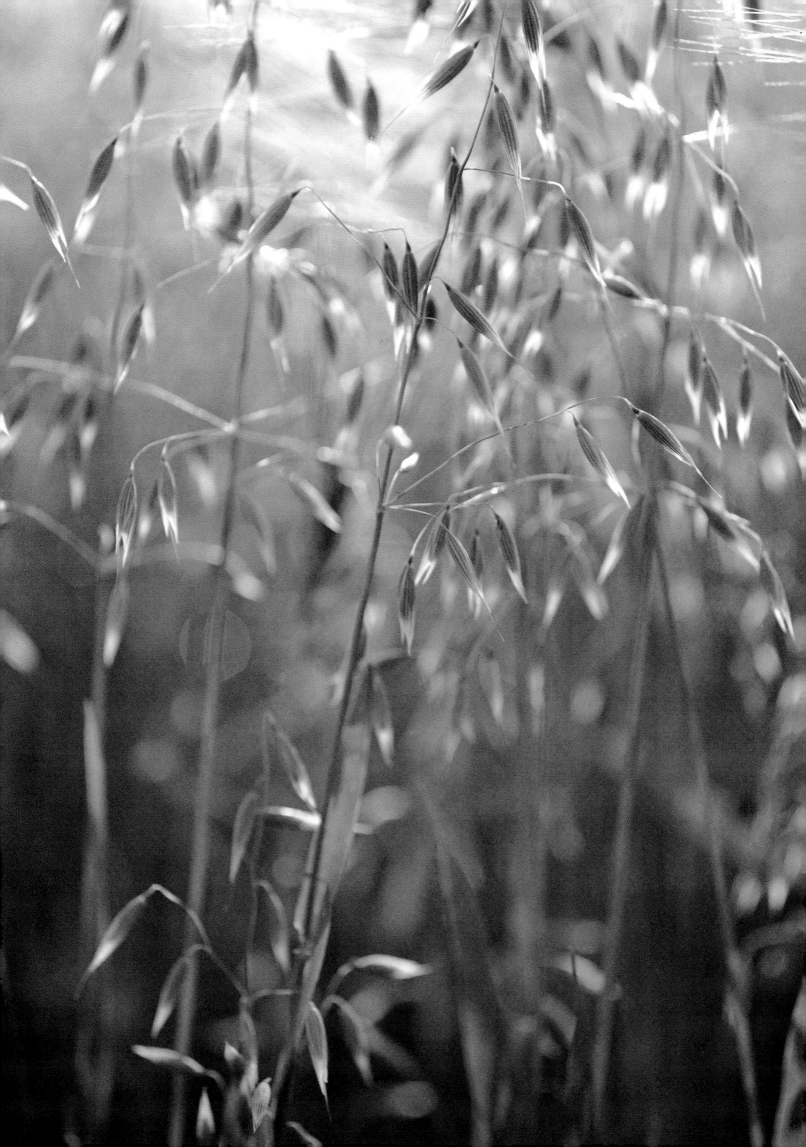

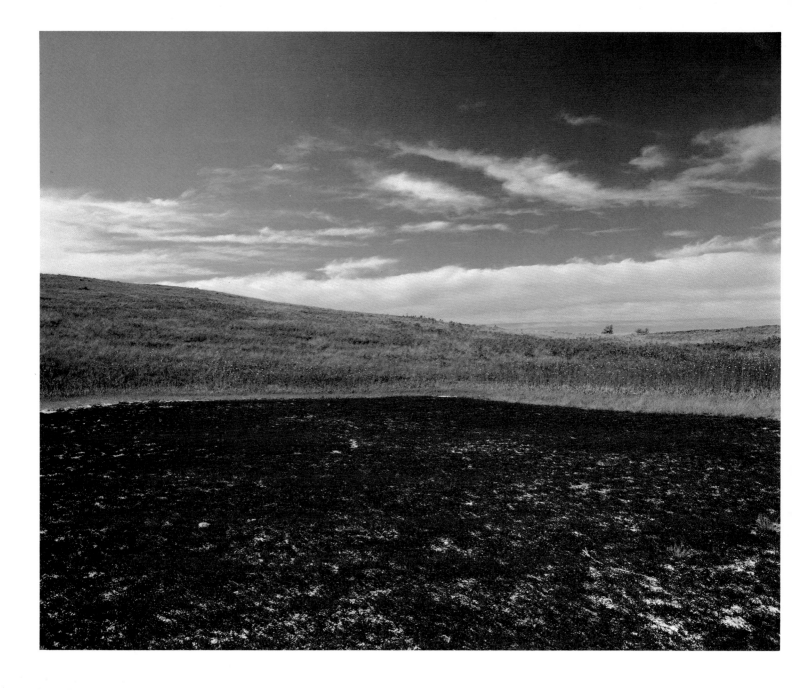

A dried-up pond creates a shallow depression.

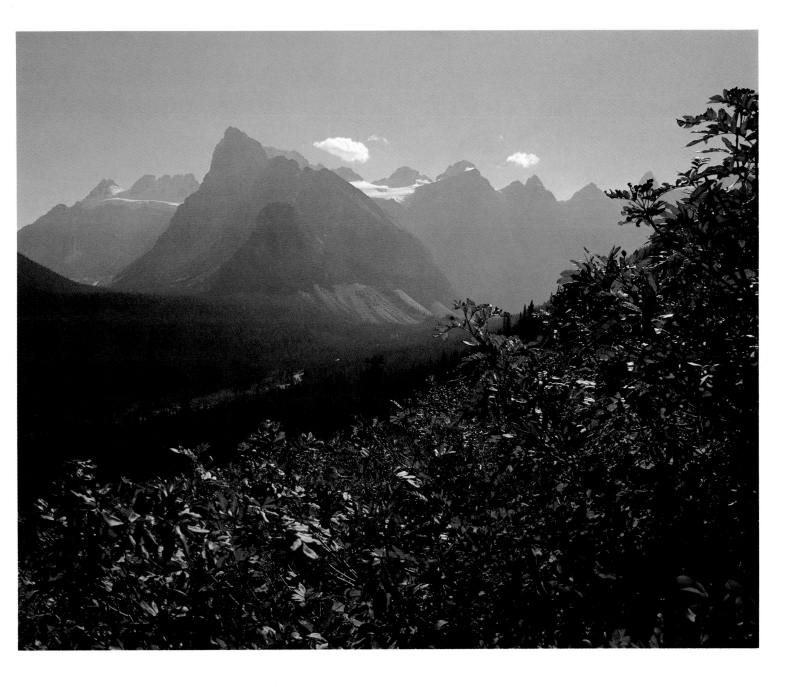

Mount Babel and Tower of Babel viewed through foliage along Moraine Lake Road.

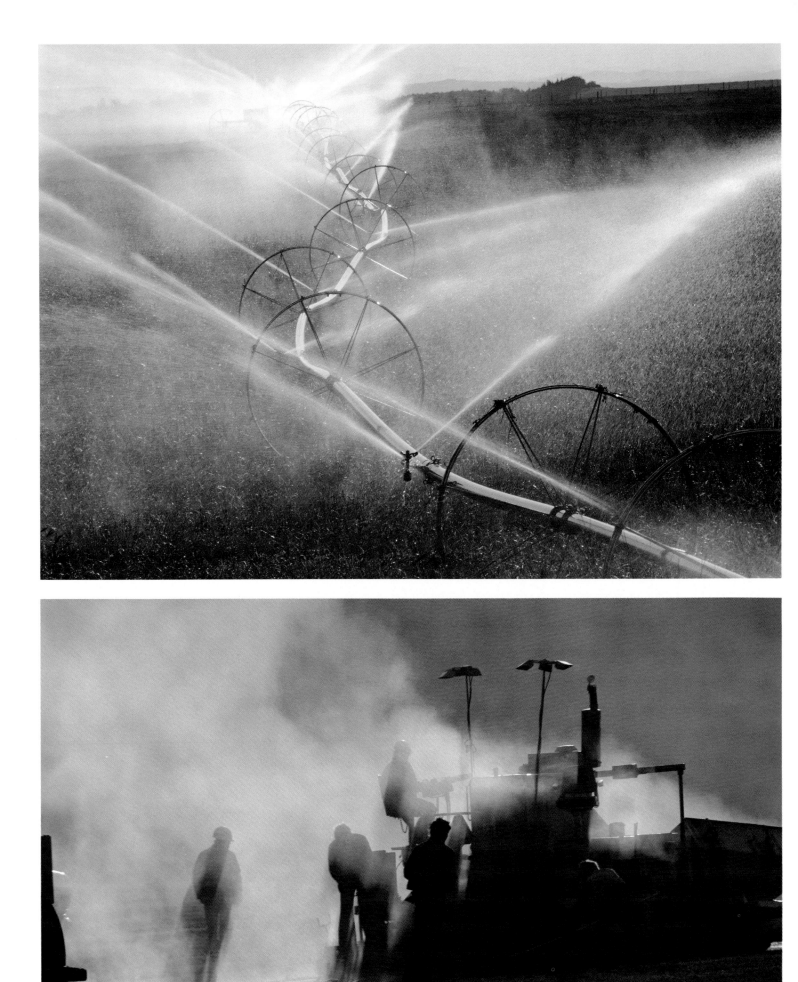

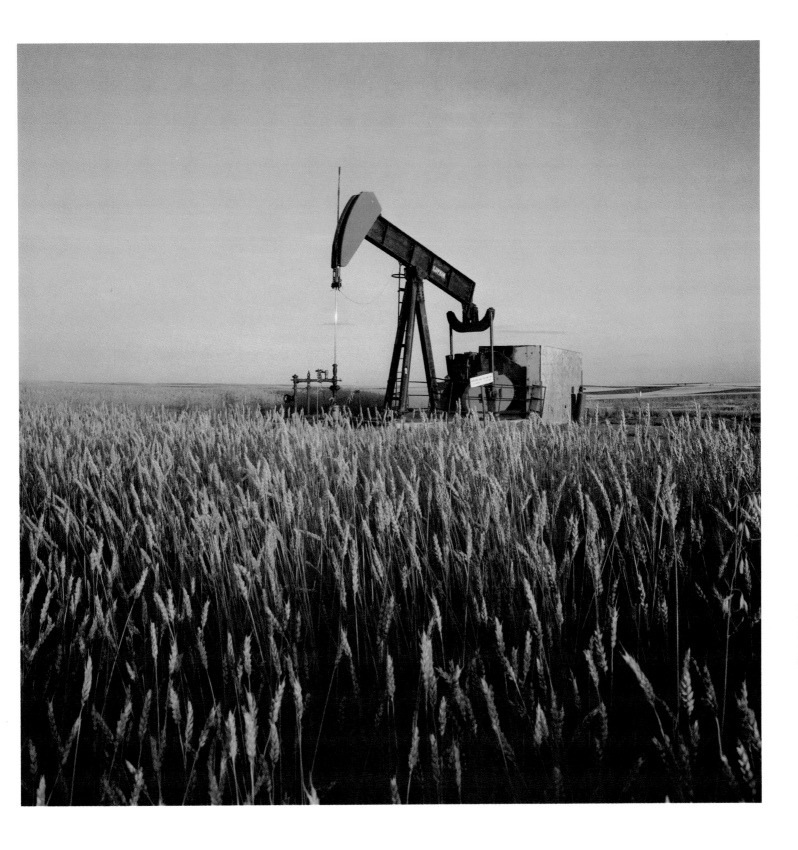

*Left top:* Mechanized irrigation near Black Diamond.
*Left bottom:* Paving the Crowfoot Trail, Calgary.
*Above:* A donkey pump in the middle of a wheat field.

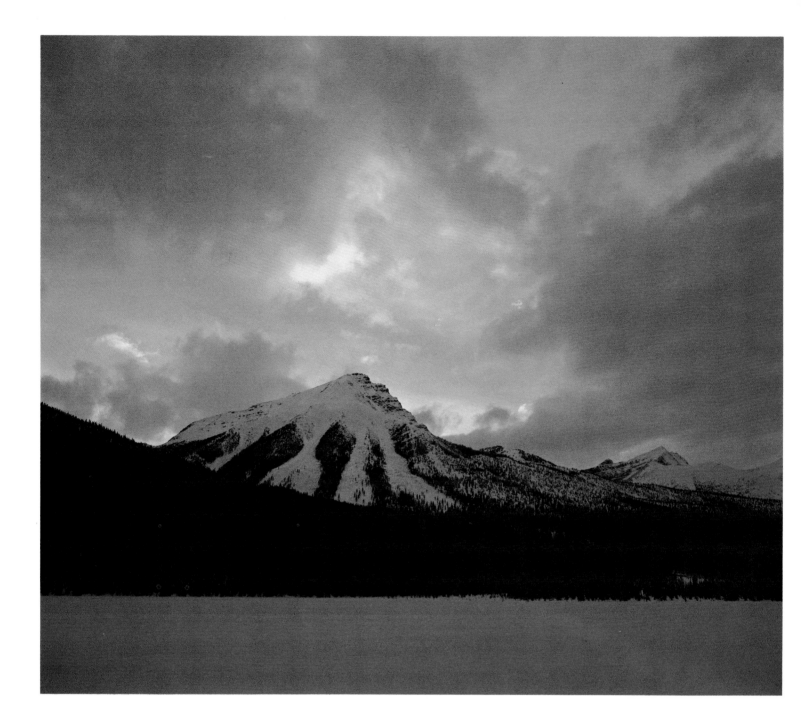

*Above:* The evening sky dramatically backlights a rugged
mountain.
*Right:* The sun's reflection shimmers on icy brook near Banff.
*Overleaf:* The Claresholm grain elevators stand like sentinels.

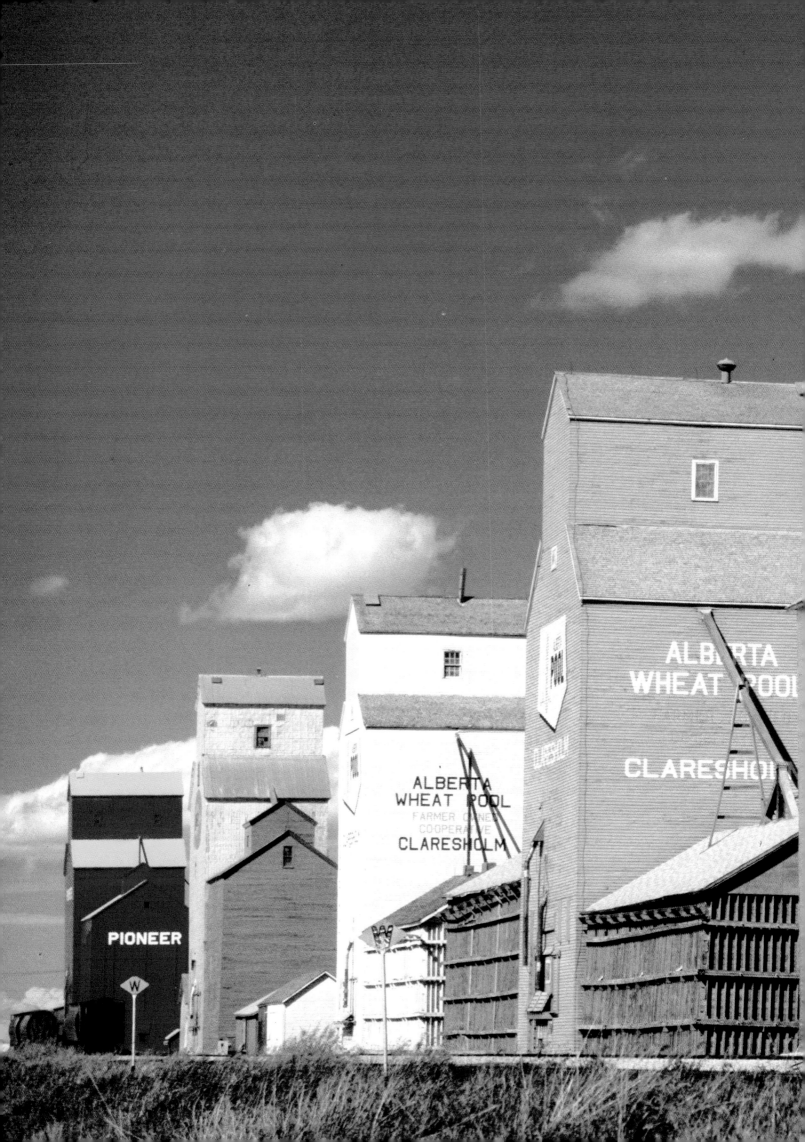

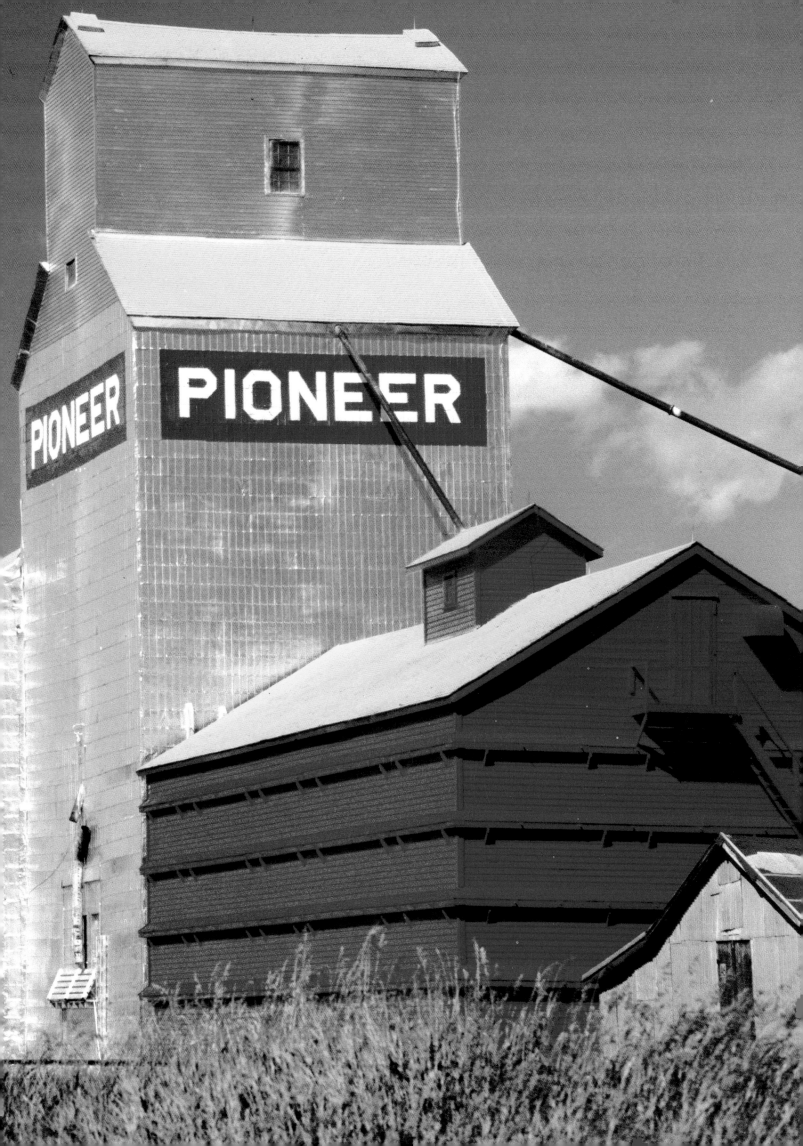

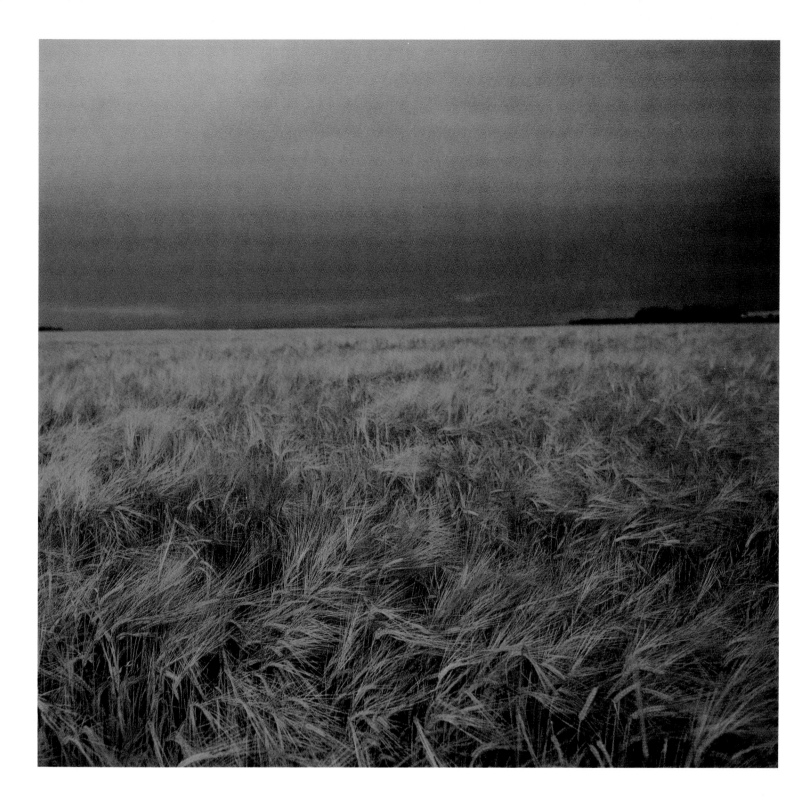

The breeze dances through barley.

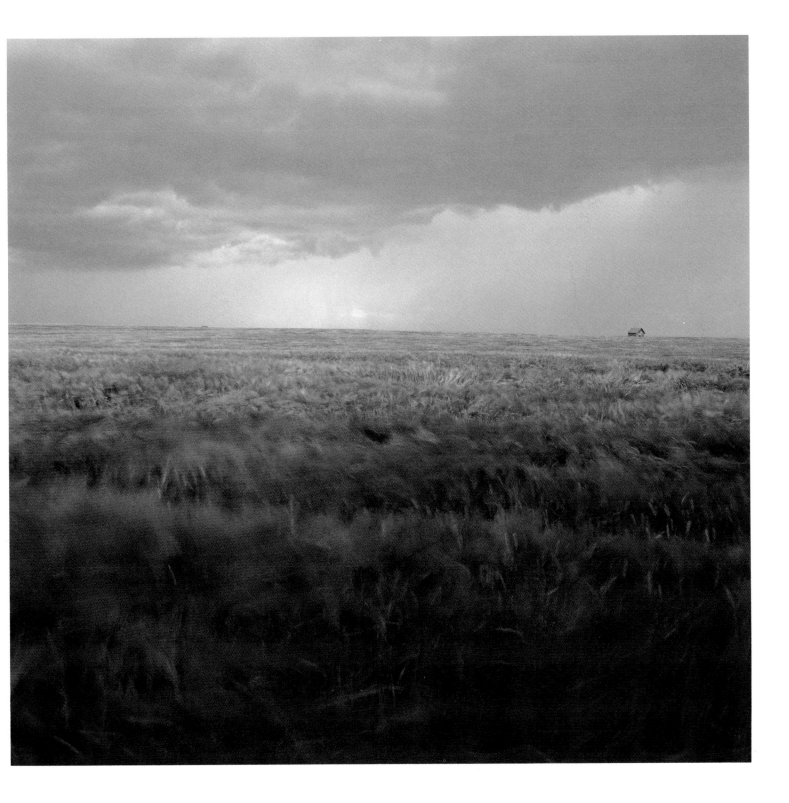

Grain storage sheds on the horizon of a wind-whipped barley field.

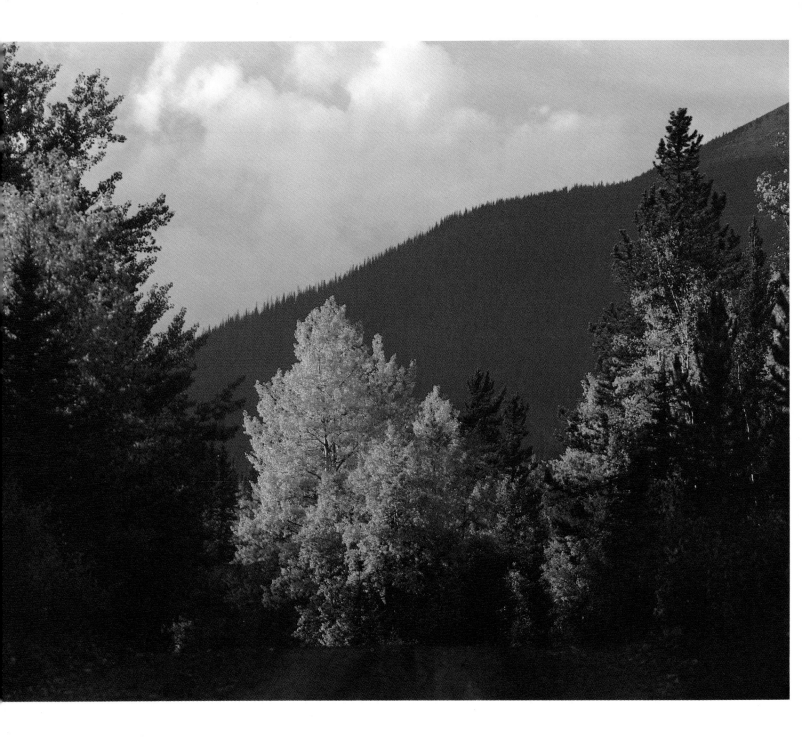

*Above:* Aspen in fall colours at Shunda Creek, near Nordegg.
*Right:* Hailstones nestling among fallen leaves.

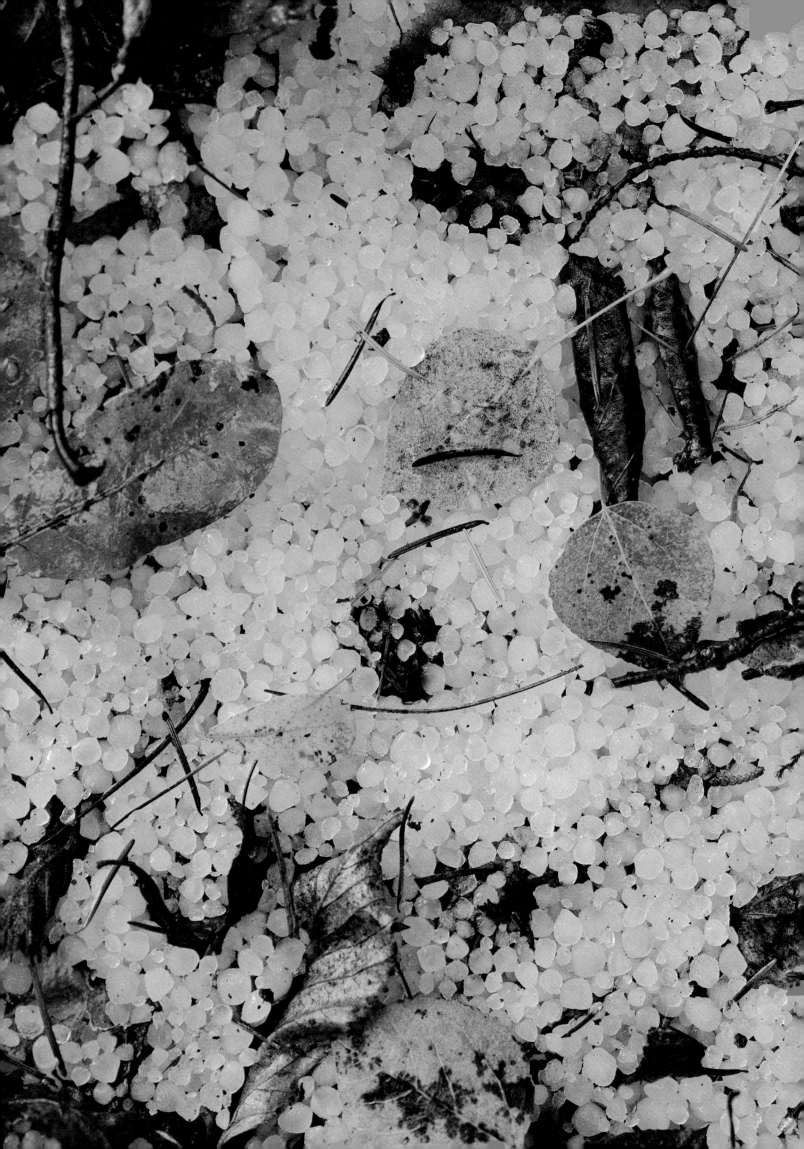

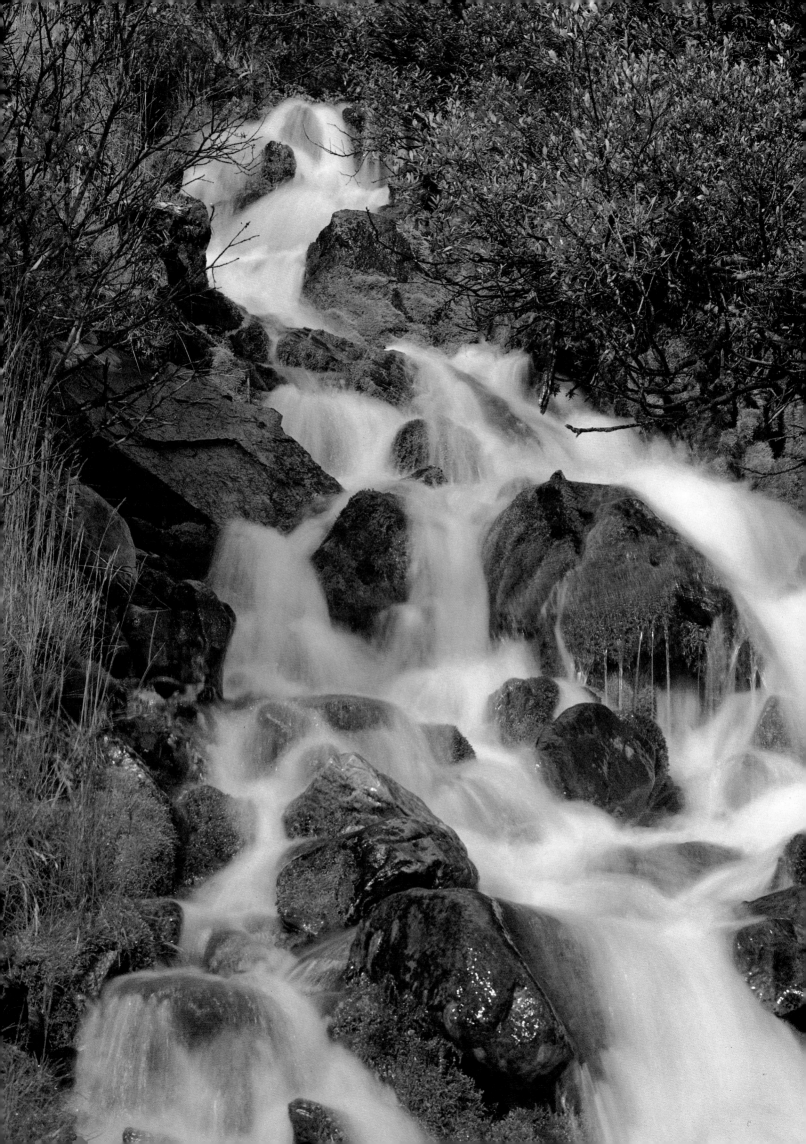

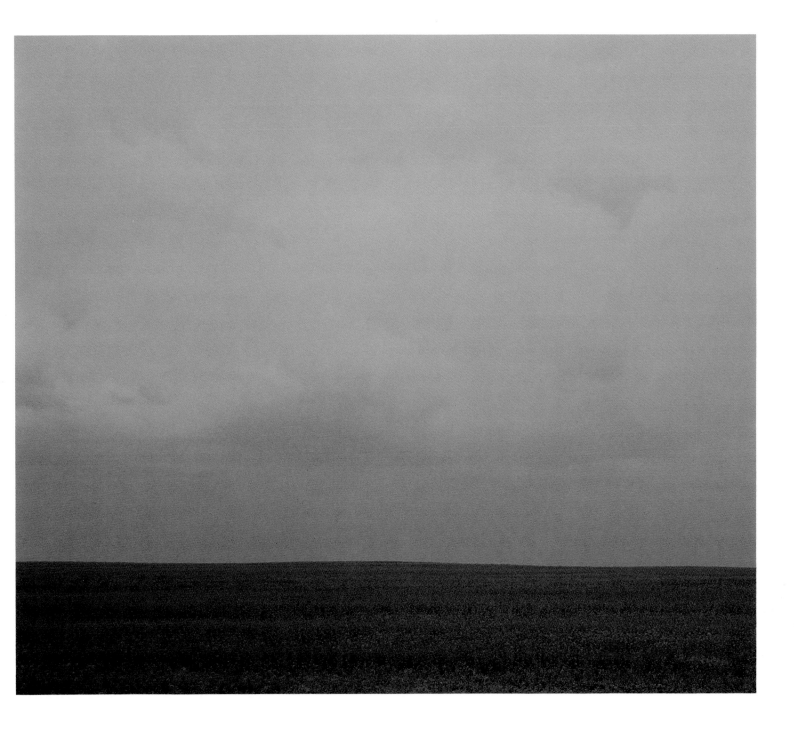

*Left:* Melting snow creates a rushing creek near Hector Lake.
*Above:* A thunderstorm approaches farmland south of Calgary.

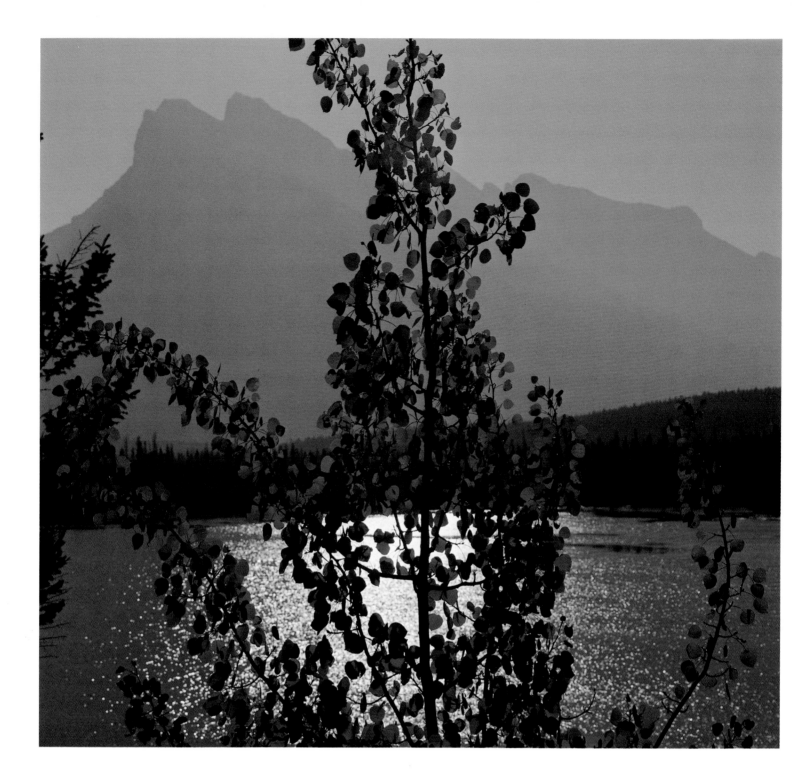

Vermilion Lake and Mount Rundle.

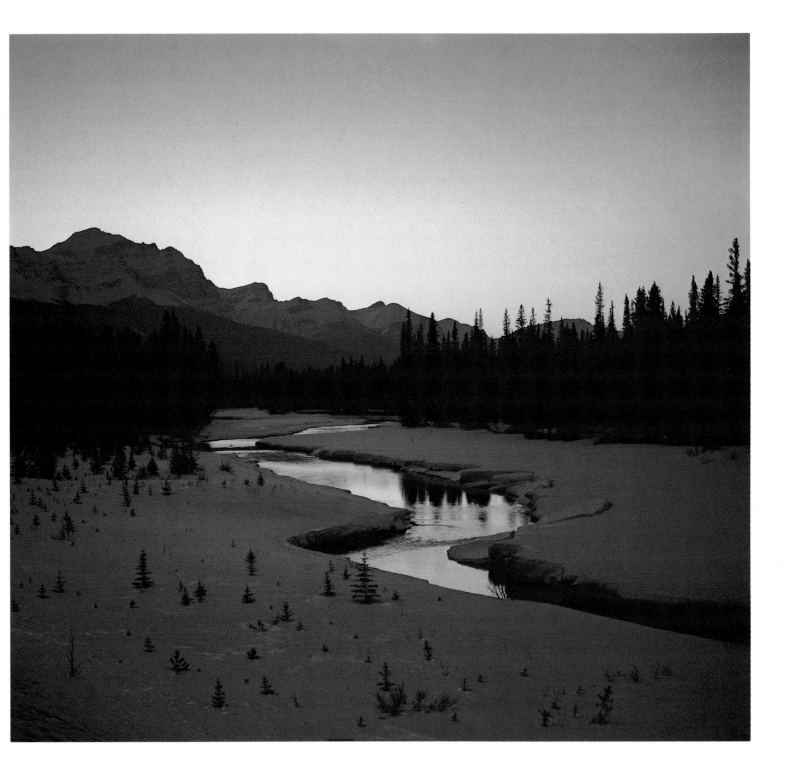

Sunset at Bow River.

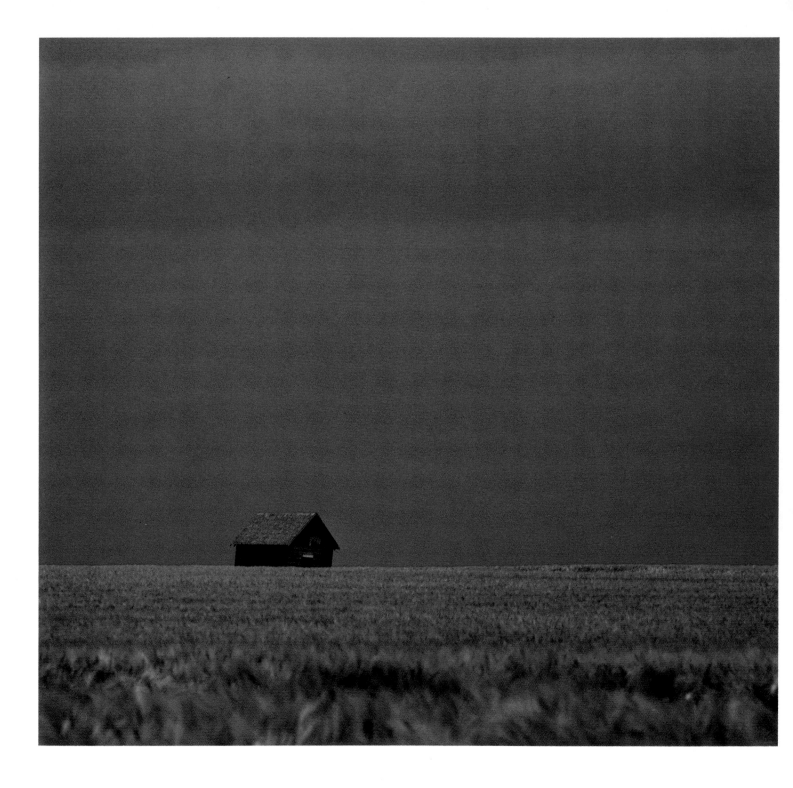

A grain storage shed in a vast field of barley, near Torrington.

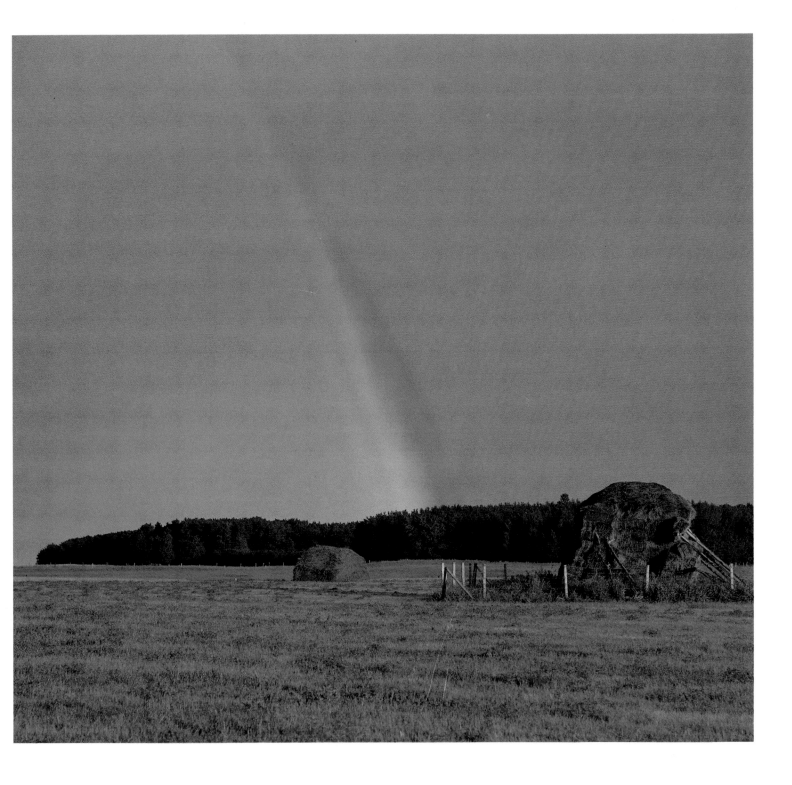

Rainbow over a hay field.

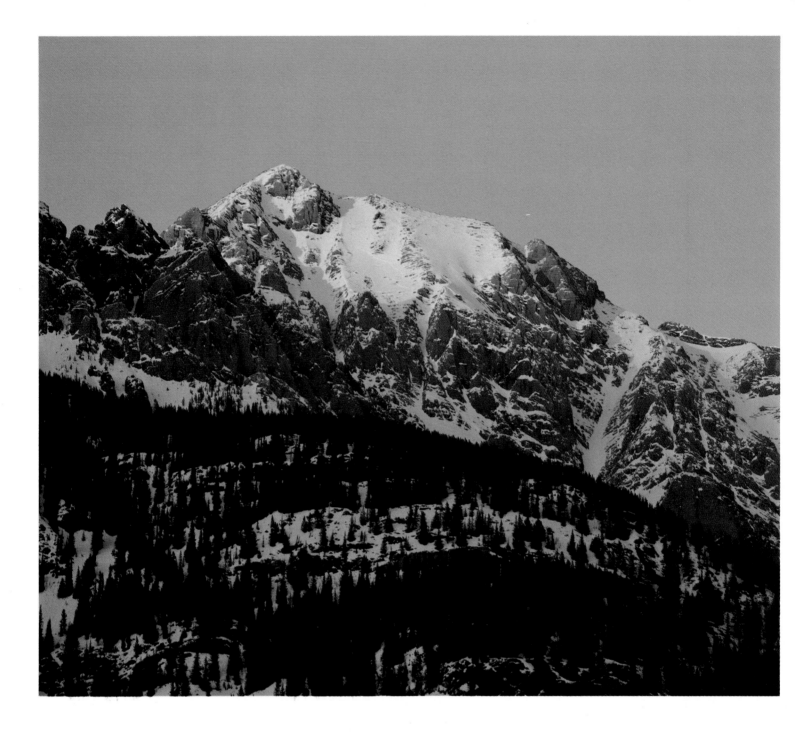

A snow-capped peak catches the sun's rays.

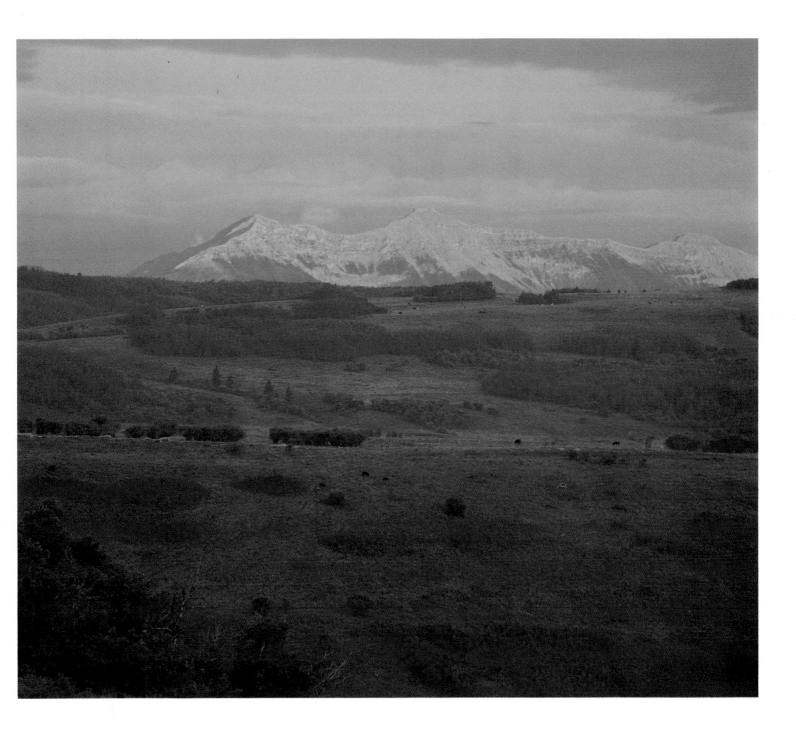

Cattle dot the land near a forestry trunk road in southwestern Alberta.

Raindrops hang from pine needles.

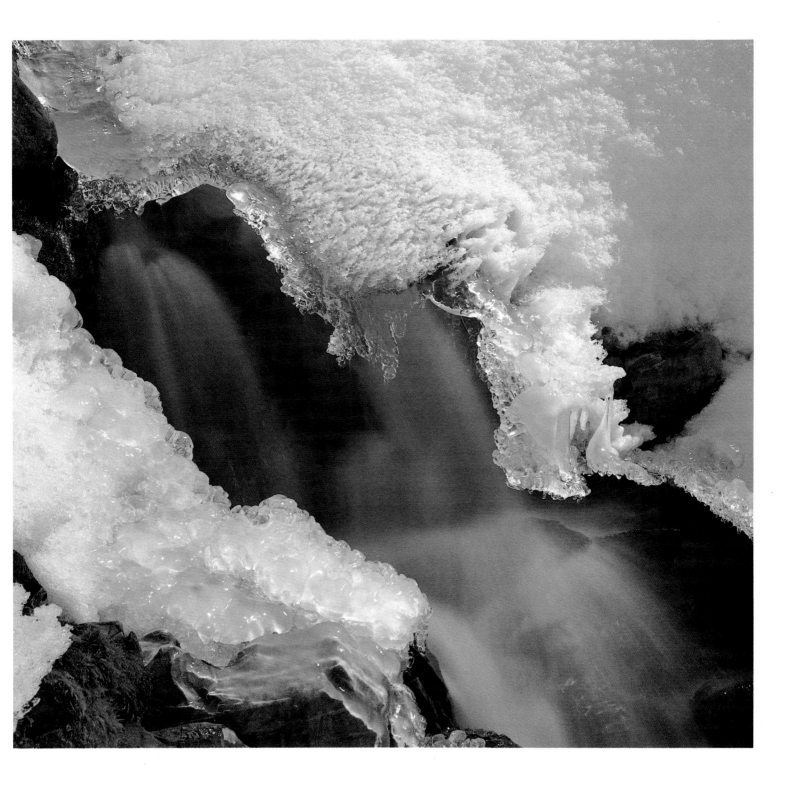

The water of Moraine Creek falls behind a curtain of ice.
*Overleaf:* Marshland near Bow Lake.

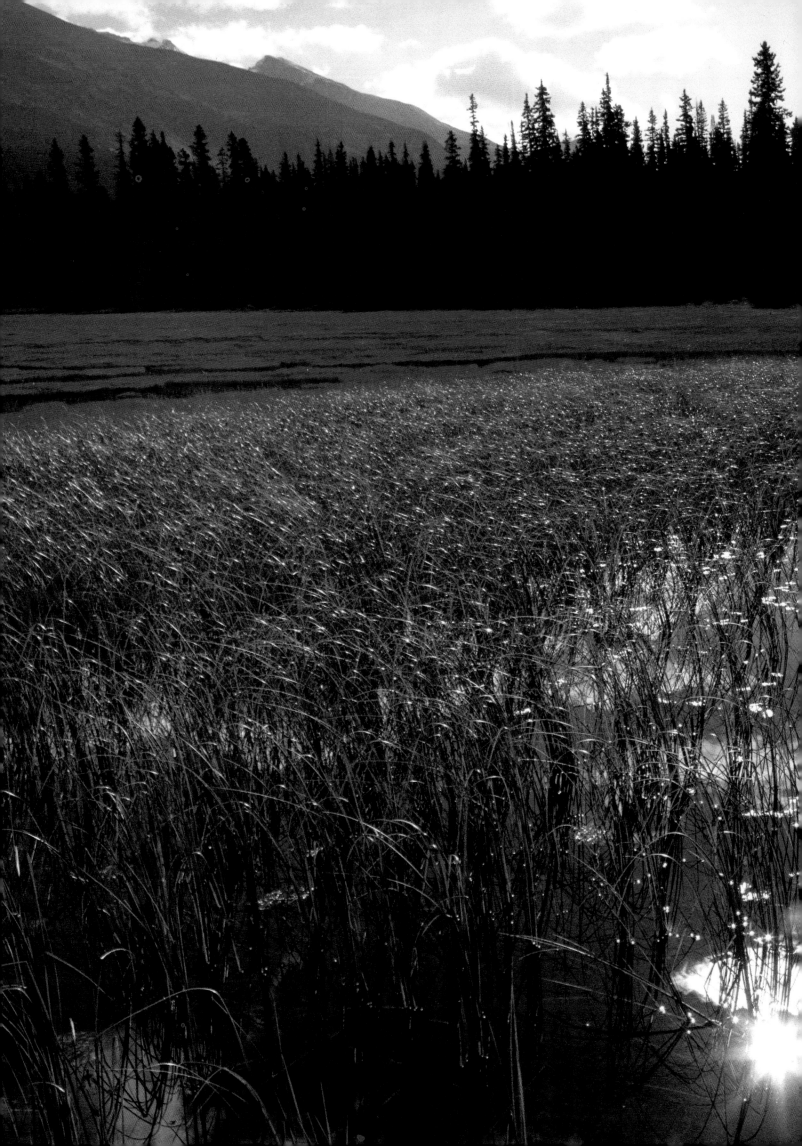

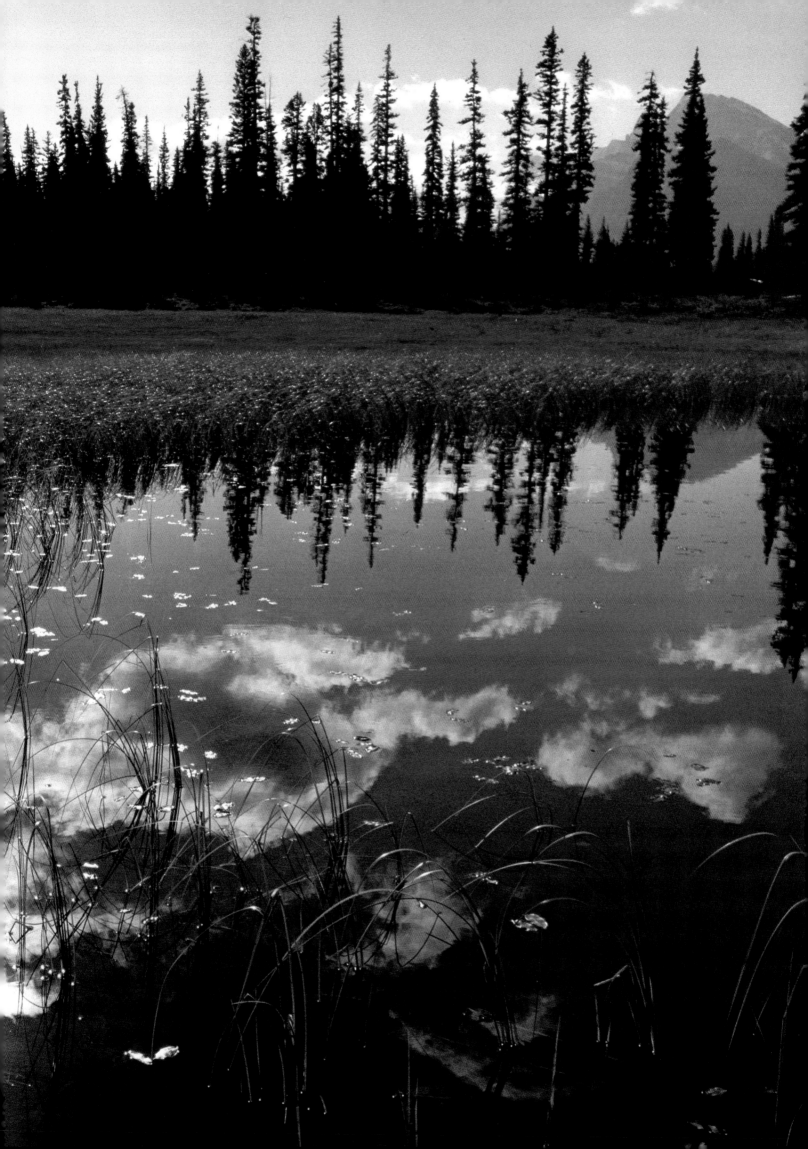

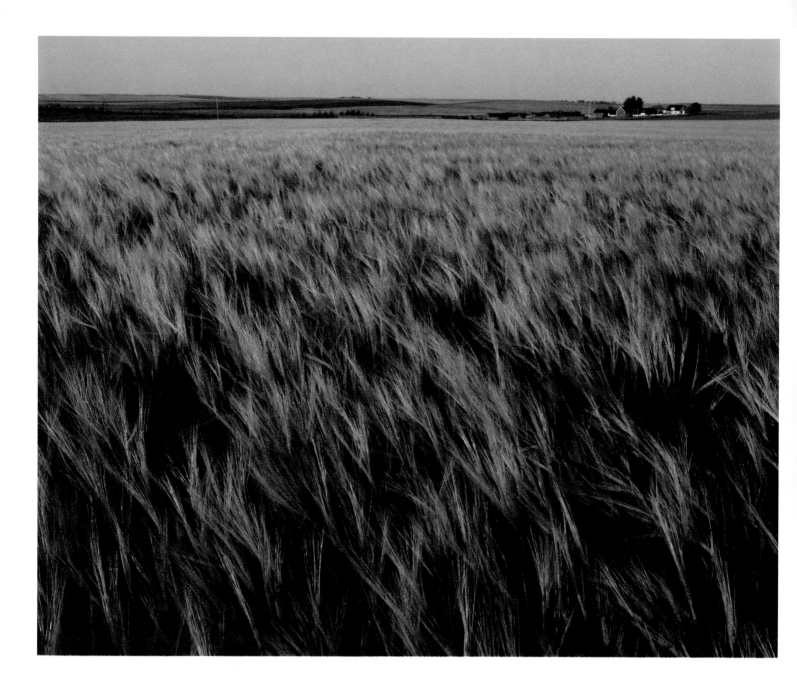

*Above:* A prosperous-looking farmstead overlooks a field of
barley.
*Right:* Prairie dogs seen through grass, near the buffalo paddock,
Banff.

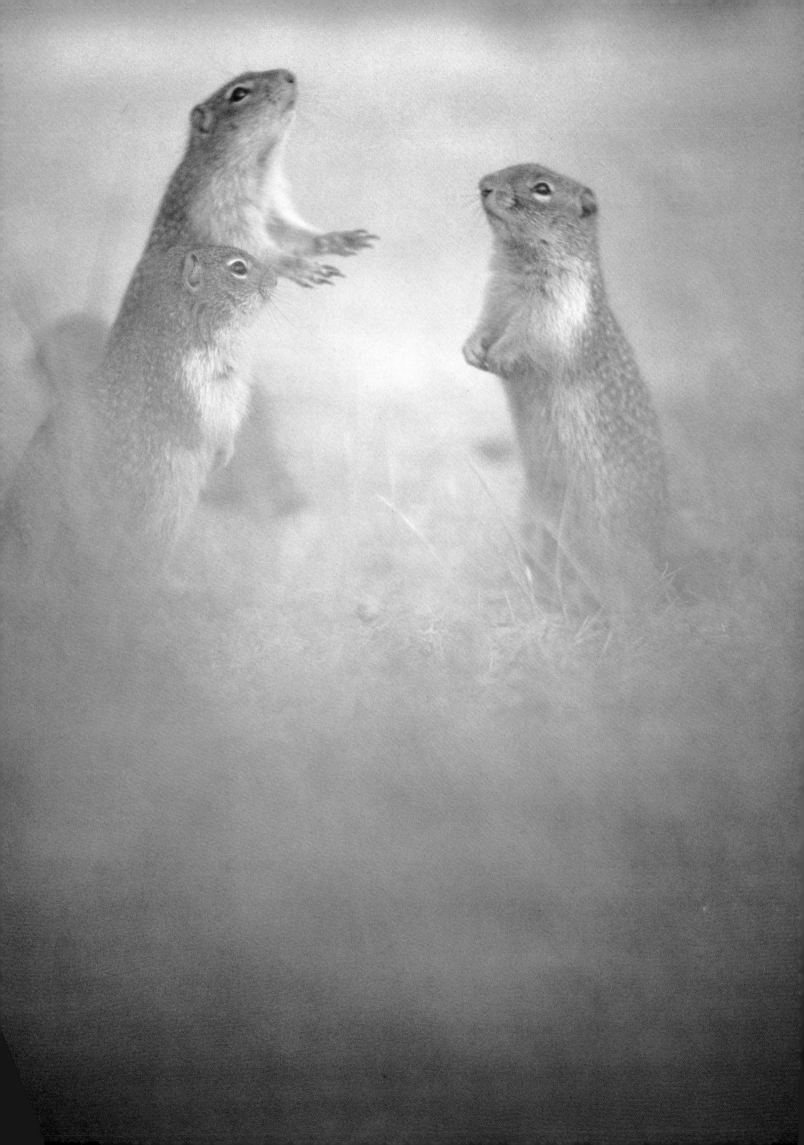

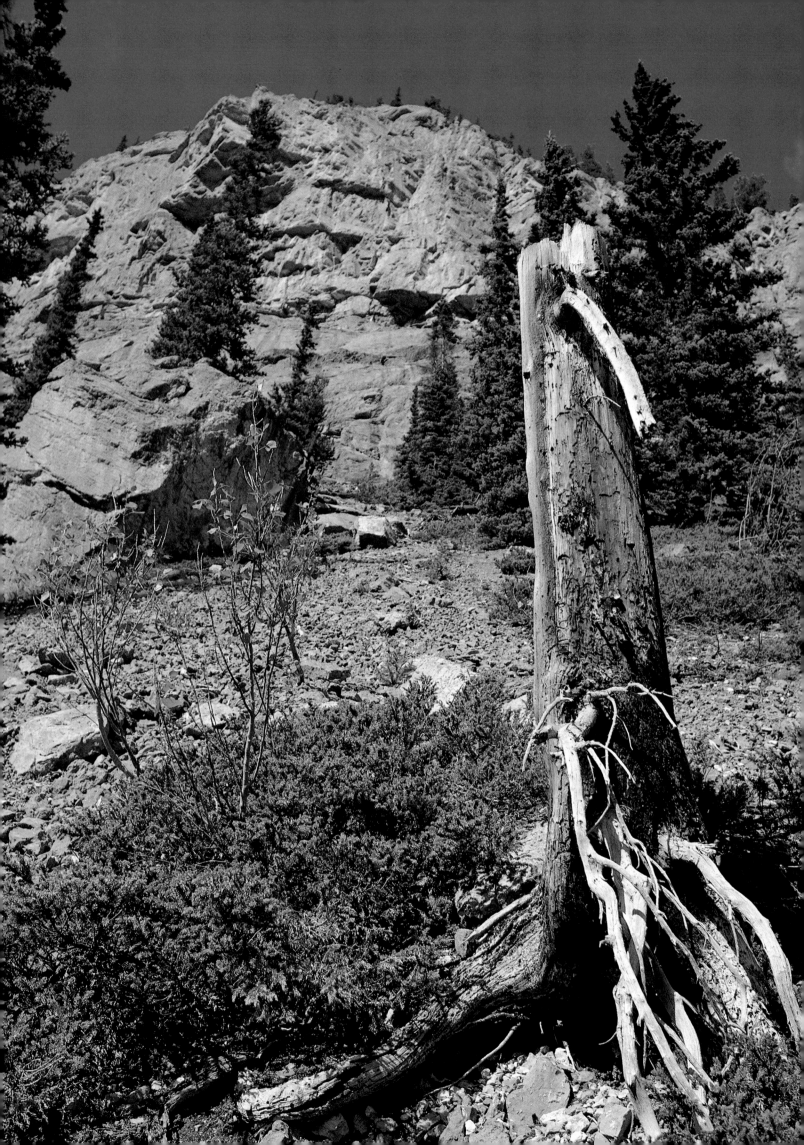

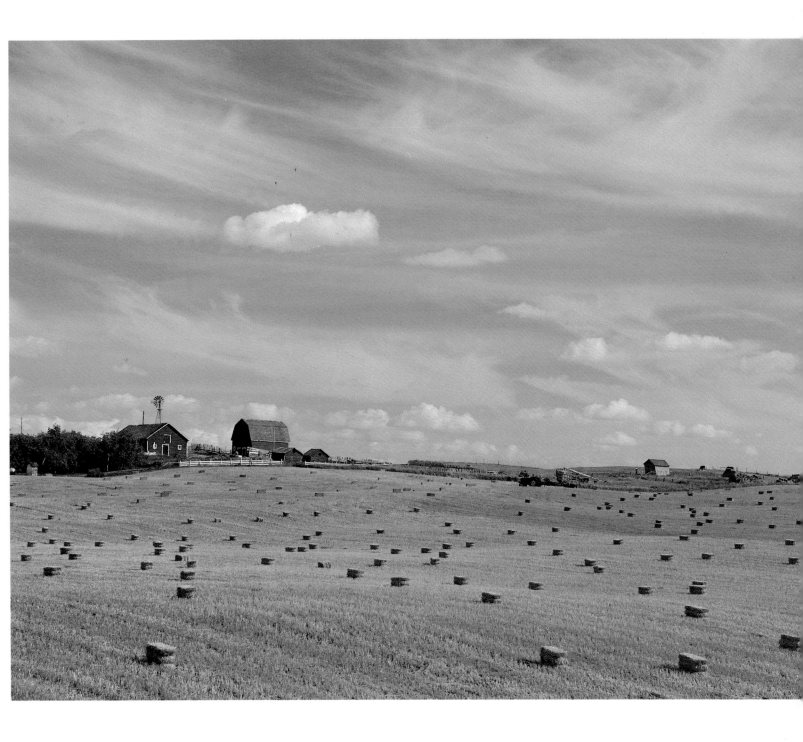

*Left:* Fall above the Moraine Lake Road.
*Above:* Harvest time on a farm near Red Deer.

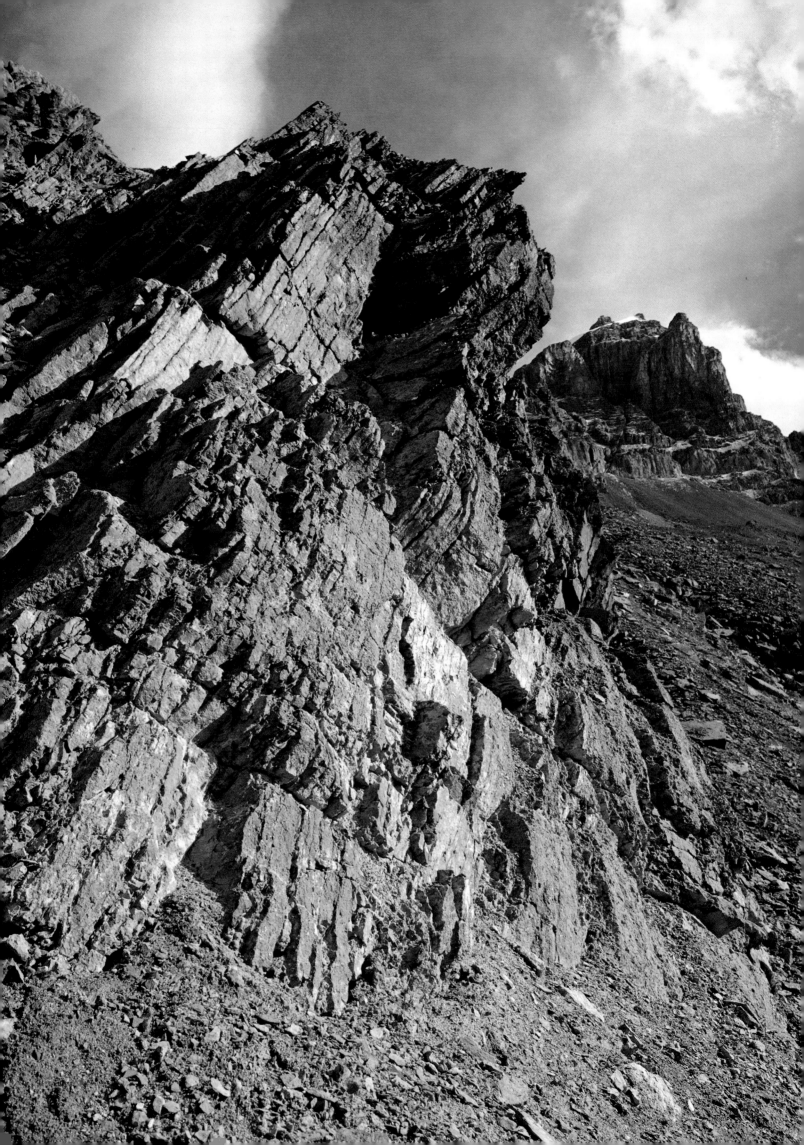

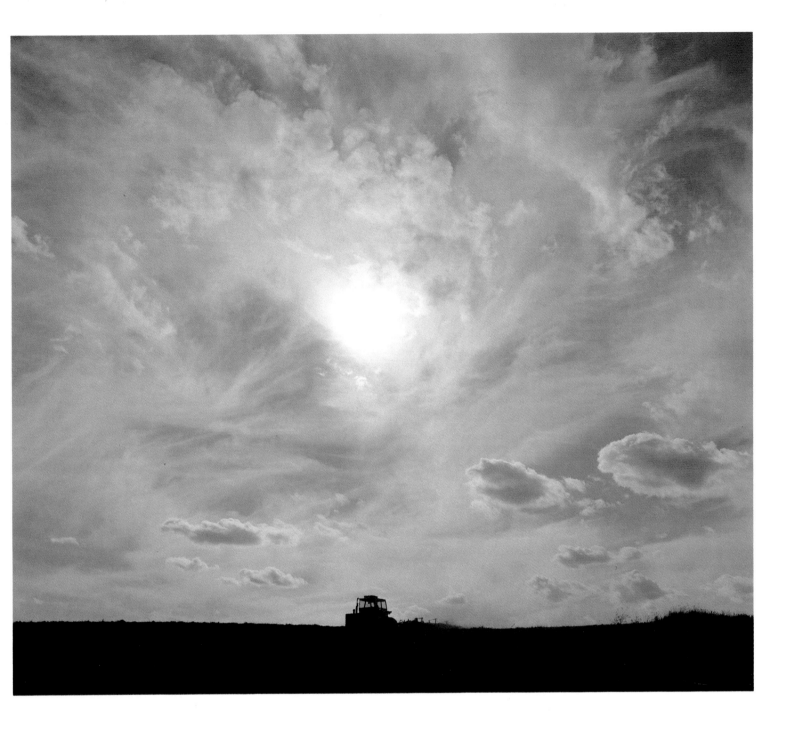

*Left:* A thrusting rock formation near the Athabasca glacier.
*Above:* A farmer near Red Deer ploughs the land.

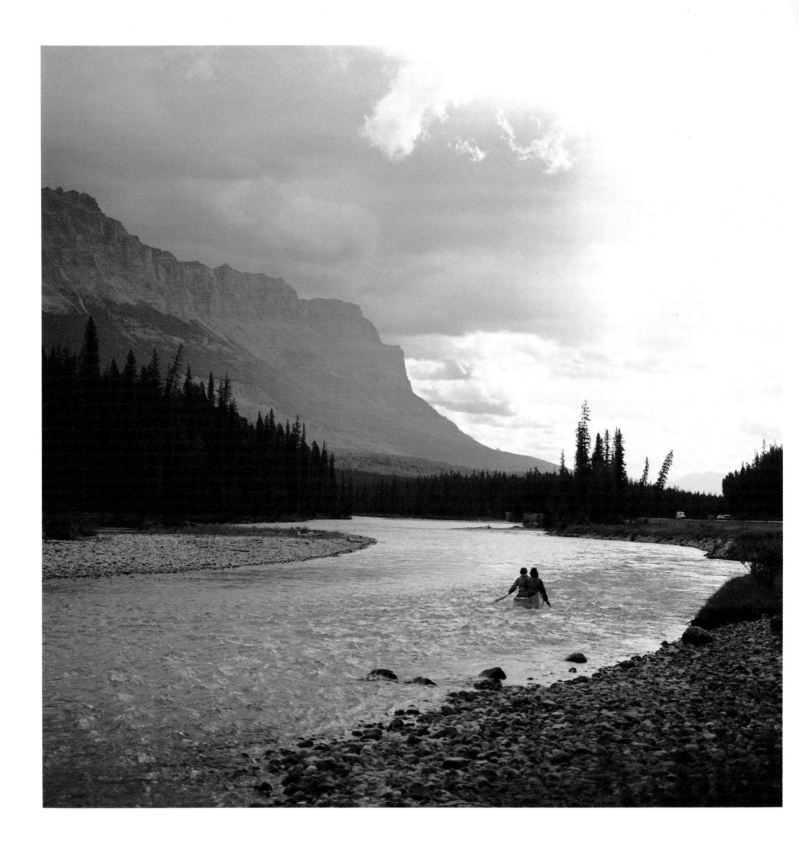

Canoeing on the Bow River near Lake Louise.

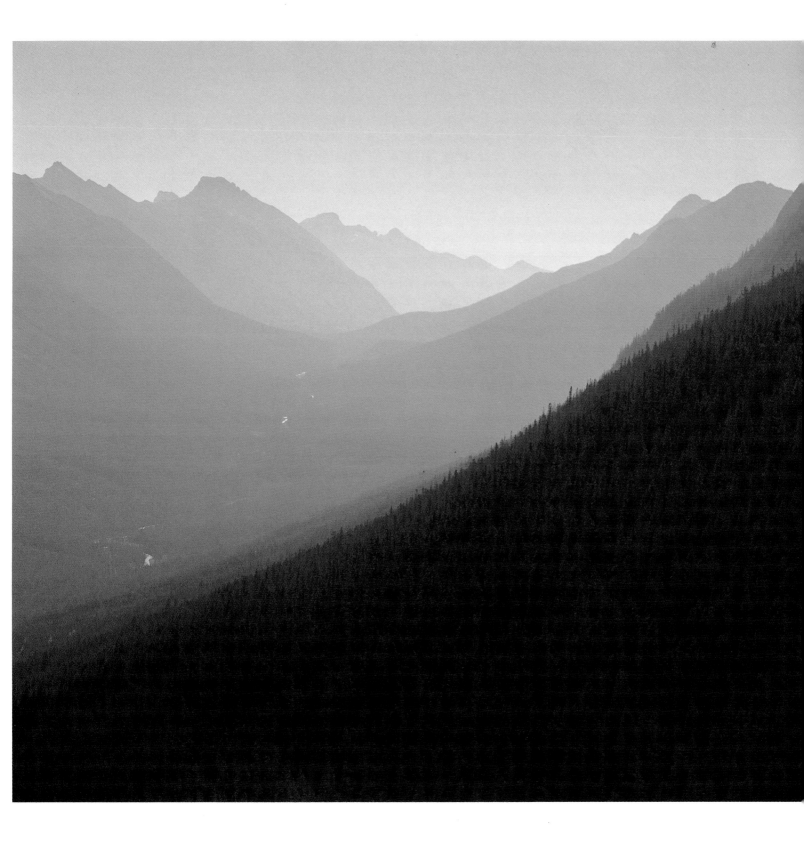

The panoramic view of the Goat Range from the Sulphur Mountain lift.

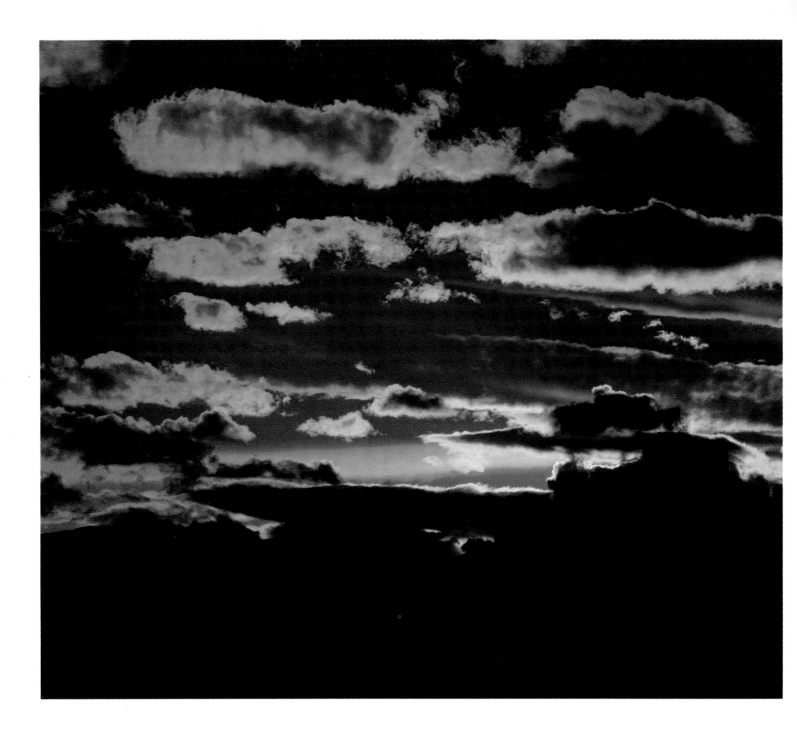

Sunset along the Banff highway.

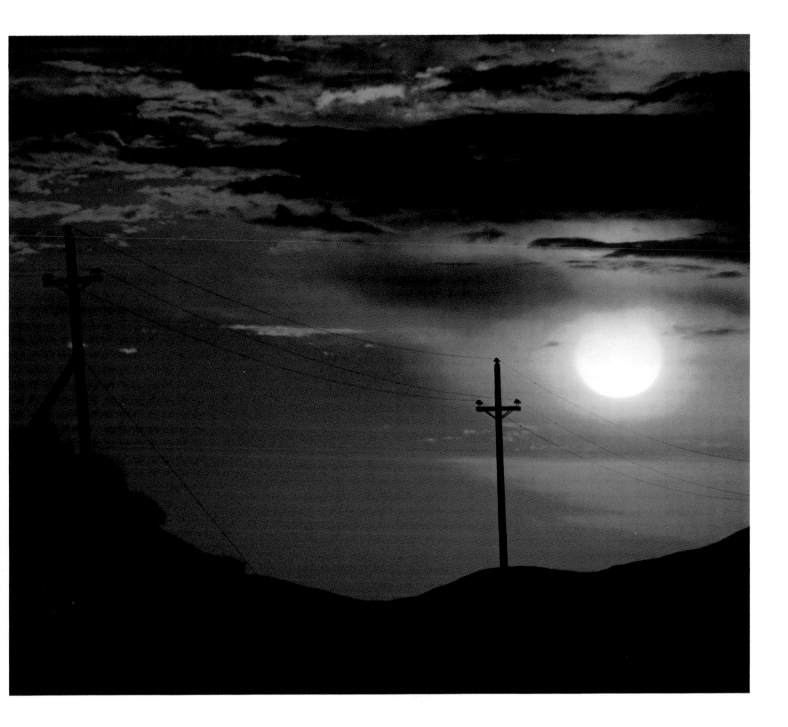

Drumheller Highway roadside at sunset.
*Overleaf:* Red and green leaves carpet the ground.

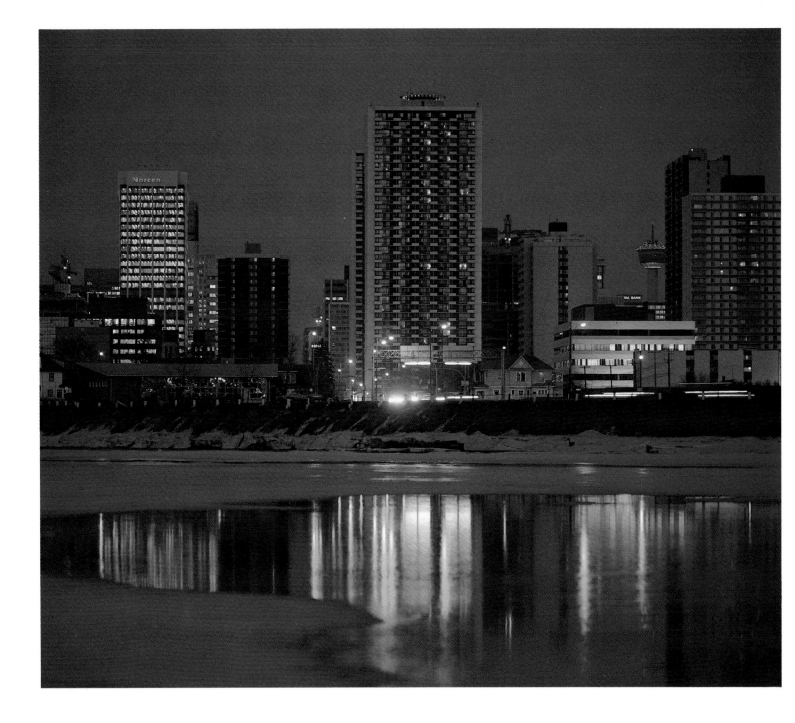

Calgary's lights reflect in the frozen Bow River.

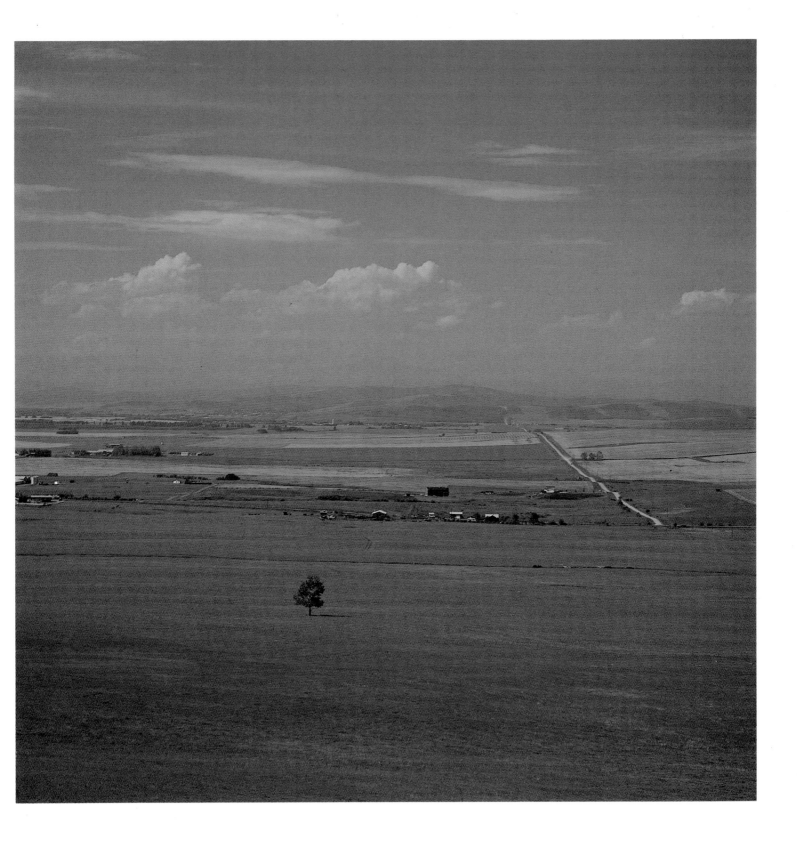

The lush farmland of Alberta continues to the foothills of the Rockies.
*Overleaf:* A farmer races against weather to finish harvesting.

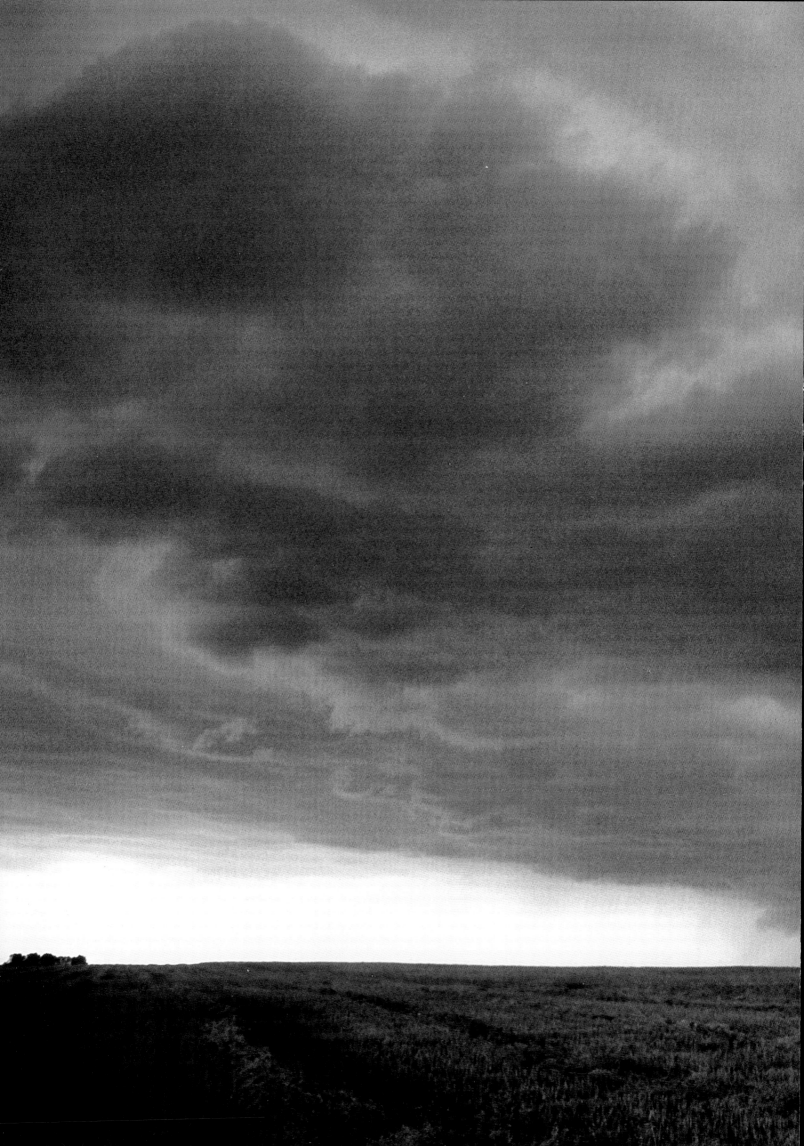

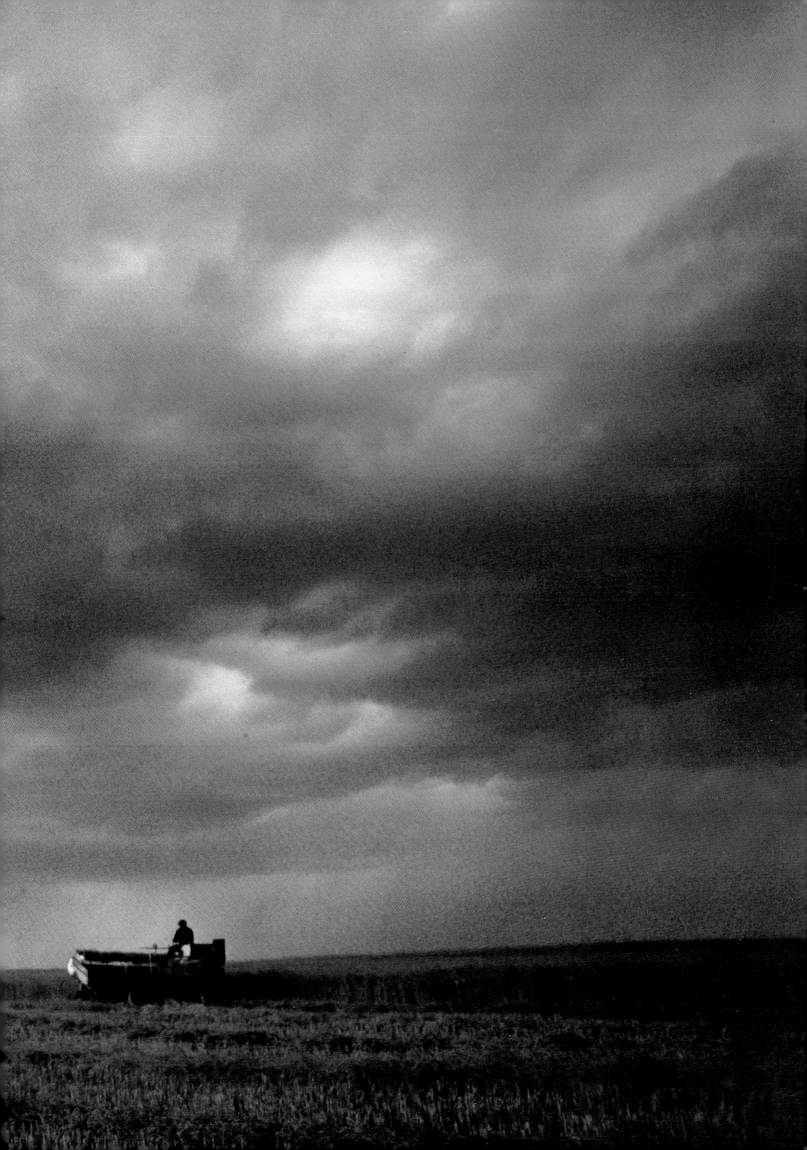

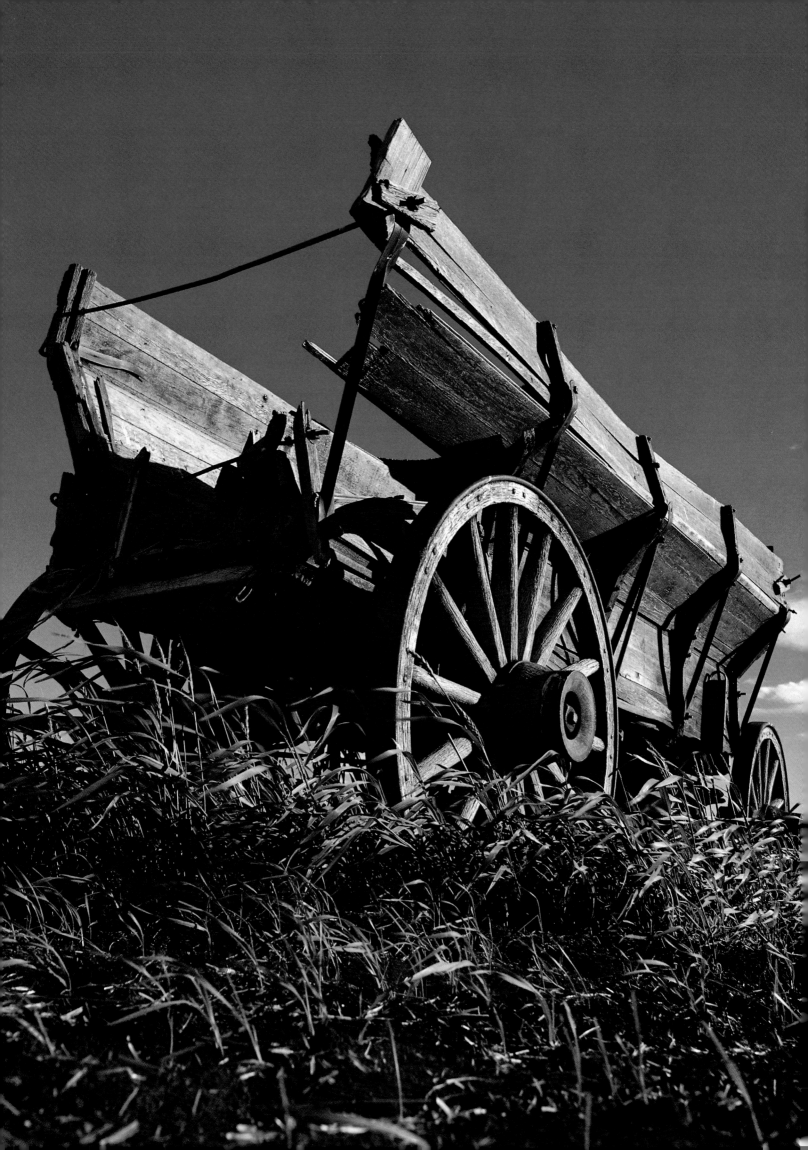

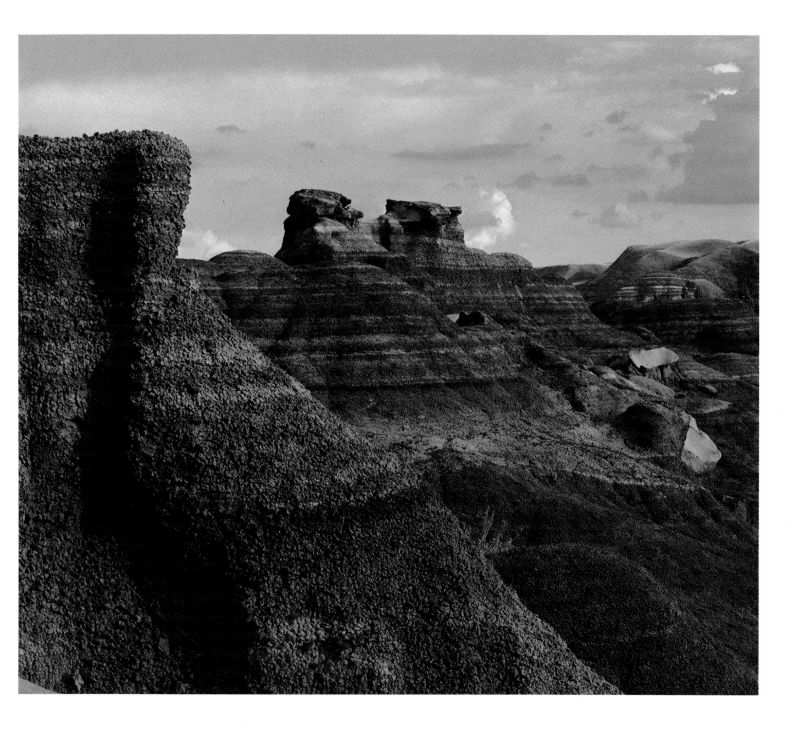

*Left:* Abandoned farm wagon near Blackie.
*Above:* The Drumheller Hoodoos - tombstones of the dinosaurs.

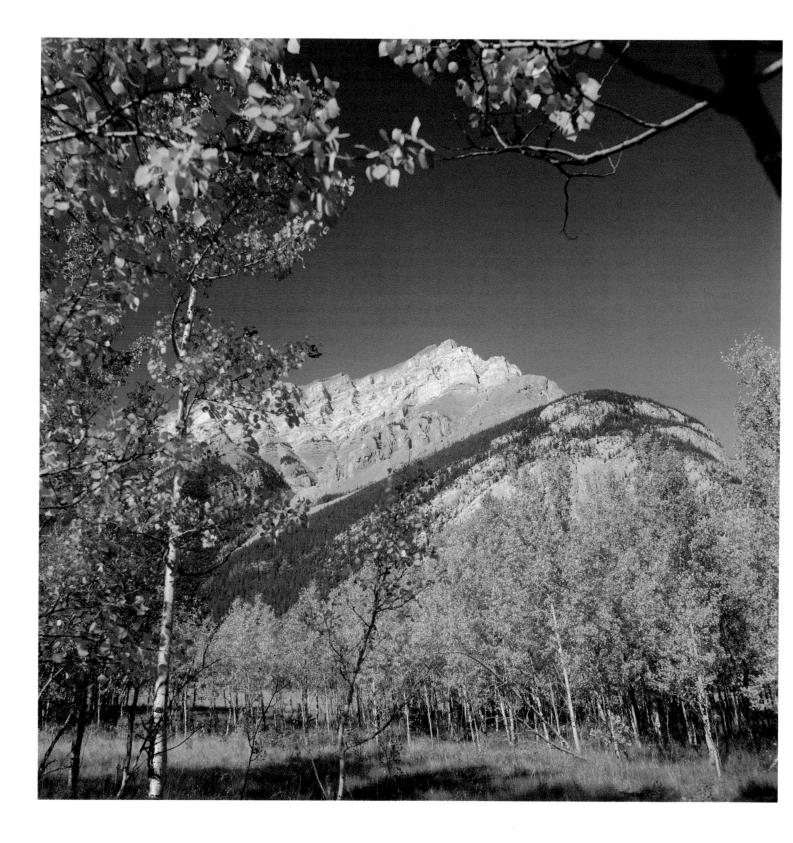

View from inside the buffalo paddock, Banff.

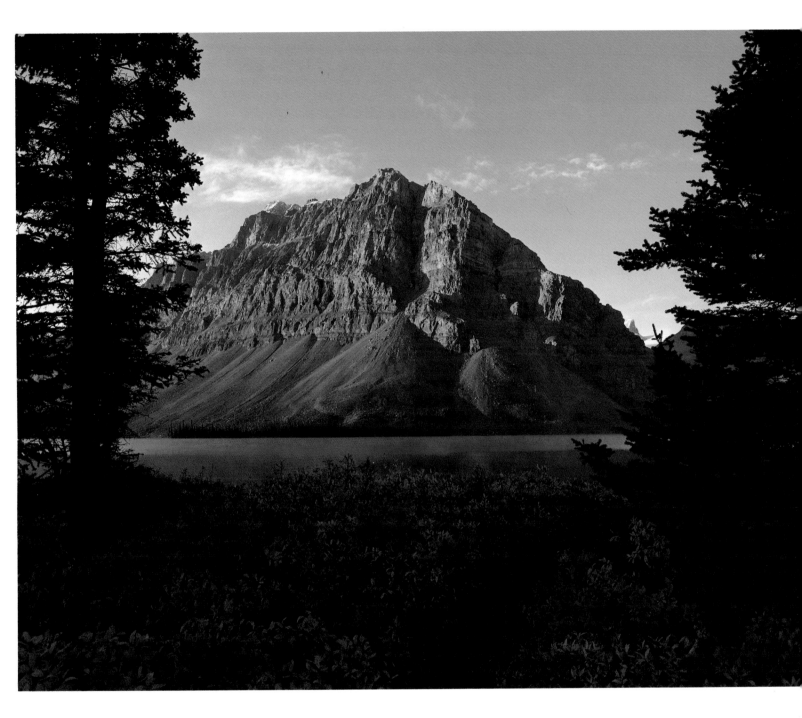

Mount Thompson and Bow Lake.

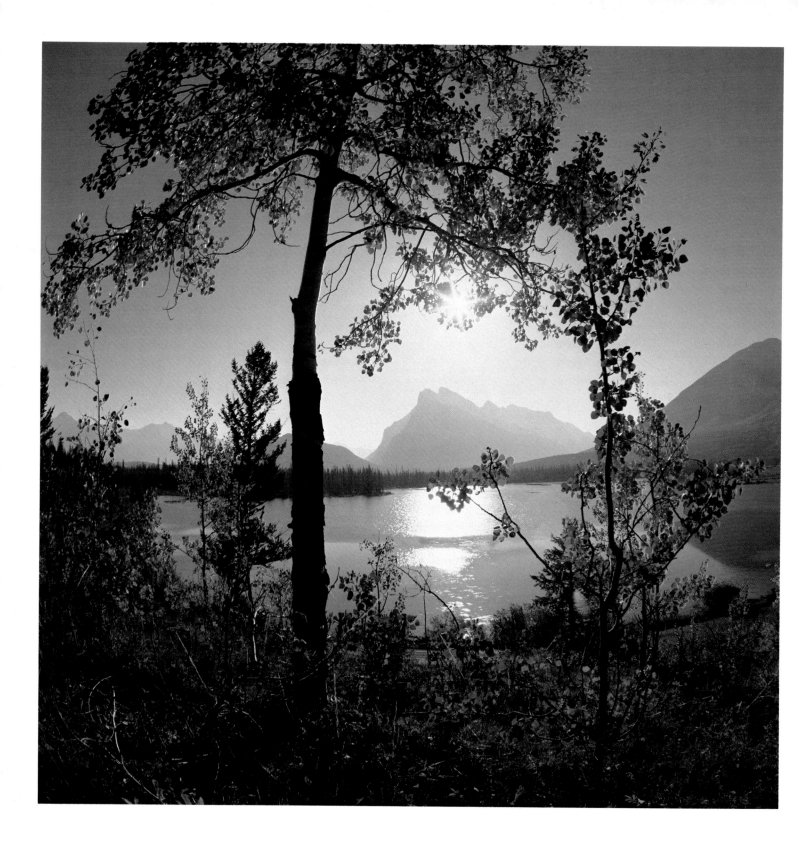

*Above:* In the distance Mount Rundle rises majestically.
*Right:* Ice patches on the Bow River.

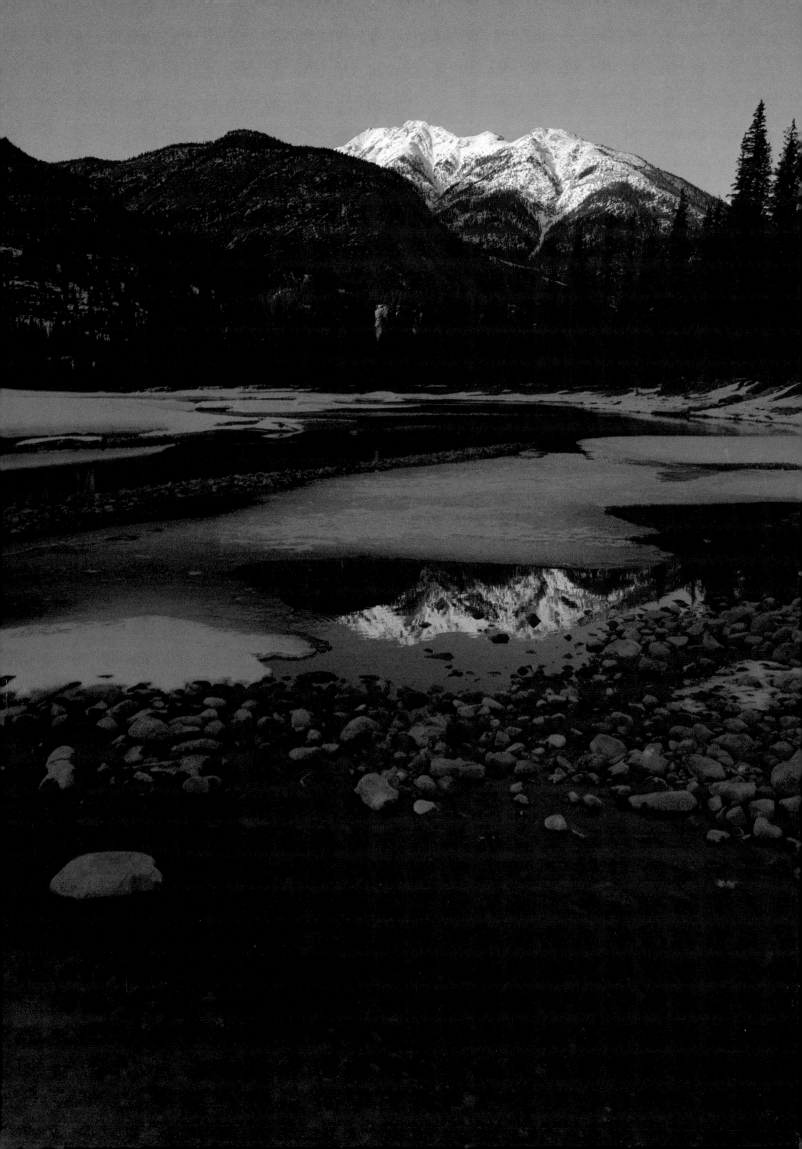

*Photographer's Note*

I found the province of Alberta a great challenge - the mountains, the lowlands, the architecture, and the people. In selecting these photographs from the thousands I took, I attempted to present a composite view of my feelings about this vital area of our country. I hope that your enjoyment in perusing this book will be equal to the joy I experienced in making the images contained in it.

Sherman Hines